the art of

ALEX GROSS

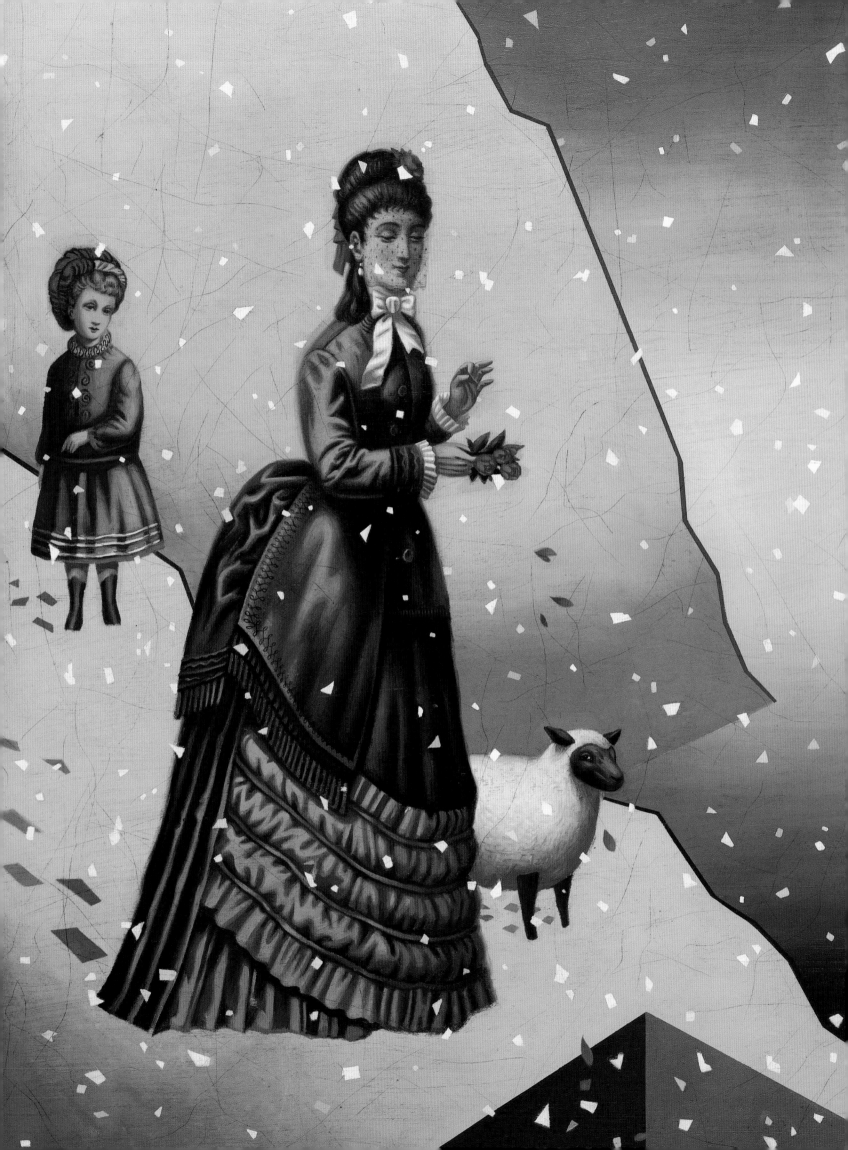

the art of

ALEX GROSS

PAINTINGS AND OTHER WORKS

INTRODUCTION BY BRUCE STERLING

CHRONICLE BOOKS

SAN FRANCISCO

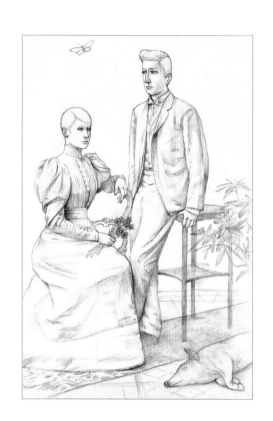

Dedicated to
my mother, Marcia,
my late father, Robert,
and my brother, Stephen,
whose love and support
have meant everything to me.

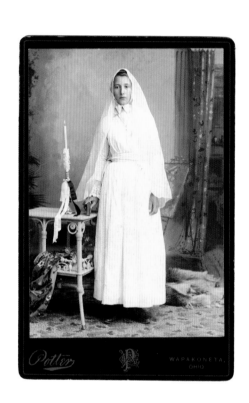

Contents

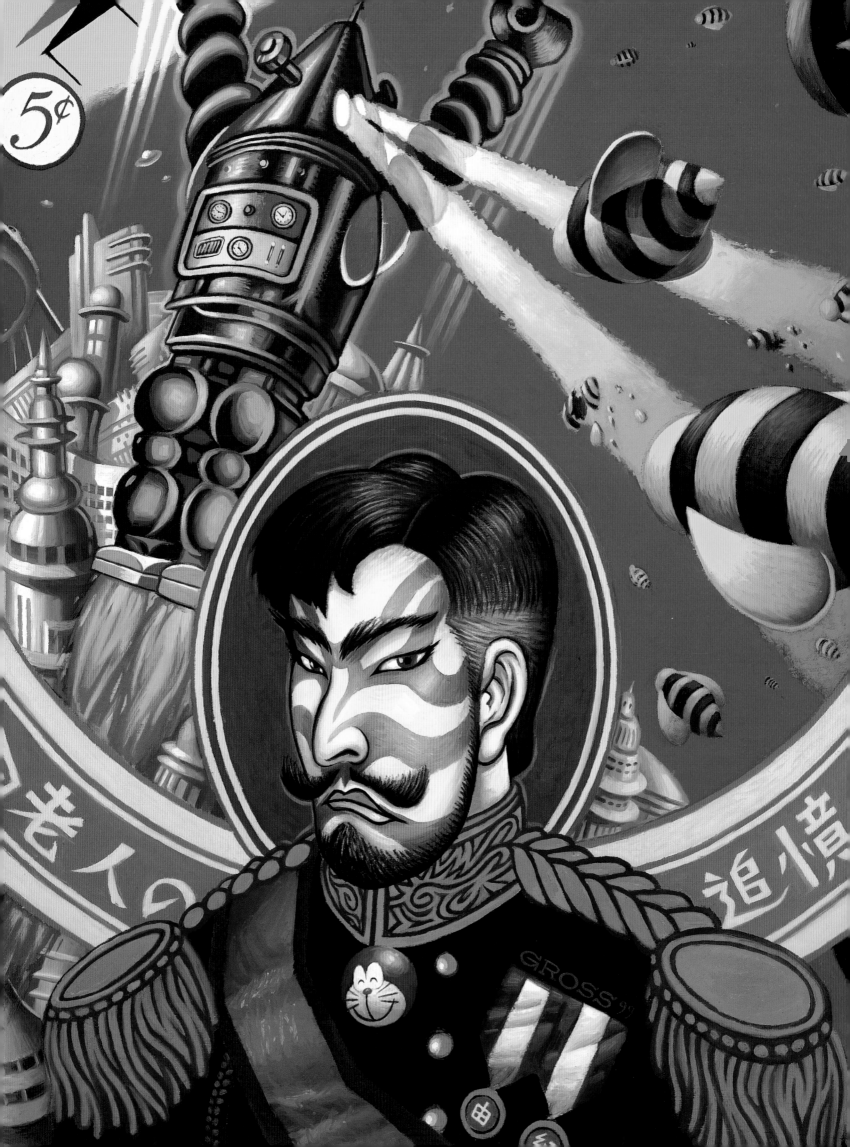

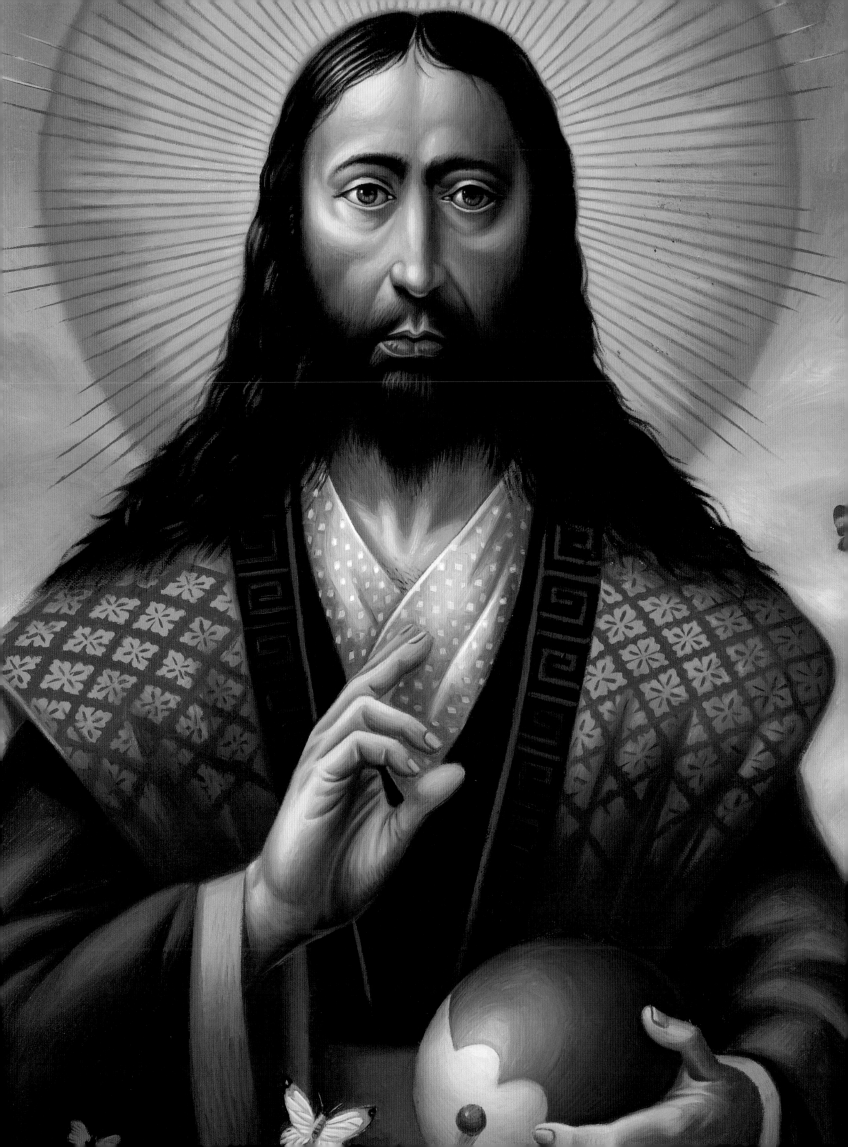

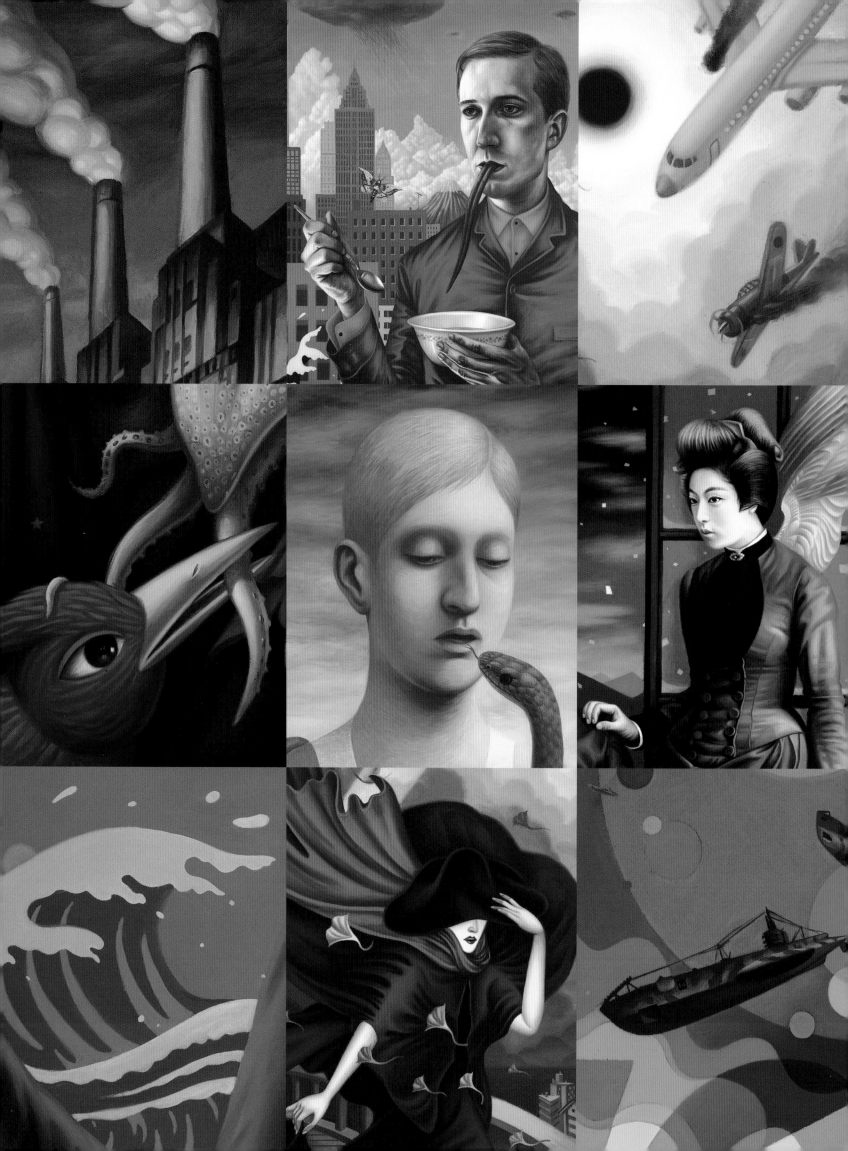

Anarchic Anachronist

BY BRUCE STERLING

Alex Gross resists understanding.

It's not that his art lacks sense; the art of Alex Gross makes *too much* sense. It's a powerful body of contemporary artwork whose themes are globalization, cross-cultural impact, commerce, engineering, great beauty, dark mayhem, and the remorseless passage of time.

Alex Gross has been called a "Pop Surrealist"—for he and his friends have caused too much stir to escape being given a label. But Alex is not a Surrealist by temperament. Instead, he's a brooding globalist. His work conjoins irreconcilable contradictions; it unnaturally bridges gulfs of space and time—because that's what the world's peoples must do, nowadays.

Back in its distant heyday, Surrealism harnessed the power of the unconscious to disrupt bourgeois sensibilities. Alex is very historically aware—few American artists are more so—but for him, the artistic key of the 1930s is not the Surrealist teachings of André Breton but the scarier lessons of 1930s Japan. As a teacher of illustration and an expert on Japanese commercial art, Alex Gross has remarkable insights into the ways that popular imagery behaves in a nation that has lost its way.

In the 1930s, while Breton held forth in his Paris cafés, Japan, a distinct Asian society in the industrial throes of Westernization, slid into the abyss of the "Dark Valley." Japanese society was enveloped in an irrational miasma of terrorism, and a ruthless right-wing militarism that crushed all domestic dissent. Yet one can open a Japanese magazine printed in that period, and what does one see there? Scarcely a hint of the kamikaze mayhem so soon to come—it's all steam irons, hair curlers, and health nostrums, mostly peddled by nicely dressed, iconic pretty girls. Alex Gross knows this; he once put together a handsome book on the subject.

That dichotomy, that disjuncture between that which is packaged for us to consume and our own unspoken distress as human beings tumbled in dark streams of history—that's the variety of "surrealism" that compels the work of Alex Gross. It's deeply repressed and hidden from conscious awareness, something like a covert bombing campaign that fails to appear on TV. That is the source of his work's dark power, its evocative sorrow, and its tangled sense of destiny.

Southern California, where Alex lives, works, and teaches, is the epicenter of Pop Surrealism. The average pop-surreal "Lowbrow artist" from the Los Angeles "*Juxtapoz* crowd" has a given repertoire of graphic motifs. These were mostly gifts from the movement's 1960s guru, Ed "Big Daddy" Roth, later expanded and interpreted by the redoubtable publisher, theorist, and artist Robert Moore Williams. Both Williams and Roth were underground counterculture figures, always keenly aware that their colleagues and their core demographic were the dispossessed, the alienated, and the artistically ghettoized.

As wary pop-cultural combatants, these Californian art pioneers came up with a set of graphic symbols that had the street-level immediacy of a Molotov cocktail or a biker's tire iron. If you're down with the *Juxtapoz* art scene, you'll necessarily exult in plastic monster models, hot rods, comic books, Mexican folk art, old record covers, and tattoos. If you're also from the Los Angeles basin (the seething menudo bowl of Lowbrow Art), you'll furthermore be into tikis, cocktails, Hollywood B movies, bad TV serials, surf art, skateboards, biker gangs, graffiti, and palm trees. California's Lowbrows are a jolly, catch-as-catch-can crowd of popular art rebels, cocking a snook at the stultified world of fine art—when not putting oil to canvas for their own thriving chain of alternative galleries, they'll whip out band posters, T-shirts, Zippo lighters, billboards, and (a *Juxtapoz* specialty) Lowbrow imagery tattooed right into the human flesh of their fan base.

It's wonderfully impressive that Lowbrow Art, a genuine outlaw art scene of authentic grease-monkey refuseniks, has lasted long enough and flourished so prolifically that there is now such a thing as an "average" Lowbrow artist. But whoever this guy or gal is (and I certainly wish him or her the best), Alex Gross is always far from average. Lowbrow works are wild jeux d'esprit full of wacky, addled joie de vivre, while Alex's graphic meditations are stark existential confrontations with a disjointed planetary fate. While they're digging sci-fi B-movies, his favorite writer is George Orwell.

Alex Gross also deploys his own repertoire of representational icons, but they're not tikis and tattoos. They are a seething Pandora's box of serpents, skewered birds, smoldering airliners, surveillant spies, skulls, sickness, skies in a cloudy eclipse, and cityscapes reeling with vertiginous architecture. Although his work is rife with pretty girls, those girls are never smiling. At their best, these elegant women might glow with a certain self-contained savoir faire as all hell breaks loose around them.

He is an anarchic anachronist, with a keen eye for histori-
cal incongruity and a taste for appropriated, repurposed
art. Nevertheless, there's a visible arc of development with-
in the Gross oeuvre. We might first consider, say, the early
work *The Burning of Tokyo*, whose horrific theme is somewhat
obscured by a comely geisha clutching a giant squid. It's a
wonderfully painted squid, but the pop weirdness of a squid
came too easily. The Grossian *sensibil-
ité* advanced with works like *La Nauseé*,
where a Meiji-era nurse impassively
offers a gaudy patent medicine to a
patient so long dead that his bones
have been picked clean. Then there's
the seriously disturbing work *Twenty*,
where a Dark Valley banzai militant
with a carbine over his desiccated
zombie shoulder lays a (consoling?
murderous?) hand on his kimonoed
wife. With her face frozen calm as a
Noh mask, she clutches the bright,
worthless phantom of a beach ball and
emits a single bubble of silent
anguish—an empty word balloon jets
from her neat black coiffure, a device
that alludes to anime comic books
without being in any way comic.

The Meaning, Part II has a particularly
effective graphic composition.
Something unspoken and awful has
just happened atop a brick skyscraper;
a young Victorian maiden, accompa-
nied by an innocent dappled fawn,
peers down into the sinister abyss of
an urban canyon. The perspectives
here are Lovecraftian; the fawn is
weirdly foreshortened, the dainty young girl perched at the
brink of death must, logically, be about seven stories tall,
while we, the scene's viewers, hover uneasily in midair at
skyscraper height. If we somehow come to grasp the mean-
ing of *The Meaning, Part II*, we will plummet instantly to the
cruel street far below.

In *Outer Space Is a Lonely Place*, a pinup girl perches on the air-
less landscape of a Saturnian moon. Her head is surround-
ed by a sci-fi bubble helmet that doubles as the aureole of a
saint, and around that suffocating bubble is her agonized,
cursive motto: "I feel so sad I don't know why." The quiet
atmosphere of loss and grief here is truly otherworldly. It is
a genuine cri de coeur of the dispossessed, the alienated,
and the ghettoized. Here the dispossession is total, the
alienation is cosmic in scope, and the ghetto is one we must
all share by virtue of our human mortality.

In the recent work *Day of the Locust*, the mannerisms and
motifs of Gross's early work have been stripped away; it's
girl versus bug, a single human being and the single insect
agent of a sky-clouding locust plague. This new work shows

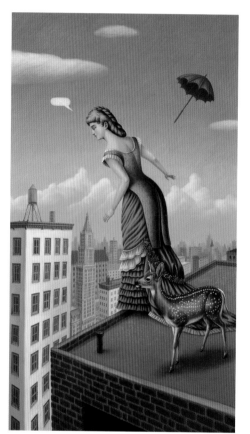

The Meaning, Part II

a new clarity of intent: it's radically different from the work
that brought him his past success, and it's also a conceptual
step forward.

In person, Alex Gross is a tall, sinewy, dark-eyed guy in a
sharp-billed baseball cap. Though his art is mysterious,
unhinged, and *unheimlich*, he has a very unpretentious affect,
something like a knowledgeable sports
fan or a competent engineer. A
meticulous craftsman, he constructs
his canvases in a deftly organized
home workspace not too much bigger
than a step-in photo booth.

His home is as densely packed as a
petrochemical plant: it's a seething
cultural arsenal of antique photo-
graphs, Japanese *ukiyo-e* prints,
Victorian *cartes de visite*, uncanny plastic
toys, splashy foreign film posters, and
prized paintings by his favorite col-
leagues. He'll never lack for inspira-
tion; he has his muse in a hammer-
lock.

He paints with fierce dedication.
Sometimes he even paints his refrig-
erator—dabbing a little pigment on its
glossy enameled surface as he waits for
the coffee to boil.

His respect for the past, his intelligent
sympathy for the alien, and his mani-
fest love for his craft have made him
very much an artist of our times. This
is the first book of his own work. I
can't wait for the second one.

— Bruce Sterling
Los Angeles 2005

*Bruce Sterling, author, journalist, editor, and critic, was born in 1954.
Best known for his eight science fiction novels, he also writes short stories,
book reviews, design criticism and opinion columns. His nonfiction
works include* The Hacker Crackdown: Law and Disorder
on the Electronic Frontier *(1992) and* Tomorrow Now:
Envisioning the Next Fifty Years *(2003). He is a contributing
editor of* Wired *magazine.*

*He also writes a weblog, and runs a website and Internet mailing list on the
topic of environmental activism and postindustrial design. In 2005, he was
the "Visionary in Residence" at Art Center College of Design in Pasadena.*

He has appeared on ABC's Nightline, *BBC's* The Late Show, *CBC's*
Morningside, *on MTV and TechTV, and in* Time, Newsweek, *the*
Wall Street Journal, *the* New York Times, Fortune, Nature,
I.D., Metropolis, Technology Review, Der Spiegel, La
Repubblica, *and many other venues.*

Detail from Twenty

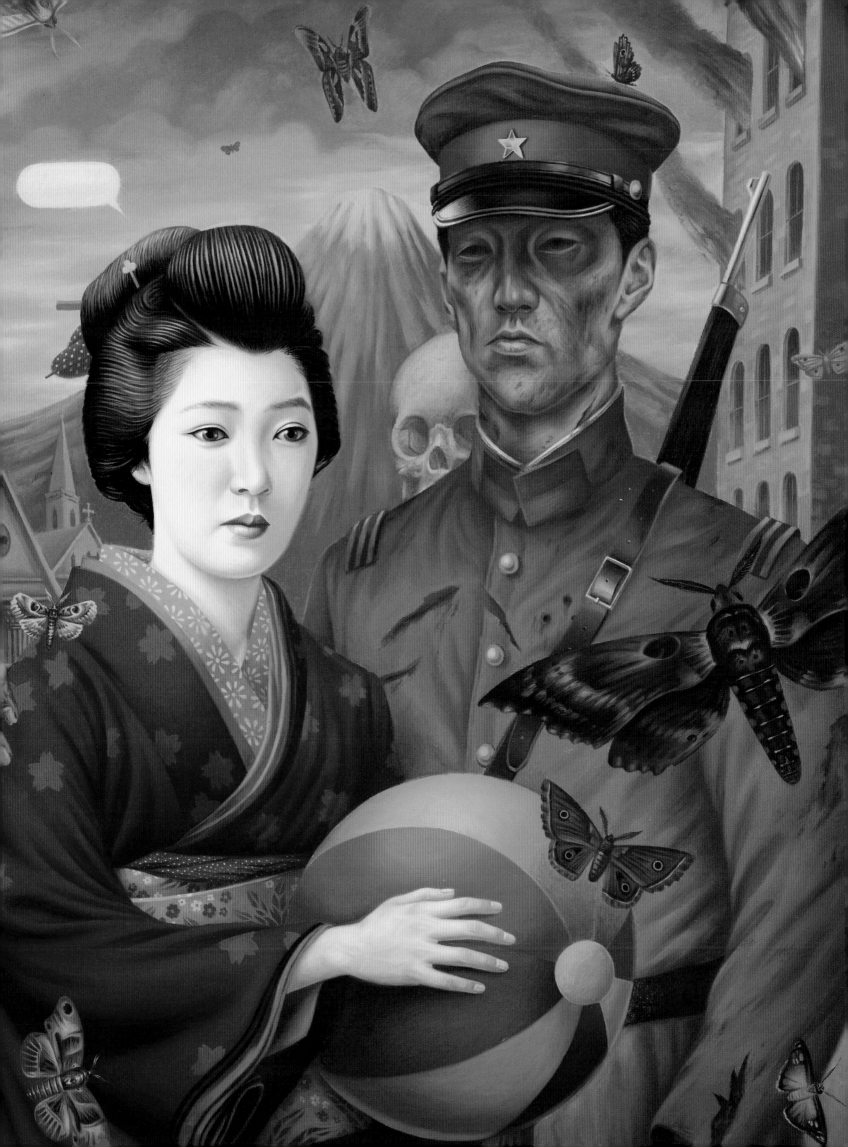

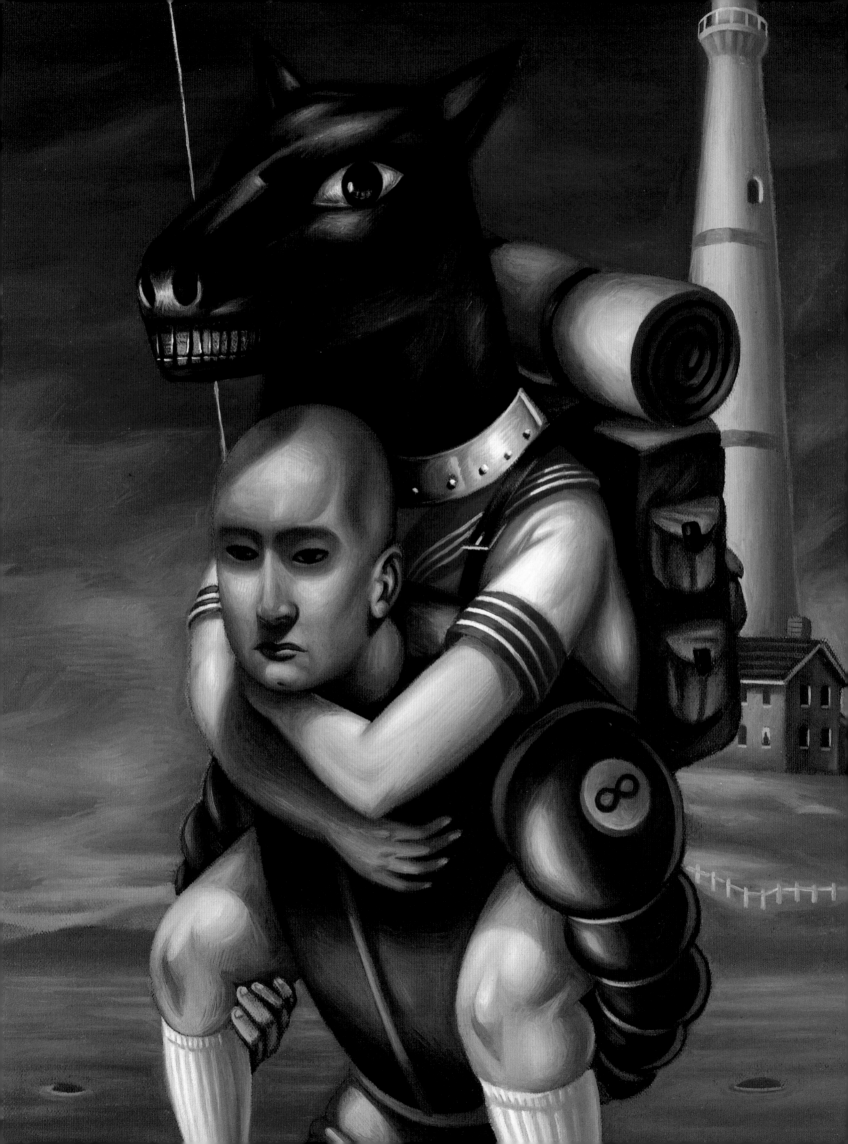

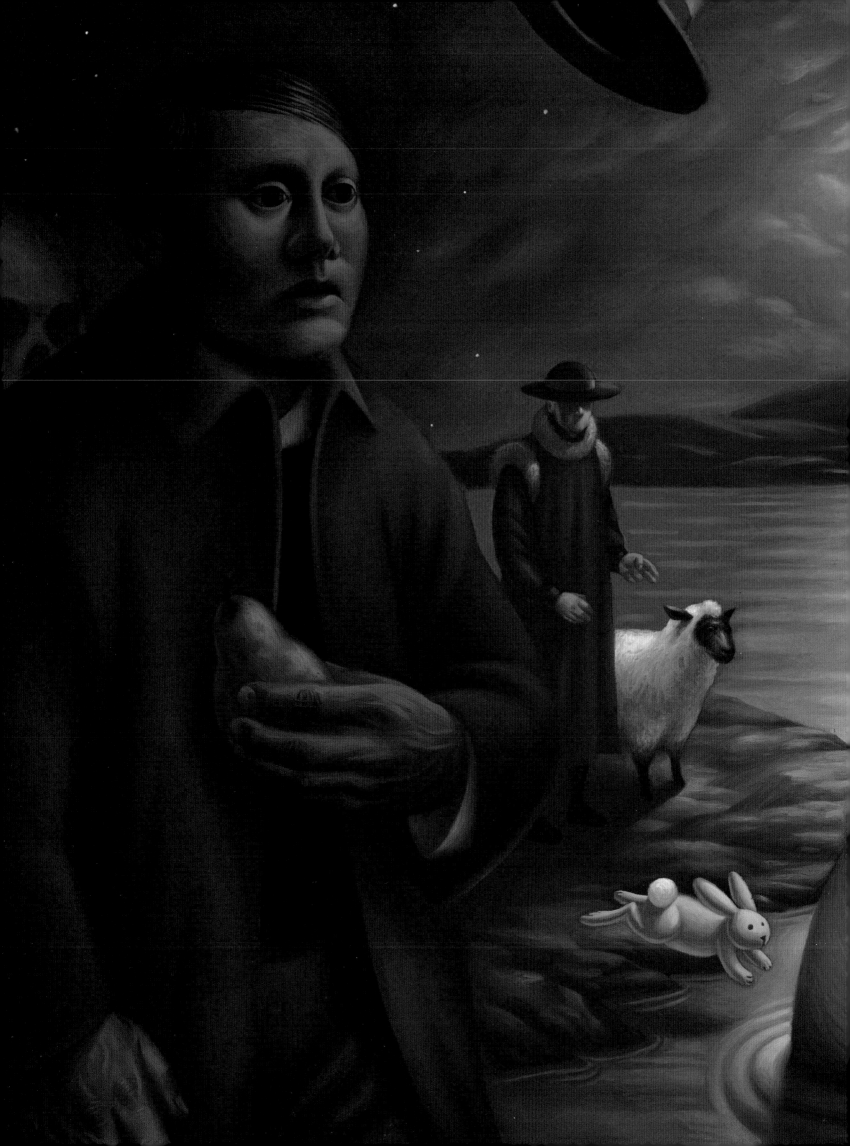

An Interview with Alex Gross

BY MORGAN SLADE

A graduate of Art Center College of Design, Morgan Slade is a photographer as well as a mixed-media artist. He currently works for a large publisher in Los Angeles and has also worked for Western Interiors and Design *magazine. Morgan's artwork has been shown at Copro Nason Gallery in Los Angeles, and he is the co-creator of Leap comics, a project that he developed with Alex Gross. In addition, he is the songwriter/guitarist for the band Miss Derringer, which is fronted by the artist Liz McGrath and whose second album is on the Sympathy for the Record Industry label. Morgan has known Alex for a number of years and has witnessed the creation of virtually every gallery painting that he has ever done. They sat down in the fall of 2005 to discuss Alex's work, art in general, and a number of other things.*

Morgan Slade: So tell me a little about the Japanese stuff. I guess only about a quarter of your work is Japanese influenced. But it seems like it was your starting point.

Alex Gross: I have always been interested in Japan, since I was a little kid. Obviously the culture is very visual. I saw a Kabuki performance in New York once when I was little. I think I almost fell asleep during the actual performance, but I loved the costumes and the program and the first scene. It was a bit slow, you know, for a seven-year-old. But I remember going home and drawing the characters; it was totally cool to me.

Before 1998 I was just doing commercial work and was totally fed up, but I really didn't know what direction to go with my work. So going to Japan in '98 for the first time and seeing all the amazing visual stuff there rekindled the excitement and interest I had had as a kid. I bought a wonderful medicine packaging book, and a great sci-fi movie poster book, along with some other stuff that I brought back. I now had hundreds of pages of incredibly inspiring imagery that was all new to me. So it was just a starting point, a creative rebirth, so to speak.

M: Do you think the inspiration was the fact that it was specifically Japanese, or just that it was something foreign?

A: Well, yes, there's something about things foreign that's cool and interesting just because they are different and you have never seen that before. There was definitely some of that. But I think that if I had gone to, India, say, even though imagery there is really beautiful too, I don't think that I would have been into it as much as I was into the Japanese imagery. Again, when I was a kid I just loved going to this Japanese restaurant that we used to eat at about once

a month. It was a big deal—you took off your shoes, sat on tatami mats, the whole thing. It wasn't like going to any other kind of restaurant, it was something unique. They even had old *enka* music playing on the stereo. I remember that the TV miniseries *Shogun*, based on James Clavell's novel, also had a big impact on me.

M: You were also into Shogun Warriors, the toys.

A: Yeah, I loved those toys as a kid, although I was never allowed to have them. So it's true that its being a new and foreign thing made the Japanese experience more interesting to me, but Japan was always a specific interest. The most powerful thing that I saw in Japan was that weird mix of Japanese and Western things. It was very surprising. I had no idea of the extent to which American corporate advertising and Hollywood was present in Tokyo. I saw a giant Hanson poster in the subway. This was back when Hanson was actually a popular band. That's quite random, seeing an image of some fake American teenybopper band-product in Tokyo of all places, or seeing Kevin Costner on TV selling cars. I wasn't expecting that at all, because there was nothing like *Lost in Translation* yet to prepare me. It was all sort of fascinating, disgusting, and mildly depressing.

M: When you thought about that, did you feel guilty, or responsible in some way, and does that play into your painting at all? In a way, it's because we occupied them after the war that things are that way, isn't it?

A: A little bit of it is, but I thought much more of it was, until I learned more about the Meiji period and the restoration of the emperor. It really started in the 1860s. Japan had been closed for about two hundred years, and as soon as they restored the emperor, they quickly started to Westernize. The empress started wearing Western dresses and encouraged all women to leave the kimono behind, and the emperor always wore a Western military uniform. I actually collect wood-block prints from this period that feature Japanese in Western clothing. This is also when English begins to appear in Japan. So, as far as feeling responsible or guilty somehow, it's more complicated than that.

M: But some of the early work you were doing [1999] deals with what you were just talking about.

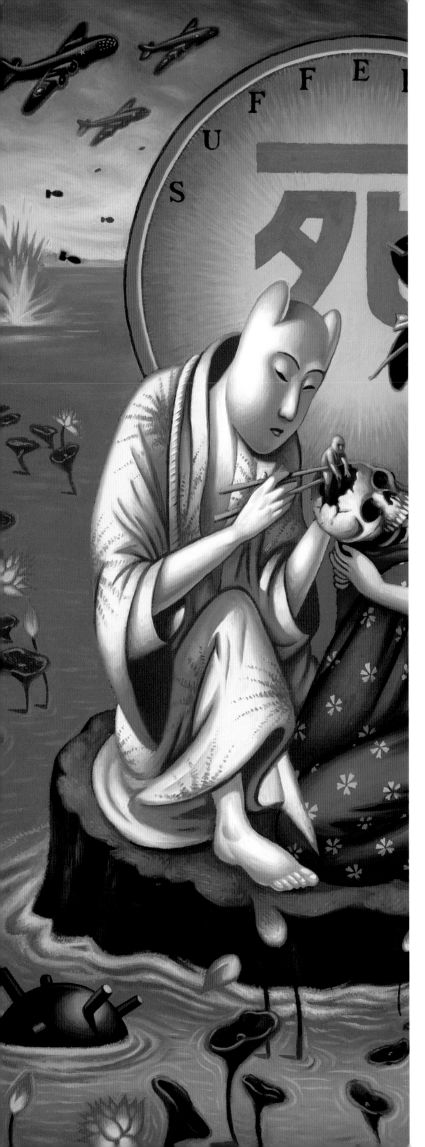

Detail from Suffering

A: I think with paintings like *Gold Bond* or *Will Make Good Friend With You*, here I'm freely mixing Eastern and Western images together, not because I'm trying to make a statement about whether it's right or wrong. I'd say it's more the idea that if a whole country can exist where different languages and cultures are freely blended like they are in Japan, then why can't you do that in a painting? Why does everything have to follow just one visual vocabulary? That's what the idea was, more than any political idea, or even social commentary.

M: Okay, so the worlds [in your art] are more this giant blending of several different cultures, rather than the idea of one culture that is dominated by another one?

A: Yes. For example, in *Suffering*, in the background there are two planes dropping bombs, and all I put was a star on each plane, specifically because it's a semigeneric symbol that a lot of nations have used. China has the star, the U.S. has the star, North Korea, and I'm sure lots of other countries use stars. But I took that painting to the place that photographs my work, and another artist happened to be there. When he saw the painting, he said "Ah, American bombers." He made the natural political assumption you make when you see images of destruction of Japan, and you see two planes. If there's anything remotely American about them you think, "It's a political statement about Hiroshima." But it's not. It's not an American military symbol, it's just a star. It could just have well been a Chinese plane. That's not to say that we as Americans don't deserve a lot of the negative assumptions based on our past and present activities around the world. But I'm more interested in the conclusions that people naturally make when presented with an inconclusive image.

M: It seems to me that since you first went to Japan, there are many more Japanese and Asian things in popular American culture than there were then. There are a lot more magazines, hip-hop has kind of adopted Asian culture, there are movies like *Kill Bill*, and anime is mainstream. Do you think there is actually more of an Asian influence on American culture than when you first went to Japan? Or do you think we are just more aware of it?

A: When I think about all of the Giant Robot type of stores, the places that sell Japanese comics, magazines, collectible figurines, and toys, obviously that is really Japanese inspired. It's hard to really notice the difference here because I live here and the change is so gradual. It's really much easier to notice the changes in Japan because I go there about once a year, which is a long enough gap to see some changes. And really the biggest change I see there now is the number of Starbucks, particularly in cities outside of Tokyo. In Kyoto, for example, there were only about two or three in 1998, and now there are at least fifteen. It's the

same phenomenon as here where you see one on the corner and then you go two blocks and you see another one.

M: There's a Starbucks in the bathroom of a Starbucks [*laughs*]. Let's talk about geography for a moment. I've always been interested in the idea that although you've done many different kinds of environments in your paintings, all of them seem to take place in the same strange world somehow. For example, you have a lot of recurring characters and elements. Is that something you do consciously?

A: There's definitely a visual vocabulary that any artist uses, which can become repetitive if they use it all of the time. Ultimately, to me, I think it's just because there is a certain set of images that I am interested in as an artist, and those images might recur for a while in my work, until I move on. And later, I might reference them again.

M: I see. So, after referencing a lot of Japanese imagery, you started moving away from that and getting more interested in Western, Victorian imagery, mixing that into your work more and more. What was the impetus for that?

A: I've always liked old things, particularly old photos. In *Outer Space* I mixed in an old photo of these two young sisters that I got at a flea market with this great Chinese poster image. That's probably the first piece where I actually used real collage, too. But after that I started to get into using the old photos more and more. I think it also coincided with using the Internet and eBay and things like that. One of the keys for me, once I started doing my own work, was that I saw how books I had bought in Japan, and the Japan trips themselves, freed me up from overthinking things. If I saw imagery that interested me I just started playing with it. So that kind of led me on this path, opened up the door to anything else that I thought was interesting. If I liked something, I thought, "Great, go for it, get that stuff, buy the books." You know, if I see an old poster somewhere, if it's an interesting image, then I think I should have it around me. If there's something I like about it, then that should be enough.

M: Actually, I think that one of the main things I learned from you was that [to do great work] you need to have a good collection of things around you, and you can't create

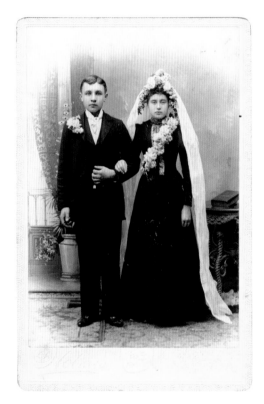

Vintage wedding photograph, circa 1880

in a vacuum. Is that when you started to build your collections? Were you already collecting things, or did it start with the Japan trip?

A: Well, I went back to Japan each year, and I started bringing back more things: toys, old magazines, old photos, and more toys. And I think that getting the old photos and old magazines was way more useful to me creatively than just buying cool toys. I really do like old toys, but most of them didn't really find their way into any of my artwork. Yet a lot of old images from magazines and posters did. So I started to realize that old photos, old advertising images, just resonate with me a lot, and it's not just Japanese stuff. Someone gave me an old mini poster from India that I just thought was wonderful and I still have it in my files. And I got an old book of Chinese posters from the 1910s and '20s around that time and it's still one of my favorite books.

M: What is it about old stuff, you think?

A: That's a really good question, because certainly a lot of people are overusing old imagery and ripping it off to make some kind of kitschy statement, and that's often really annoying. I think it depends on what the thing is in particular. My latest fascination is these old wedding photos, from around the 1860s to around 1920. I think they are just amazing because of how serious everyone always looks. They're never smiling. It would be harder to find a bunch of old wedding photos where they look happy than to find pictures where they look like they're at a funeral. But that fascinates me because around the 1930s it changed totally.

M: Probably part of the function of camera technology. In those old ones you had to sit still for a really long time, and you couldn't move at all.

A: I'm sure you're right, although to me it just feels like it was just so much more serious to be alive back then. Not that people were necessarily unhappy—just that life was a lot harder back then. There's something about the look in people's faces and eyes that I relate to more when I see an old photo like that than when I see a wedding photo from the '50s where they've got these shit-eating grins and obviously the photographer said, "Say cheese."

M: Because by the '50s people had learned how to be in front of a camera, and everyone really became actors.

A: Exactly. I guess that's it; it captured something real about the people when it was still a new technology.

M: Is that what you like about the old advertising too, that it wasn't so formulated and it wasn't so put together yet, so that people were still trying to figure out what they were doing?

A: I don't know about the advertising part, but definitely about the real photos of real people. The old advertising stuff, well, for one thing they're usually retouched photos or actual paintings, and they're like lithographs and so on. So there's a lot of craft, and they are really well designed. I remember, probably it was about the early 1990s, when all the new movie posters stopped being done by good illustrators and started being done by bad art directors who had Photoshop, and how horrible they were. I remember *L.A. Confidential* in particular. It had one the worst posters I ever saw; Kevin Spacey's shoulder was where his ear should be and stuff like that. It was just a terrible abuse of Photoshop, and I avoided that movie when it was out just because I was so pissed off about the poster. So I think old advertising just has great craft, no matter what country it's from. Advertising imagery from Victorian England is gorgeous and amazing, and gas station signs from the U.S. from the 1920s are all well painted and memorable images. Later, you know, things changed. Everything became, "Let's cut down the time it takes. They don't need to be so nice." So everything turned around and the audience became just a bunch of consumers.

M: Right. And the imagery is just a brand.

A: Yeah, it's just branding, and I don't know where I heard this, that phrase "the death of excellence"—maybe it's someone's album title? [Low Pop Suicide—Ed.] We certainly helped with that before, with that phrase. Of course there's still some excellence left in the world. But certainly in a lot of areas quality is no longer the overriding concern, whether it's movie posters or the actual movies themselves. That's why old movies are often better than new ones. At

Movie poster, 1962

some point the studios decided, "There's a formula! If we use the formula, we can cut costs, shorten the process, make more money. We don't care if it's actually good, as long as it sells." So that's probably why I like any Hitchcock movie better than virtually any movie I've seen in the last fifteen years. This is the era of the corporation more than it's ever been. You could say that the Victorian period was the Industrial Age; after all, that's what it's called. But giant conglomerates didn't dominate every single facet of life in the way that they do now.

M: Which brings up the following question: In your early work, you use a lot of advertising imagery. It seems you're revolted by the idea that, through advertising, corporations are influencing people's lives, dictating what they like to look at and so on. Are you poking fun at this? After all, there would be people who say that advertising is not an art.

A: Well, it is an art; great commercial art is a very high form of art. That's why I have old movie posters in my house, and that's why I published a whole book of Japanese commercial art images. In *Reminiscences*, that whole background image with the robot, and even the way the type is done, is very similar to this old robot toy package from early postwar Japan. Those toy packages are the creative equal in my mind to any of my favorite fine artists.

M: So then it's not intent, it's craft, to a certain extent, that makes it art for you?

A: Well, advertising imagery uses type, and maybe growing up on comics—they were a big art influence in my life, at least for the first eighteen years—maybe that's why I love images that have graphic bold type on them, that are more than just an image or a painting. So I always identified with posters and packaging, and stuff that looked like comics. And I think that first trip to Japan, seeing all those books of posters and packaging, seeing how great the material in there was, it made me think, "This stuff's art. This is fine art." I know this was all created for commercial purposes, but each piece is like an art object, and I can make a painting that looks exactly like this and it can just be a painting. Who says just because it has some type, whether the type is in English, Japanese, or whatever, who says that it's a package? We're now in an age where you

can do whatever. Certainly if performance artists can take enemas and squirt something out of their ass onto a giant canvas and call that art, there's no reason you can't do this. So, I think it's all fair game. I was never making a statement, again, about commercial art and its validity in the big picture. My background is in commercial art, and the thing I've always loved was commercial art. And I think a lot of people grew up like me, playing with toys, reading comics, and they were more influenced by the box of the cereal they would eat every morning than by what Jackson Pollock was doing, and I like Jackson Pollock's work. I think that line between what's commercial art and fine art is starting to disappear, as it should. One day there will be virtually no distinction between anything. Of course, that is not always a great thing. When you hear a new U2 song and it's a fucking iPod commercial, what's that? It's sort of a U2 song, but it's a commercial. Is it a jingle or a song? I don't think that song ["Vertigo"] had been released yet when the commercial came out. That's not blurring a line, that's selling out. But interesting artists do all kinds of projects; Shepard Fairey's got his own line of clothing. Gary Baseman has done TV shows, films, product work, gallery work, and just about everything. If they were making T-shirts when Picasso was alive, would he have made them?

M: Probably. I don't think artists got so snobby about art until much later on.

A: He did every medium he could find. He was excited by everything.

M: Corporations are getting into people's daily lives. What they value. You grew up as a product of that and you are reflecting that in your art. Now, people respond to the advertising images in your art. There's kind of an interesting feedback loop going on there, wouldn't you say?

A: Well, there's a difference between corporate branding of a product that we have a fond memory of and being brainwashed to think that some pathetic product (like Hanson) is actually good and we should all buy it. I think there's a couple of different things that we're talking about here. The difference that I'm talking about, the "death of excellence" issue that I mentioned earlier, is a quality issue. There have always been products sold to us, since before our grandparents were born. There were still companies, although there were probably less of them, in the 1800s. But in the 1950s when they made toy packaging, they hired a really good illustrator, they did a really good painting, they designed the type really nicely and made a really great package. Of course, they probably tried to make it cost-effective so they wouldn't go bankrupt, but I think their overriding concern wasn't only cost, it was making a great package. I feel like what's happened now is that the quality of the image on the

Japanese movie magazine, 1949

package is about the last thing a company thinks about. They have this long list of other objectives and they have all of these test marketing groups that see the toy, play with the toy, and they try to get all of this feedback, like, "How would you like this toy? What features would you like to see in this toy?" They try to make it more attractive to you as a consumer. It's really all about cost-effectiveness and if somewhere in that equation their polling indicates to them that with a really attractive illustrated image, it will sell more, then it might be in their plan. But illustrators were making ten to twenty grand in the '70s and '80s for big movie posters. They realized, "We can save that chunk and have a guy make it in Photoshop for basically nothing." That's obviously a choice that is not made based on the visual quality of an image. It's simply dollars, and it's underestimating the value of a graphic image, which is sad.

We all know, at least I know how strongly an image on a package or a poster can grab me and always has since I was a kid. Practically every toy I ever wanted was because of the package first. Even today, if I see a really powerful image, I pay attention. I just think it's a change from the idea that people used to think, "If there's a lot of quality in this product, and there's a lot of quality in the way we market this product, it will benefit us." I think at some point, that

just shifted to, "If we've got a mediocre yet cost-effective product, and we have a cheap way to market it, and we keep costs down, we've got a winner." That's what I think changed somewhere.

M: Back to the subject of your work, you started referencing more Victorian imagery as you became more aware of stuff on eBay and as your interest in it grew. And from there, it seems you then started taking your work in a more personal direction, around the time of *My Own Death* and *Arrival* and *Departure*. The work became more personal, although it still related to the previous body of work. Talk about that a little.

A: Probably *Abstürzender* was really the first personal piece, the first piece that was about my life, but you're basically right about the others.

M: So what made you start turning inward? Were you aware of it at the time, or did it just gradually happen? I remember when you painted *SAVOR*, afterward you said that you realized that the piece seemed to be about some breathing problems you were having at the time, although you were not aware of it consciously.

A: Well, I think that once I started doing the earlier pieces like *Will Make Good Friend*, *Gold Bond*, and *Suffering*, I was experimenting. I didn't know what I was doing; I didn't have any real plans. And I used a lot of found imagery and incorporated it with a lot of other elements. But once I started doing it over and over, every month doing a new painting and starting to think maybe there's a future in this for me, I started thinking, "What do I want to do next?" For a while there was a flood of images I had seen that I wanted to bor-

row and twist around and make something from. But sometimes I'd feel uninspired by that. So I remember when I did *Abstürzender* and *Sleepwalkers* too, I was thinking about doing something that was a little more meaningful for me personally. That became almost a self-portrait, with my ex-girlfriend on my back. She was this weight because at the time I was feeling a lot of pressure from her. Ultimately it was very rewarding to be able to make a piece that was still me and that still worked with my other paintings but wasn't just about images from pop culture or Japan or anything.

M: Actually, I think that Doraemon [popular Japanese cartoon character] drowned in this one, right? Kind of killing the pop culture reference.

A: Yeah, very symbolic. Which doesn't mean I couldn't go back and mine those images later, because I totally did, and I still do. It's just opening another door for myself for a place I can go with my work. And now I'm much more in that place than I am in the pop culture place. I find in order to keep being inspired and keep making new artwork it's got to be more personally meaningful for me. And again, I still see lots of great images in books or on posters out on the street, or anywhere really, that I love and I want to borrow from somehow. But I do feel that the kind of unconscious meaning within a piece has become more and more important to me than it being visually catchy.

M: Are you saying that when you started painting, maybe at the beginning, you started off thinking that, for example, the Gold Bond label is really graphic and it'd be interesting to put this in a painting together with a geisha and a surfboard? Whereas now, you start with something that you want to express, perhaps just an idea?

Japanese movie poster, circa 1950

A: It almost always starts with a figure; all my stuff has a figure. I haven't done any landscapes with no living beings yet. So there's usually a main character image that's either just in my head, or from something that I saw somewhere. Ultimately, in all of the paintings I do, there is a certain kind of feeling, a tone that I want to convey right from the start. It's always there in my mind, half unconsciously, and as I think about it, that unconscious thing in my mind dictates, "Yes, it would work to put this in," or "No, that would be too much."

M: So you're never consciously thinking something like "Life is really short. I should do a painting about how life's really short."

A: It's not that conscious.

M: Obviously you draw from things you see around you, people you know, a lot of different things you see, and you sometimes put them directly into the paintings. How much can you borrow before it becomes an ethical issue? For example, in *Matasaburo of the Wind* you referenced the main image from a Japanese artist, or in *Ace Hardware* I know that you appropriated a character that your ex-girlfriend had drawn.

A: Well, in both cases I gave them credit. In *Ace Hardware*, the image you are talking about is less than 5 percent of the height of the total piece. It's way up in the corner and it's really small. Actually I think a better example of appropriation is *Sekidome*, which is largely from an old medicine packet. Usually what I do is I just take one part of an image, then what I do with it, the environment it goes in, how much I change everything else, is enough for me to be comfortable that I've just taken that as a main influence and then done my own thing with it. Another example is in *Suffering*. The woman on the right is very much directly from an Utamaro wood-block print image, but everything else is completely different about it. The character on the left was also inspired by the Utamaro image but I completely changed him and made him into some kind of supernatural being. In *Sleepwalkers* the figure on the left is definitely a George Tooker man, although the original Tooker man is not holding a pear. And in that particular case it's absolutely an homage to Tooker because he's such a genius. He's such an influential painter for me that I would hope that people who know his work would see that and get the connection. As a matter of fact, a woman who did her master's thesis on George Tooker recently bought a print of mine, and we started communicating via e-mail. When she mentioned that she had met him and interviewed him, I said that Tooker is one of my great influences. She wrote back that once she had seen *Sleepwalkers* she knew that, but she didn't want to seem presumptuous by mentioning it. So, I'm pretty confident that if Tooker ever sees this painting, he would understand the tip of the hat and not consider it stealing. I believe that anyone can see how I incorporated that one element into my world as one of about sixteen characters in the entire painting.

M: I think it relates back to what you were saying earlier about a world of completely combined influences and origins all in one place together. So when you put a character like that in your piece, are they functioning as themselves, referencing their source, or are they simply used for their visual effect?

A: It totally varies. I've got a few paintings where I've based a larger part of the painting on something, and in those cases I actually give the artist credit where I sign it.

M: I know in *Evolve* you put Yoshitoshi's name.

A: Yes, and in *Ascent/Descent*, after the signature I wrote "after Roger van der Weyden." Because the composition's his, and Mary on the ground is completely copied with absolutely no change, except a less accomplished technique. Every single other character I've done my own thing with. A lot of the women characters are based on Chikanobu woodblock print figures and I give them three-dimensional form. Some of the other faces are from actual people, some who modeled for me, some of whom are famous models.

But that composition is van der Weyden's *Descent from the Cross* and even though I changed some things it's very clearly based on that image. That's why I put his name down there, so anyone who knows this image will know I based this painting on his image but they can also see how really far it's come. It's just like Led Zeppelin covering an old Willie Dixon song. By the time they're done with it, it doesn't sound anything like the Dixon song. So I've done that with a couple of pieces in the past.

M: So, you feel that if something interests you, you can more or less do whatever you want with it and make it your own. Are other artists doing that now?

A: I don't know. I know for a while Mark Ryden painted Colonel Sanders and Abe Lincoln over and over, but they weren't from any one source; they're just cultural icons, really. Most of the stuff I'm looking at, it's not obscure but it's not exactly familiar to most people. The artists are either dead, foreign, or from long ago. They're certainly not mainstream American cultural icons like Mickey Mouse or Babe Ruth. George Tooker is still alive and Shinohara Katsuyuki is also alive and well. But the poster of his that inspired *Matasaburo of the Wind* was from around 1974. In *Koshimaki-Osen* it's just the type treatment that's taken from the Yokoo Tadanori poster. And he's still alive too. In that case, it's homage again. When you see the original you can see what I did with it, how different they are, and just how far they've come.

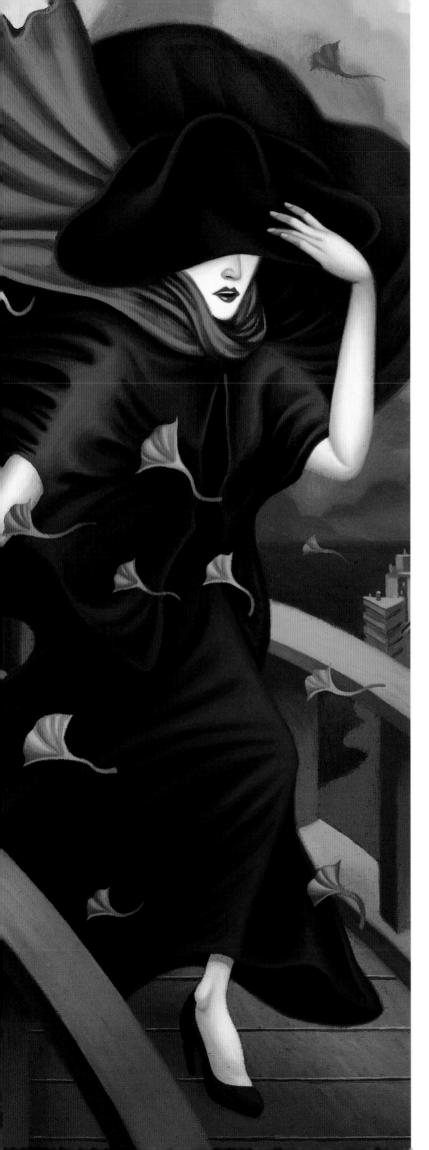

M: Okay, let's shift gears a little bit and talk about women in your work. It seems to me that you have painted many beautiful women. Any reason for this in particular?

A: I think I have painted more men than women actually. But maybe my earlier work was more about women. I think all heterosexual males like to draw beautiful women. I'm just as fascinated now in interesting-looking guys, whether they're handsome or just strange. That's why I painted you (see pages 28-29).

M: I know, strange. It seems that a lot of your sketches are pretty close to the final piece. I know that over the years you've been interested in loosening up the process of creating your paintings. Does that include the way you come up with ideas, or is it more about technical painting style?

A: Well, it's always a challenge to keep being inspired and keep being productive, and I think whatever you can do to get yourself painting every day is a good thing. It can be hard for an artist to sit down and start painting because the painting is so realistic, or whatever the reason is. Maybe it's time to start changing things so that he's a little more motivated. For a while I did some nearly photo-realistic stuff. *The Sugar Sickness* for me is the epitome of photo-realism in my work, not in the background but in the characters. It's still one my favorite pieces. All three characters, especially the man and the angel on the right, are composited from different photos. The woman, the drapery, the chair, the hands, they all took me so long, months and months. It was a large painting, and it was so difficult. I found myself not being able to sit down and paint. *The Forgotten Thing* also started off very realistically, but as I got to their faces I started to stylize them just a little more and that was a lot more fun for me. So I found that being that tight isn't that fun or rewarding. And if I keep doing it, it could affect my drive or my productivity as an artist.

M: Burning out?

A: Yes, burning out. My recent work has still got a lot of detail but it is approached differently. Starting with *The Meaning* I was consciously trying not to be as realistic anymore, but still trying to have a lot of interest by playing with graphic spaces. The main character's whole outfit is completely flat; there's no blending at all there. The only modeling of form is in her skin, the sky, and the hair. The play of graphic against form was interesting to me visually, interesting to me in the experience of painting. After that, *Koshimaki-Osen* and *Decay of the Angel* are continued experiments with that. And then in *Jaundice* I took it one step further—none of the buildings have any dimension. They're all completely flat although they appear to go back

Detail from Matasaburo of the Wind

in space through value, color, and overlapping. The clouds have form but the buildings don't. The skin is modeled and the suit also has a kind of simplified form. So I played with form versus graphic a lot on that one and I think it's one of my more successful pieces. Yokoo Tadanori was a very big influence on me at that time and on that painting, although the only way you'd know it is in the small wave that pops up in the corner.

M: So, are you saying that many of the ways in which your work is changing are really the product of trying to keep it interesting for yourself?

A: Exactly. Keeping it exciting, being able to experiment. And I think that it also becomes more interesting for viewers, to see the evolution of the work.

M: Would you say that the most important thing to you, as far as creating art goes, is to stay interested in creating art?

A: Creating art as opposed to cranking out product, which unfortunately people do. It's understandable for a lot of reasons, in terms of the financial pressures on a successful artist to repeat their formula that has been successful.

M: I'm sure you get a lot of people asking to have a piece just like that other one.

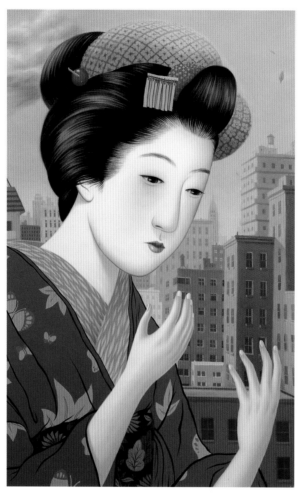

Detail from The Meaning

A: Not so much from individuals, but you hear it from galleries. They tell you which pieces do really well and that they'd like to have more pieces like that. *Jaundice*, which certainly didn't seem like it was going to be one of my more commercial paintings, was actually the first one that sold before the opening of that show. It's really nice when you can't predict what people will like. It's a very gratifying feeling for me, that I tried something new and people appreciated it.

M: It must be hard to have the confidence to do what you want to do, even if it's a big change, and to believe that it really is the best thing for you to do as an artist.

A: It's hard because people like to know what they're going to get from you. With galleries, if they are going to spend

their time and money to give you a show and you give them a whole body of work that's really different from what they were expecting, it's not necessarily fair to them.

M: In a way it's not that different from illustration, sending in a portfolio . . .

A: Unfortunately that's true, and that's probably why I'm so insistent on pushing the bounds and experimenting, because doing illustration for over a decade where everybody really wants you to repeat yourself, that really wore me down. I'm rather determined to not do that anymore. I'm just going to do the work that I'm interested in. Whether people buy it or not is not going to be my main motivating factor.

M: Of the artists that you're more or less grouped with, given the span of your career, I'd say your art has evolved maybe more than most of theirs.

A: Well, I would take that as a compliment. I don't think it's a coincidence that out of the big names of this group of L.A. artists, I'm also one of the poorest [*laughs*]. I do all right but I'm probably not quite as marketable as some of them, and there's nothing wrong with that. I'm grouped with some artists whose work is really identifiable and probably doesn't change that dramatically and it's still really good. I just can't personally imagine painting the same way throughout a career of thirty or forty years, or even ten or twenty years.

M: Despite the strong influence that you say advertising has had on you, you seem to not have this fear of being poor, like many Americans have.

A: I think something went wrong, because my parents encouraged me a little too much to do what I love instead of to make money. Many kids that I knew really approached college or at least post-graduate education with the goal of having a stable career and raising a family. Now that I'm getting closer to raising a family I definitely appreciate the value of having a stable career and having a nice income. But unfortunately it's a bit late to have a normal career and

I don't want to compromise myself as an artist to meet that end. If my art doesn't enable me to raise a family, then I'd probably do something else to bring in money rather than be a purely commercial fine artist.

M: Going back for a minute to that group of artists you're often thrown in with, some people in L.A. call it Lowbrow Art, and now I guess they're calling it Pop Surrealism because I guess many of the people in Lowbrow Art don't want to be called "lowbrow" anymore. Regardless, you're often grouped with them, and I'm confused as to exactly why, because I don't see the connection. One of the things that's great about that scene is that it spans a lot of different directions. But do you think you're grouped with them because you're contemporary and come from the same school or background that some of them do?

A: I think it's a very complicated question and it's a very complicated reality. But a lot of it is just games, a lot of it is perception, and a lot of it is the fact that people always need to categorize things. Just look at music: if there's a new band everyone needs to know what kind of band it is. Are they hip-hop, are they alternative? You can't be hip-hop, alternative, and techno at the same time. People can't handle that, or at least that's what the labels think, because then they don't know how to market it. With a band like Radiohead, it's almost mind-boggling that they've been as successful as they have. They've changed so much from album to album, tried so many different things, pushed the envelope, and you know how rare that is in music. It's the same thing with art. Thirty years ago in L.A. there were a couple of people painting things that didn't fit the contemporary art scene, that were referencing things like comics, cars, or pinup art, and they'd only show it in one or two galleries, because nobody else would even consider showing that stuff in a real gallery.

You had people like Robert Williams doing very sophisticated paintings, but including these pop culture elements,

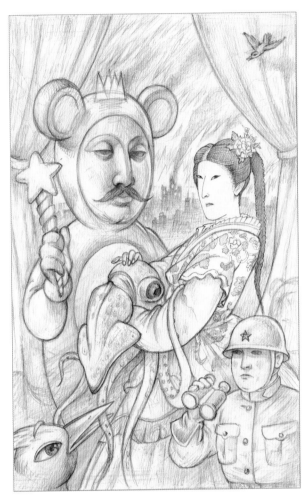

Sketch for The Burning of Tokyo

which most "serious" galleries were not interested in. Like you said, that's probably initially why it was called "lowbrow." He pushed his work beyond that simple label and eventually crossed over into mainstream galleries. And in the next decade or two, there were all these other artists, like Manuel Ocampo, and the Clayton brothers more recently, who started in that scene but have also moved past it. I don't feel a huge distinction, but still, a lot of the established galleries seem to. Unfortunately, most of them draw the line at figurative work. I really think "lowbrow" is a horrible misnomer now. A lot of "lowbrow" artists are just figurative painters.

M: But wouldn't you also say that one of the things that ties "lowbrow" together is their referencing of popular culture on some level?

A: Yeah, but so does a lot of "highbrow" art.

M: The funny thing is that were Warhol or Lichtenstein working now, they would be "lowbrow."

A: That's a really ridiculous irony about this whole thing, isn't it? For example, E. V. Day is an artist who does a lot of sculpture and 3-D work, and it's really good. A lot of her work deals with gender roles. There's this one called *Bombshell*, and it's basically an exploding Marilyn Monroe dress from *The Seven Year Itch*, where it famously blows up over her head. It's a great piece, and it's totally referencing pop culture, yet she is considered legitimate in the most "highbrow" art circles. She's making a bigger statement about the role of sexuality and beauty for women in today's society and culture and I think that's part of the reason why. If someone's just painting sexy devil girls, that doesn't seem to really have any deeper meaning, and would probably be justifiably termed "lowbrow." The other reason she's taken more seriously lies in her resumé. It's called an MFA from Yale. This is not to demean her work in any way, because I respect her very much and love her work. But there is this whole establishment where the prestigious graduate art programs feed their alumni into the "highbrow" galleries, and it's very incestuous and there's nepotism, and you cannot enter that

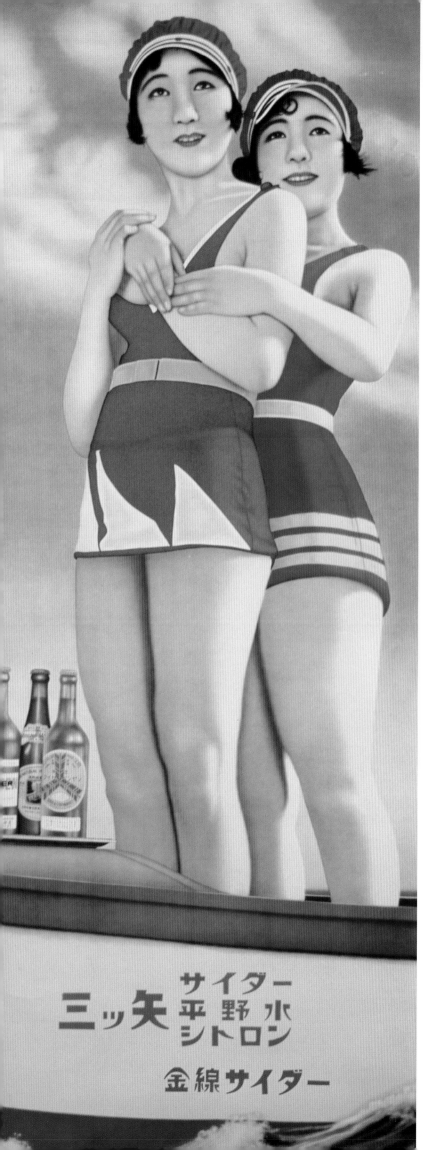

Japanese alcohol advertisement, circa 1920

world if you're not one of them. I don't fit into that world, but I also don't think that my work is "lowbrow." There are many artists I feel a kinship with creatively, and some of them are considered part of this scene, and some of them are not.

M: Is the "lowbrow" scene making art dumber, is it making art freer, or is it not really having an effect?

A: I think fine art is already pretty dumb as it is [*laughs*]. No, what I said before about the lines between commercial art and fine art blurring more and more, I think that's continuing and I think "lowbrow" is just becoming part of that, just like advertising, music, and commercial art are all a part of that. There's already much less distinction between media and art. People perform something and it can be considered art, or someone can put an object somewhere and call it an installation. There's no limit on what great art can be and there's also no limit on what dumb art can be. We've seen dumb art in all forms. But the fact is, most people who don't have an MFA from Yale will appreciate an image that has some craft to it, that they can look at for a while, and that has something interesting about it, for them. Fortunately, some people still like paintings and a few of them actually buy them. Obviously, there's nothing really modern about painting. It's a very old-fashioned thing to practice and they usually frown on it at most graduate fine art schools. But that doesn't matter to me. Just like there are still people who make pottery in Korea in the completely traditional way, or people who still make wood-block prints in Japan, there are people who practice all forms of art that are antiquated. I think the high art world is a little too preoccupied with the medium, and that everything must have this incredibly complicated rationale. Most people outside of their little community don't care about that. They respond to an image if it is presented to them in an interesting way.

M: "Highbrow" art seems to be art about art, made for the purpose of impressing people who write about art. There are people who make art about changing the world. Whereas you make art simply because you want to do art. You may be trying to make people think, but you're not trying to make some huge statement about art or the world, or are you?

A: A lot of contemporary high art is speaking to the high-art community—it's usually got some sort of political message or content, which is presumptuous. There's this idea that if it's not making a really big statement about society somehow then it's not valid. That's not what I'm concerned with at all. If I feel the need to put some social or political content in some work, then I'll do it. I just feel that I express my creativity in images. Right now they are paintings. I could make a film—I love film—and I still think it'd be the same thing for me. Just like in music, which I know is a really big influence in your

life and mine. When I hear music that really affects me it can be because the lyrics resonate with me somehow in a meaningful way, or it could just be because the music is so fucking beautiful. So I want it to be the same thing for people who like my work. Either there's some intellectual content in there that has some sort of connection with the viewer, or the work is physically beautiful, or ideally a combination of both. I think that's what any good artist is doing, whether they're doing it with dance, filmmaking, music, painting, or whatever. They're not just masturbating creatively. There's nothing worse than one of those big-budget films with amazing production design and a shit script. Good art has something to say that we can relate to in some way, and it says it in a way that's interesting and that expresses beauty. That's what's been lost in a lot of the high forms of art that get so much attention. They're not about craft and they're not about beauty at all. They're almost anti-technique.

M: A lot of them seem to be actually anti-beauty. Isn't it almost like beauty is the enemy?

A: That's probably another thing about the "lowbrow" or Pop Surrealist artists that separates them from that group. They make images that are either beautiful, or at least trying to be beautiful [*laughs*].

M: They think they're beautiful.

A: They think they're beautiful [*laughs*]. They *are* addressing technique and craft, and that's why most people like this type of art better than that type of art. There are a lot of artists who cross over and should cross over. Ultimately, I just don't think all those divisions are necessary, and hopefully one day they won't exist.

M: Do you have any parting words?

A: Well, this subject makes me think of a quote from Kerry James Marshall: "I find myself at a crossroads today, mildly interested in some of the things I see, rarely excited and discouraged in the lack of clarity and aesthetic ambition breed-

ing in art schools When in 1999, the *New York Times* asked a selection of them the question, 'Is it art, is it good, and who says so?' the consensus answer was not illuminating. 'Anything can be a work of art if an artist or someone in the know says it is.' This attitude exacerbates public frustration with contemporary art, and abandons students of the discipline to a crapshoot wager on novelty."

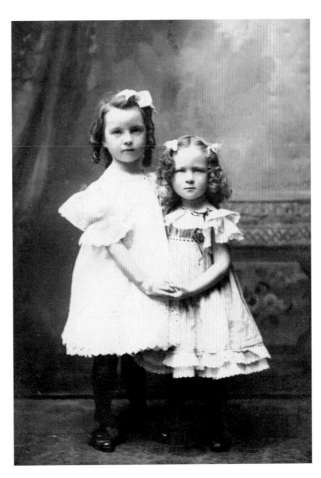

Vintage photograph, circa 1890

M: That's true. There's a higher value on something being done in a really clever way than on it being done really well. Clever is the new intelligent.

A: Well, here's what he predicts for the future, somewhat facetiously but not really: "After several more years of incredible growth, the art-industrial complex will collapse under its own weight. Thirty percent of the world's population, an estimated 3.5 billion people with Master of Fine Arts degrees will have no outlets for their work. Dominant globalism will have erased significant cultural differences so that everyone's work looks more and more alike. The art industry will be controlled by a network of a super-galleries, known as its acronym, PAC, or Pan-Aesthetic Coterie, a shadow society run by ex-museum docents fired for curatorial espionage."

M: Sometimes I think "experts" are about the worst thing that can happen to anything. What really made me notice that was being asked to do a portfolio review at a local art school. Not that I don't know anything, because I think I learned a little something between college and the working world, but still, you realize that when you're considered the expert, the experts are full of shit.

A: Amen to that.

M: Well, thanks so much for your time. It's been illuminating.

A: My pleasure. You did an expert job.

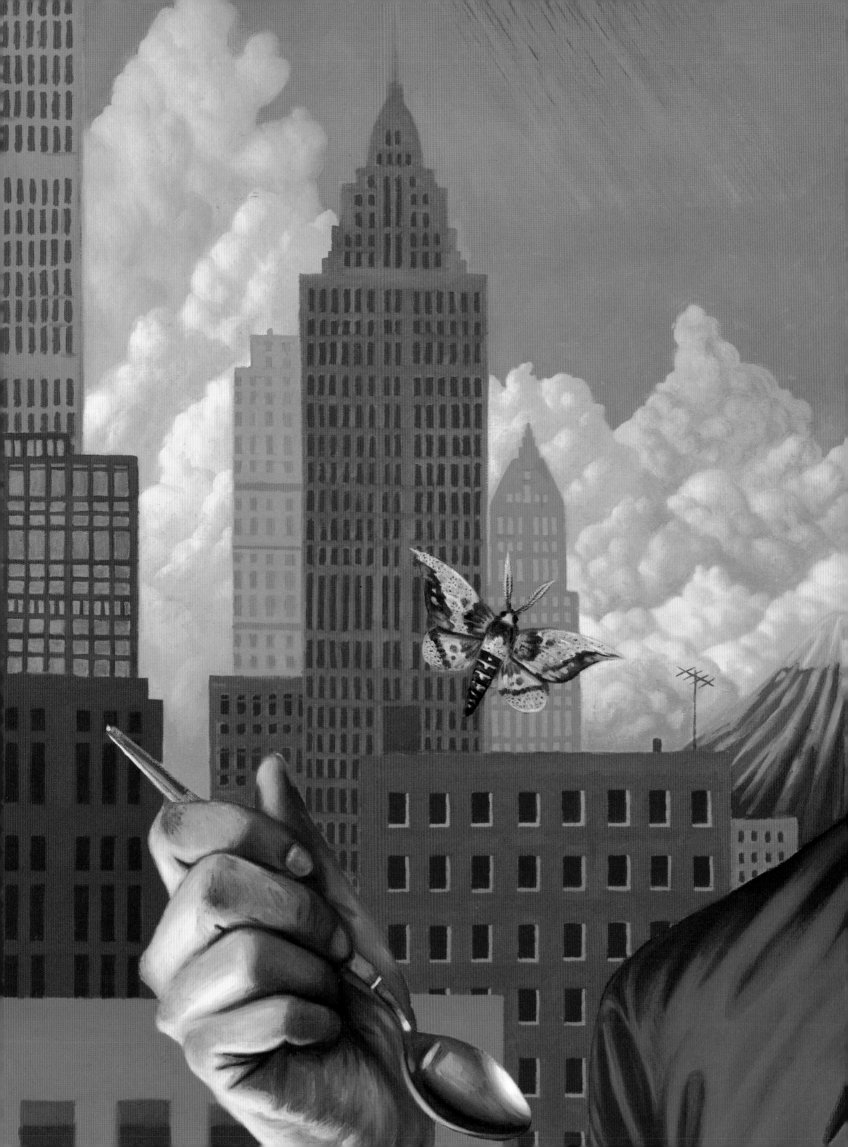

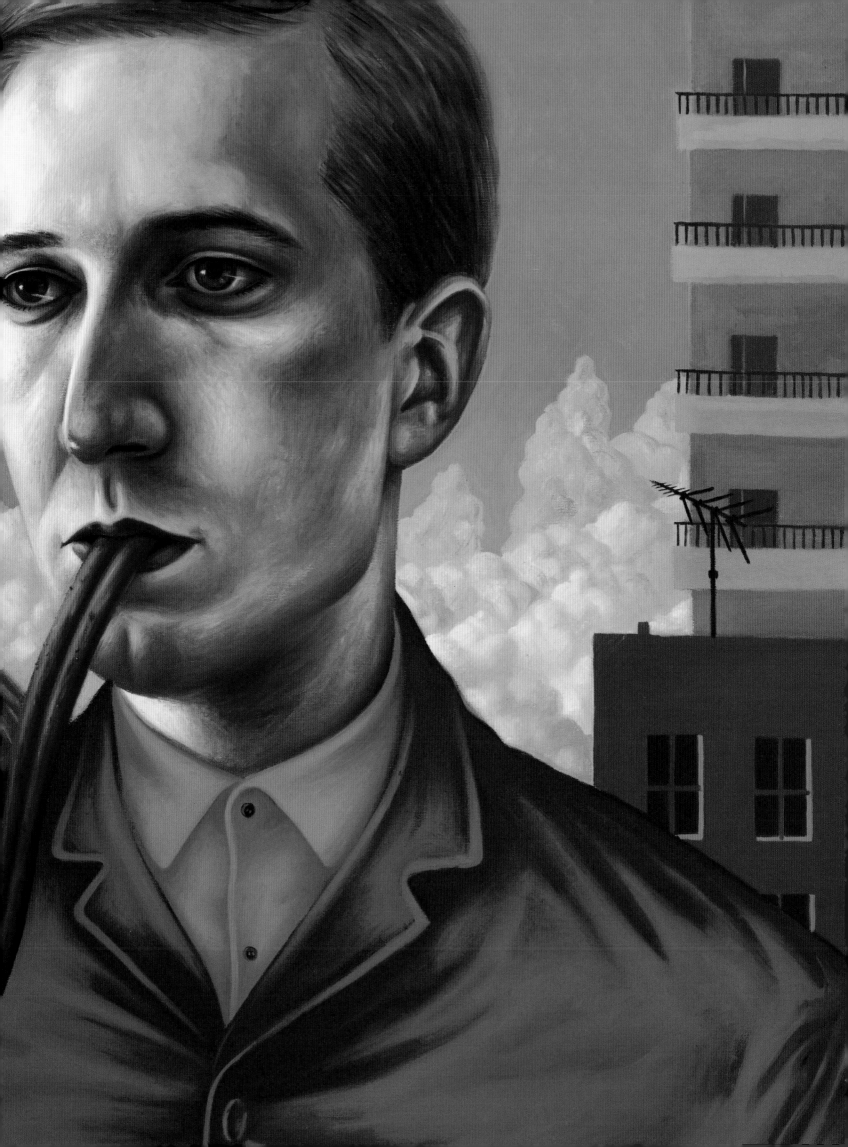

PAINTINGS

A monstrous [poster], ten feet high
at least, advertised Bovex . . .
"Why should you be thin and white?
And have that washed-out feeling?
Just take hot Bovex every night—
Invigorating—Healing!" . . .
Yes, war is coming soon.
You can't doubt it when you see the Bovex ads.

from Keep the Aspidistra Flying,
by George Orwell
(Penguin Books, 1936)

GOLD BOND
1999
OIL ON CANVAS, 51" X 34"

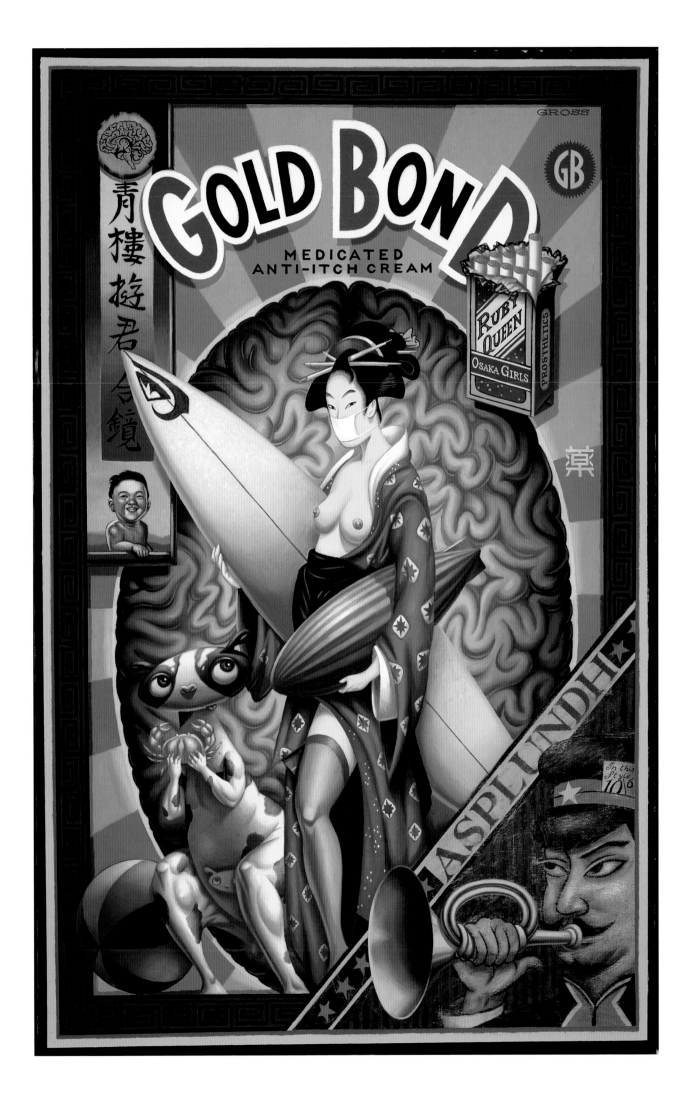

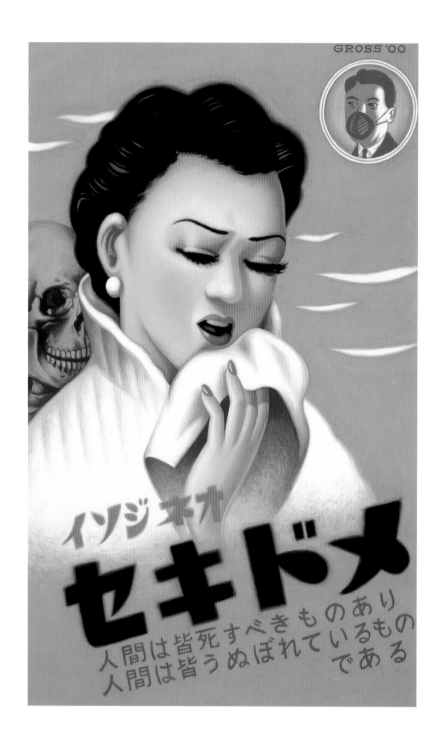

SEKIDOME
2000
OIL ON CANVAS, 28" X 21"

(right) **WILL MAKE GOOD FRIEND WITH YOU**
1999
OIL ON CANVAS, 39" X 27"

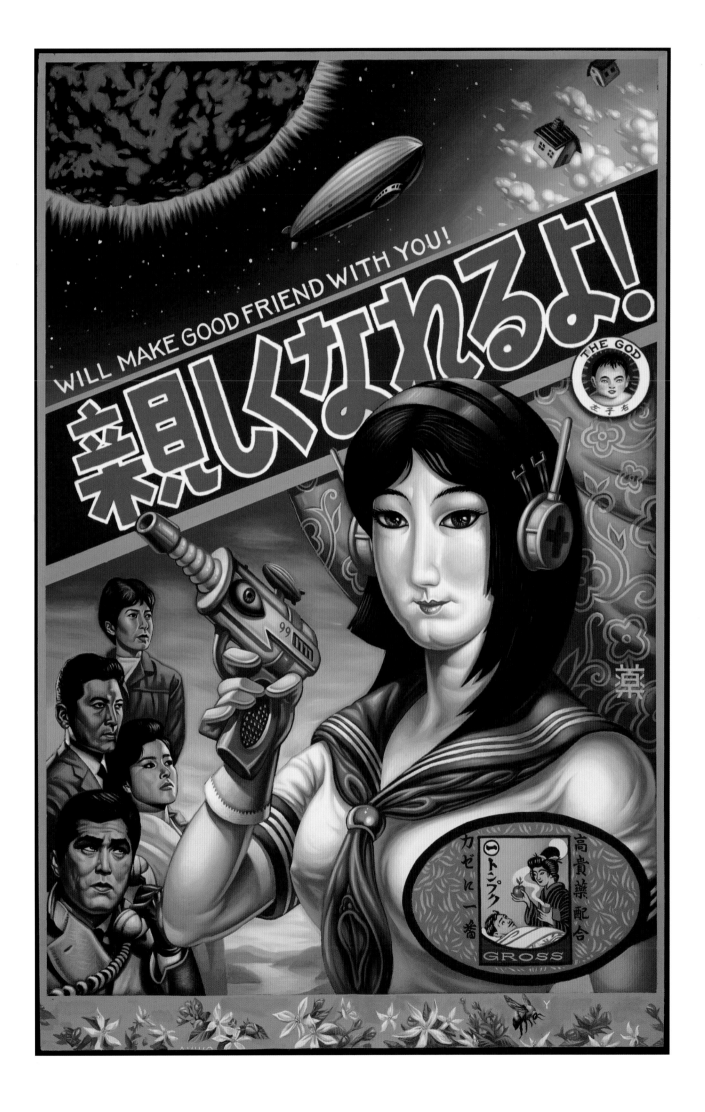

ACE HARDWARE
1999
OIL ON CANVAS, 52" X 52"

(*following spread*) SAVOR
1999
OIL ON CANVAS, 27" X 44"

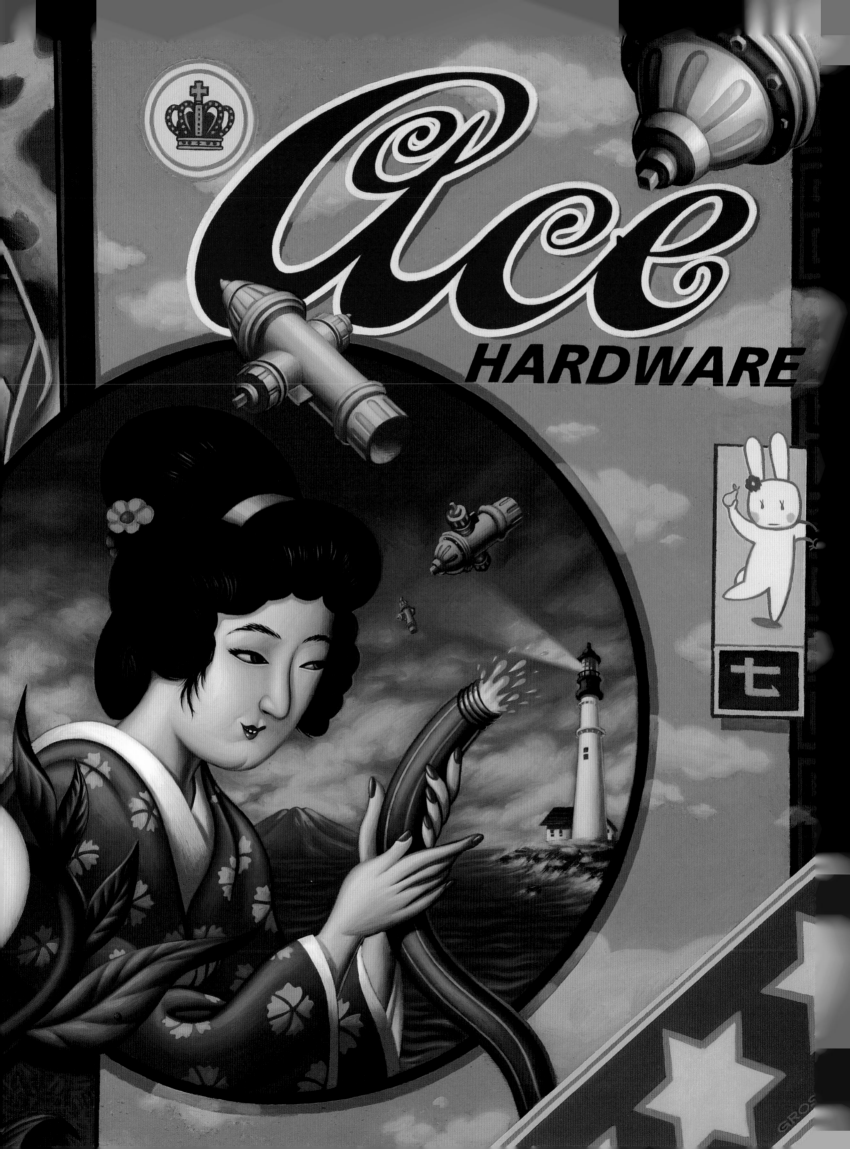

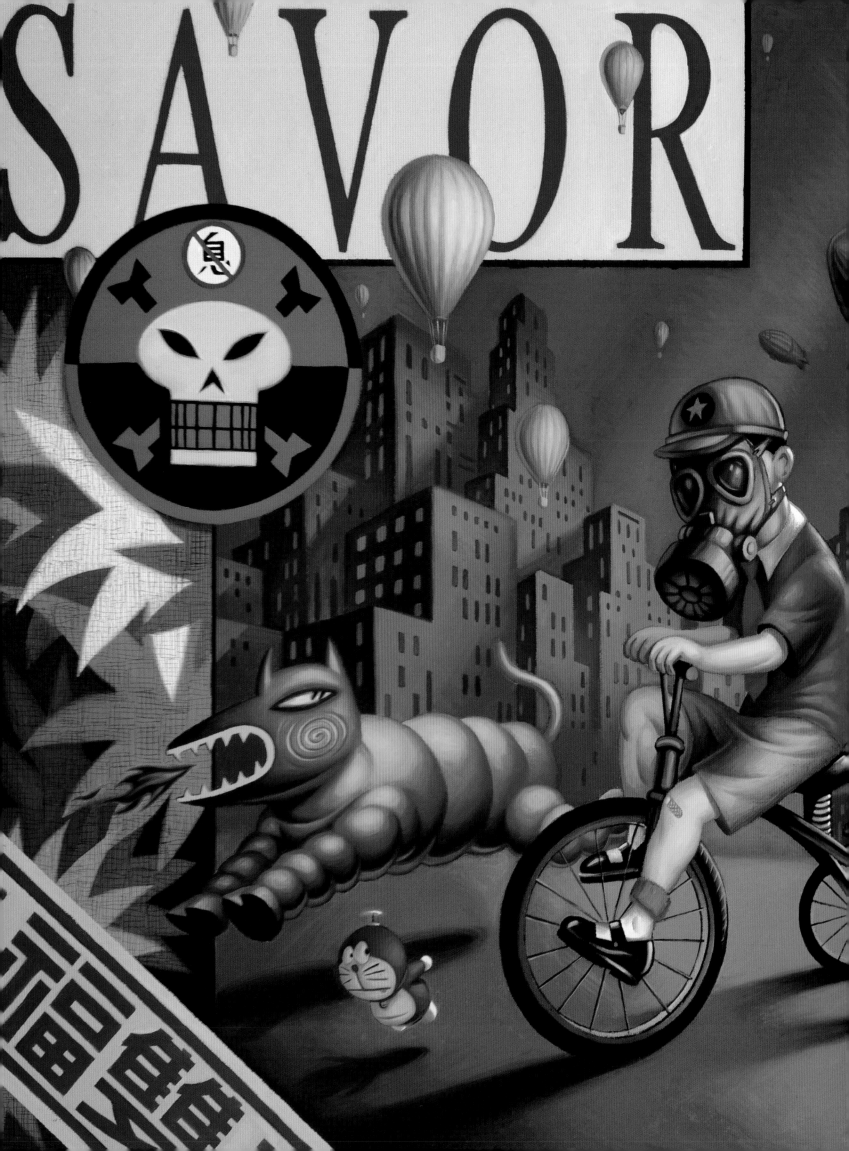

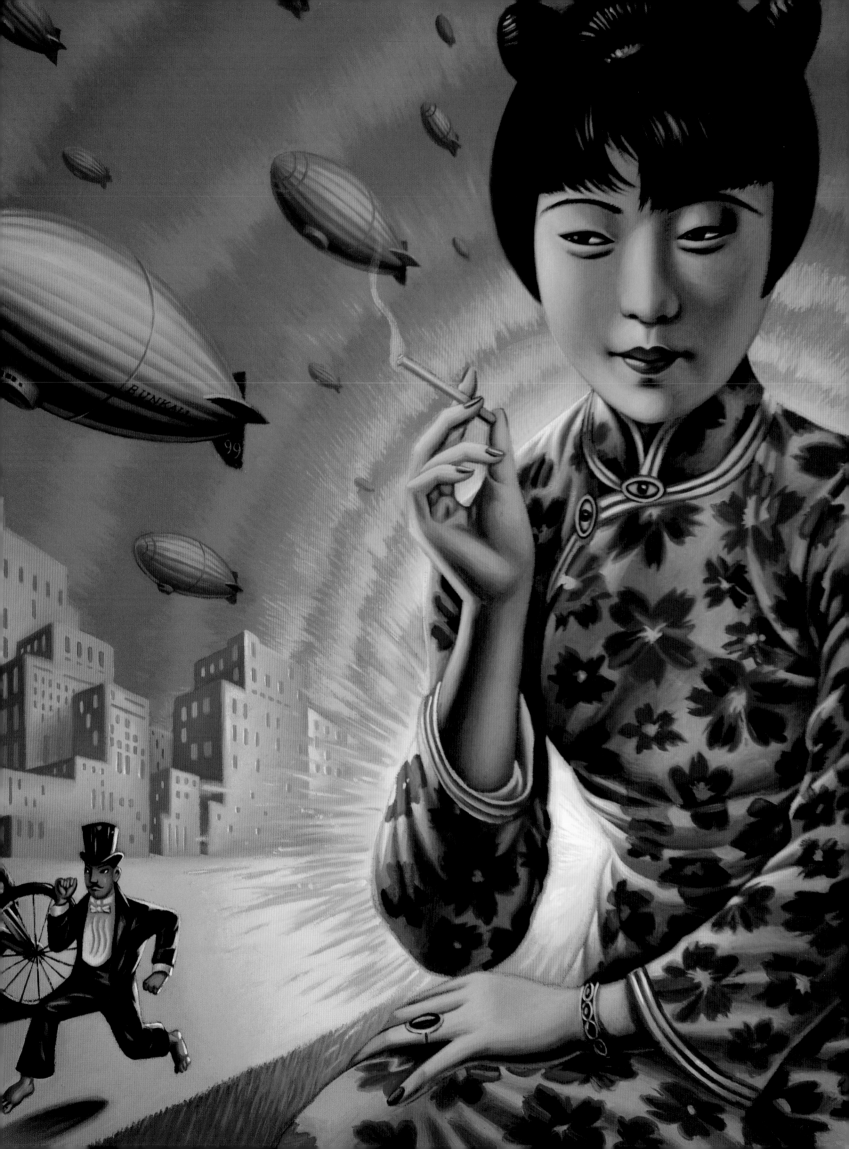

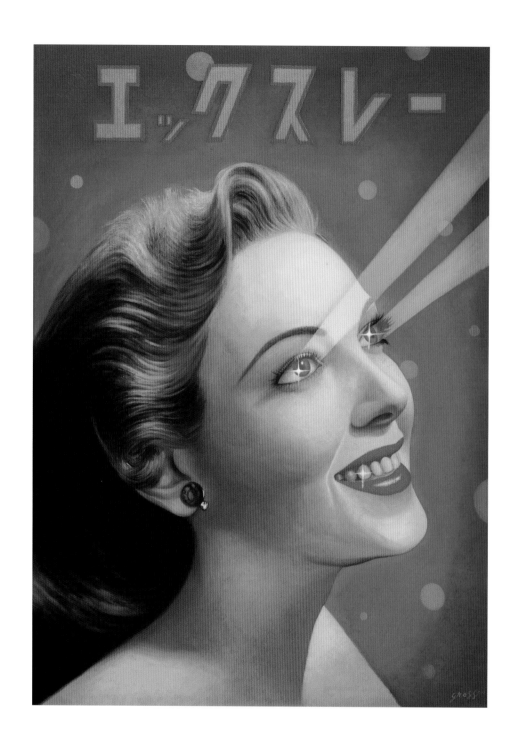

X-RAY GIRL
2005
OIL ON PANEL, 36 1/2" X 28"

(right) REMINISCENCES
1999
OIL ON PANEL, 41" X 25"

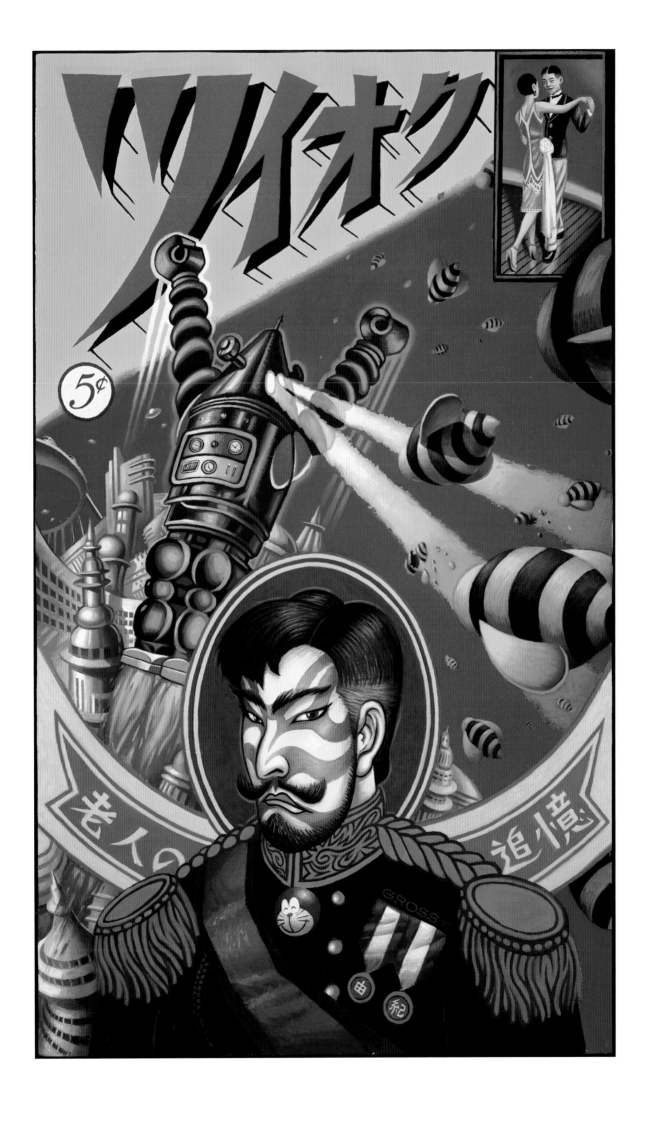

MILK FOR JESUS
2000
OIL ON CANVAS, 48" X 22"

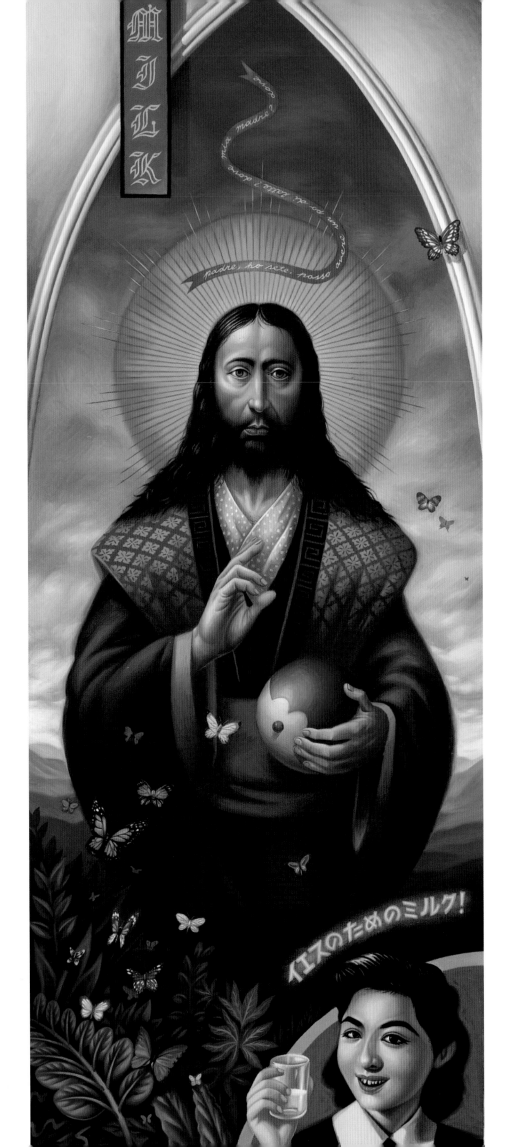

43

SHUNGA
2000
OIL ON CANVAS, 20" X 26"

(following spread) **THE DREAM (GDANSK)**
2000
OIL ON CANVAS, 25" X 41"

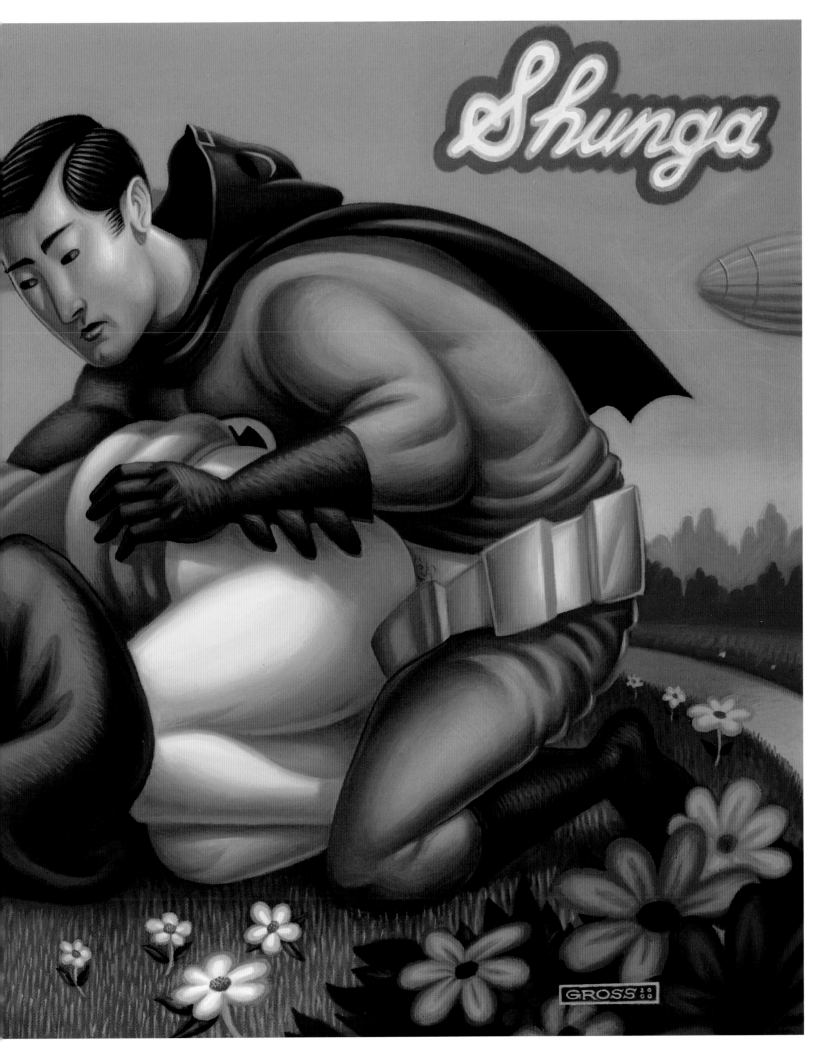

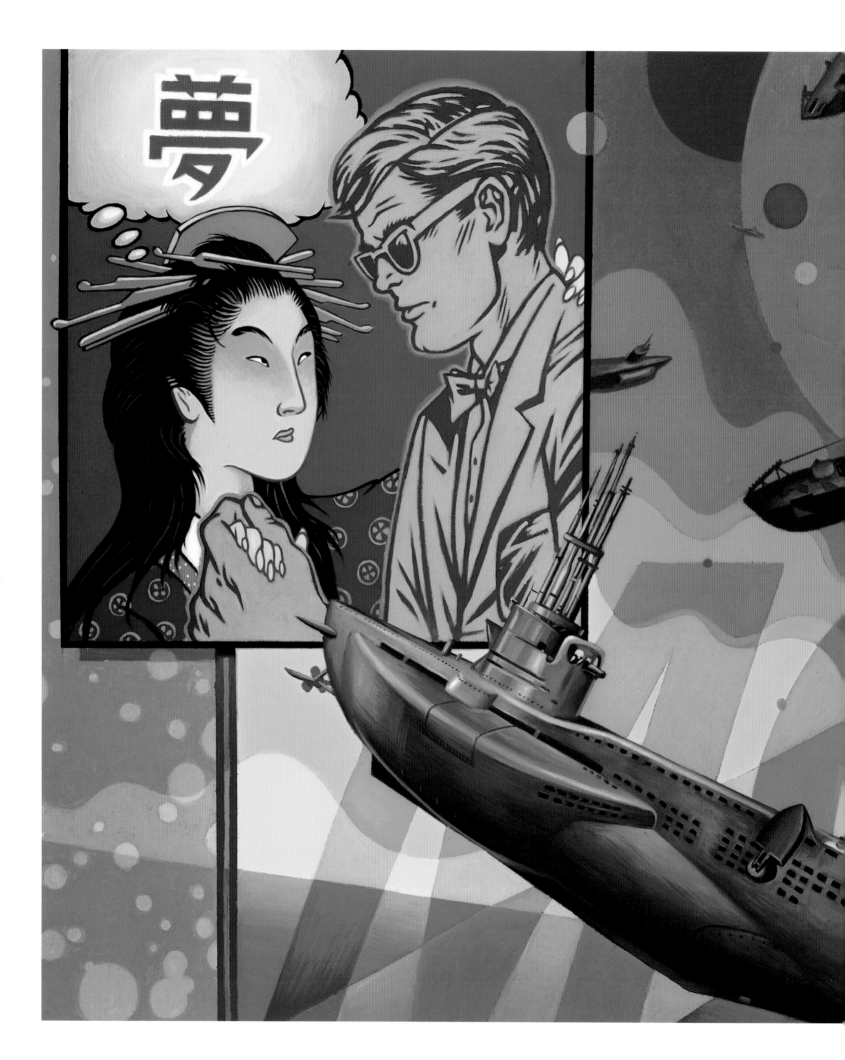

Painting detail

EVOLVE (AFTER YOSHITOSHI)
1999
OIL ON CANVAS, 55" X 28"

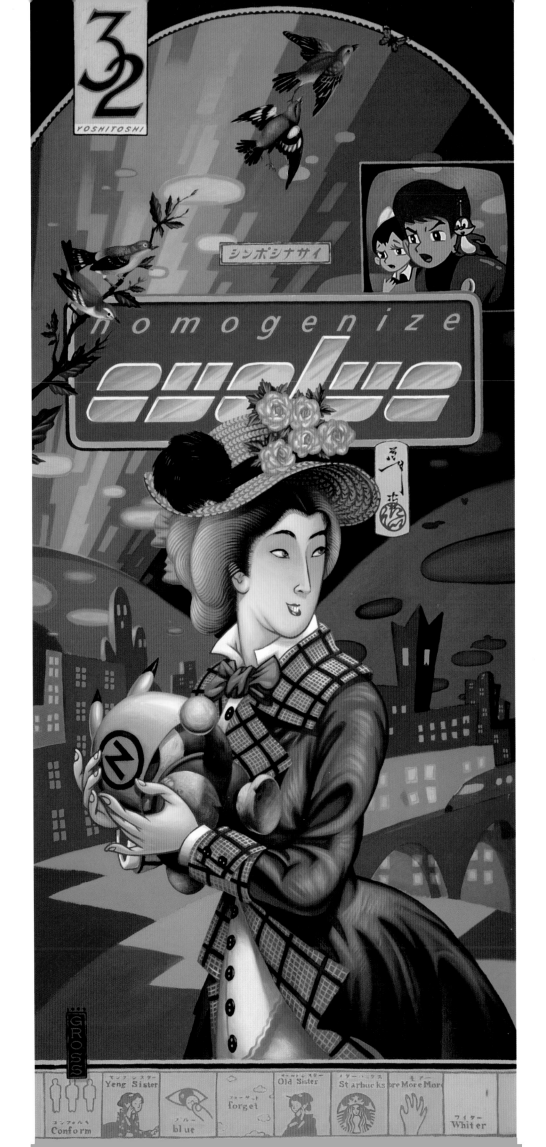

Vintage Japanese match cover

MOLLY

1999

OIL ON CANVAS, 45" X 20"

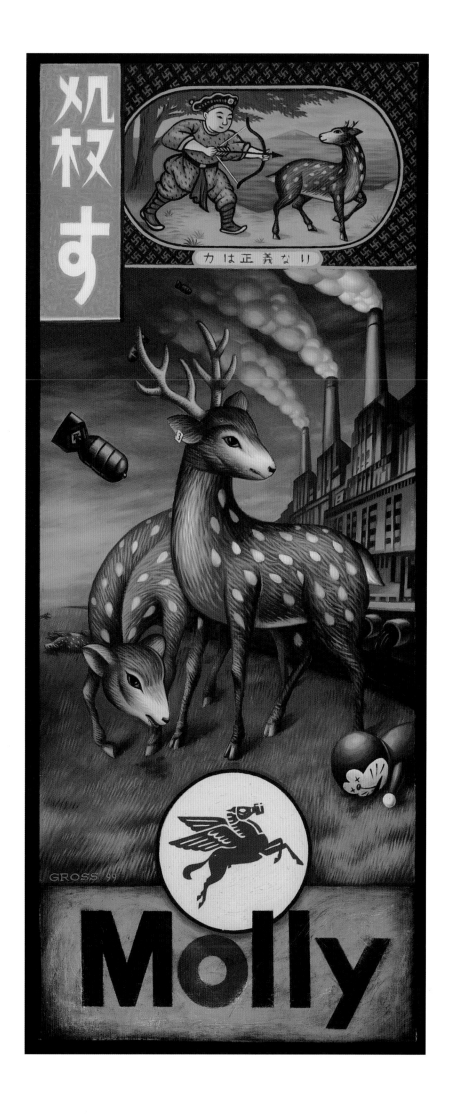

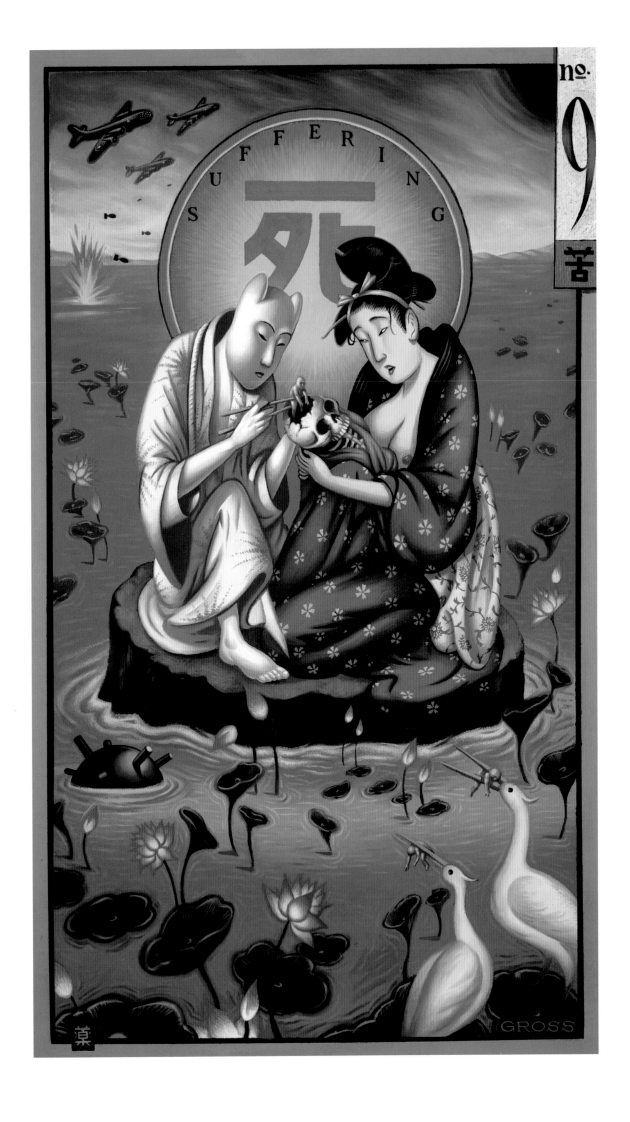

This was achieved, this great thing, this only thing:
he had let himself fall.
That he was letting himself fall into water and
into death would not have been necessary:
he could just as well have let himself
fall into life.
But that . . . was not important.
He would live, he would come again.
But then he would no longer need suicide
or any of these strange detours . . .
for then he would have overcome the dread.

from Klein and Wagner,
by Hermann Hesse
(Farrar, Straus and Giroux, 1920)

ABSTÜRZENDER
2000
OIL ON CANVAS, 43" X 16 1/2"

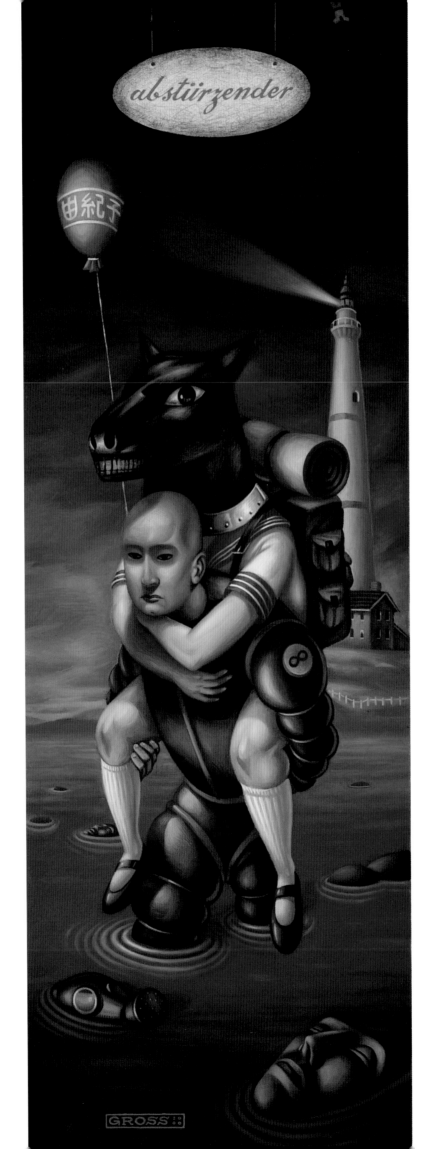

55

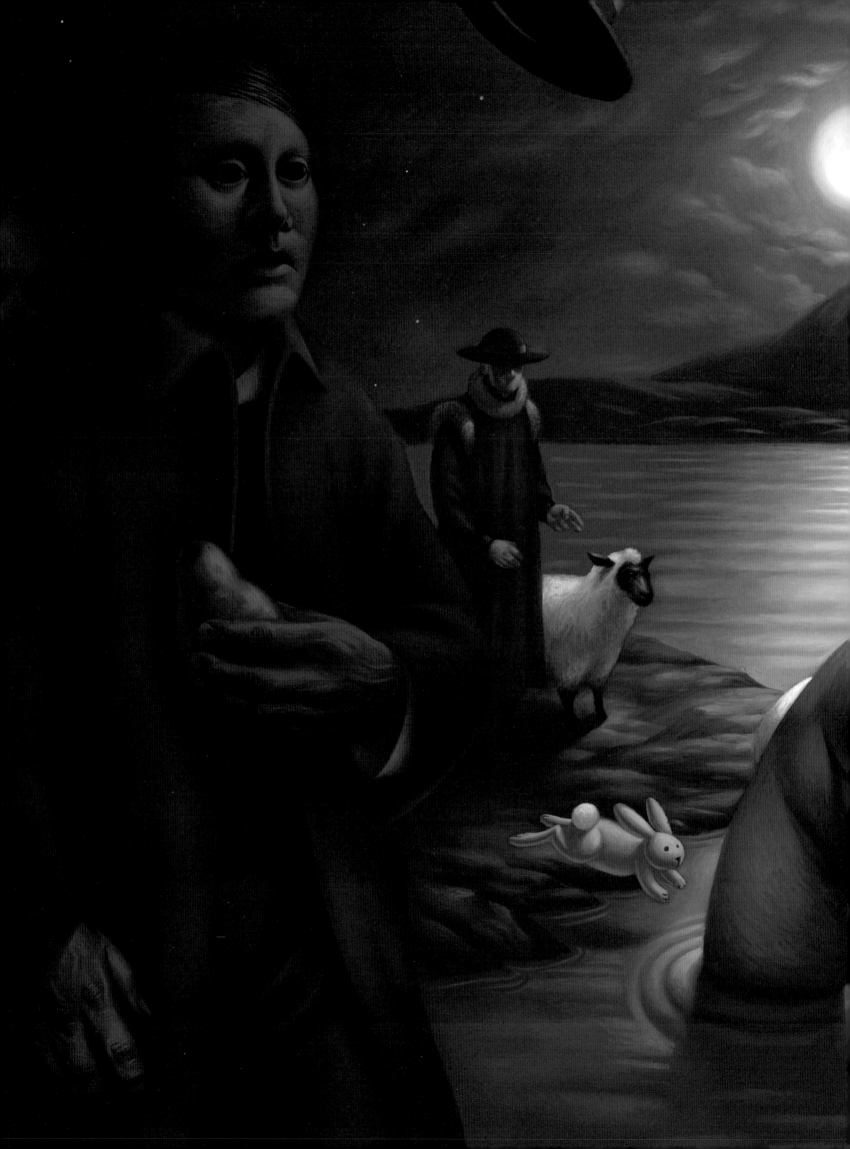

(right) "S"
2000
OIL ON CANVAS, 46" X 29"

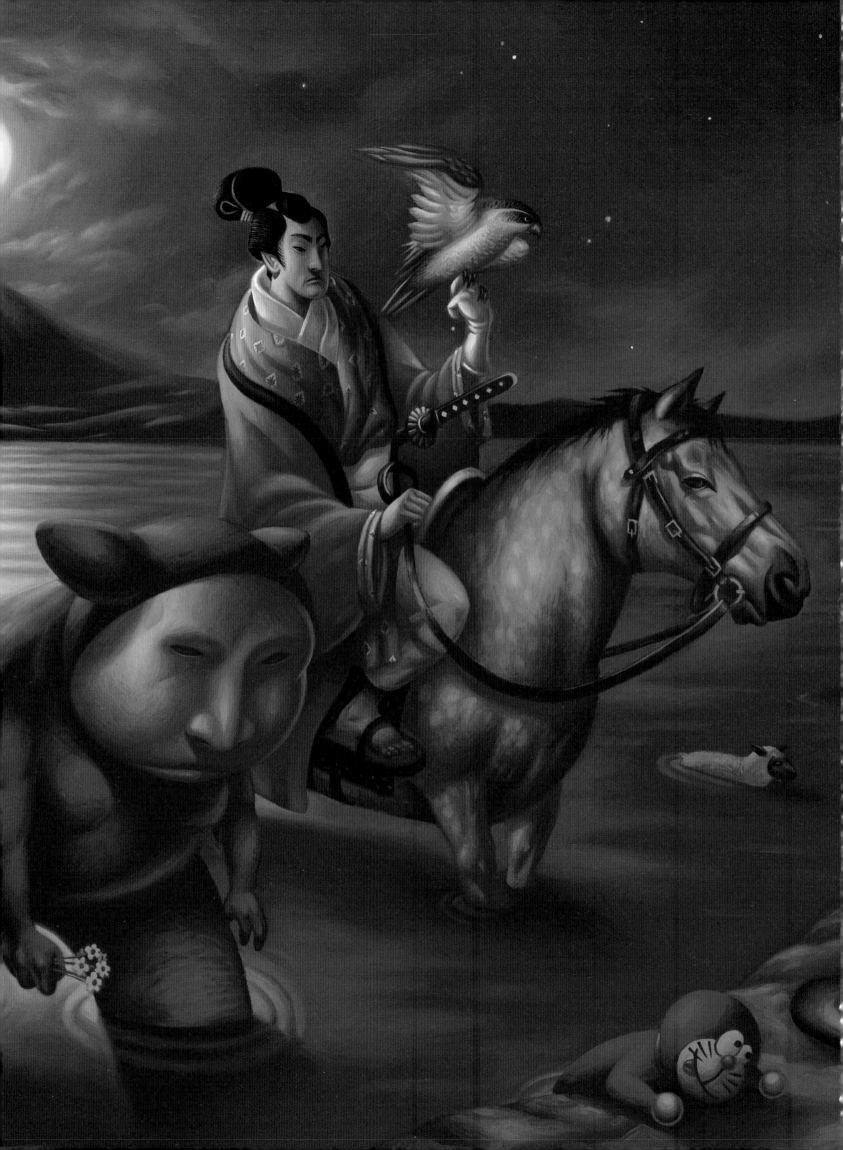

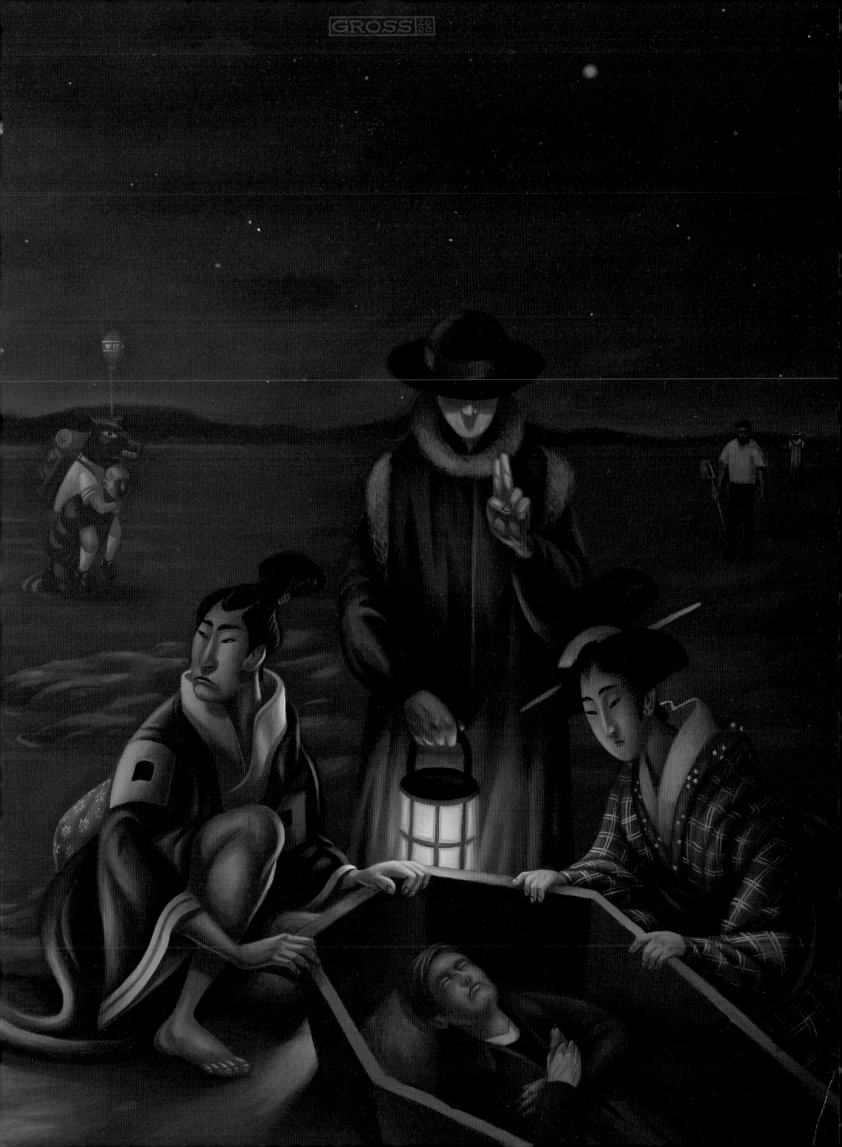

SLEEPWALKERS
2000
OIL ON CANVAS, 42" X 70"

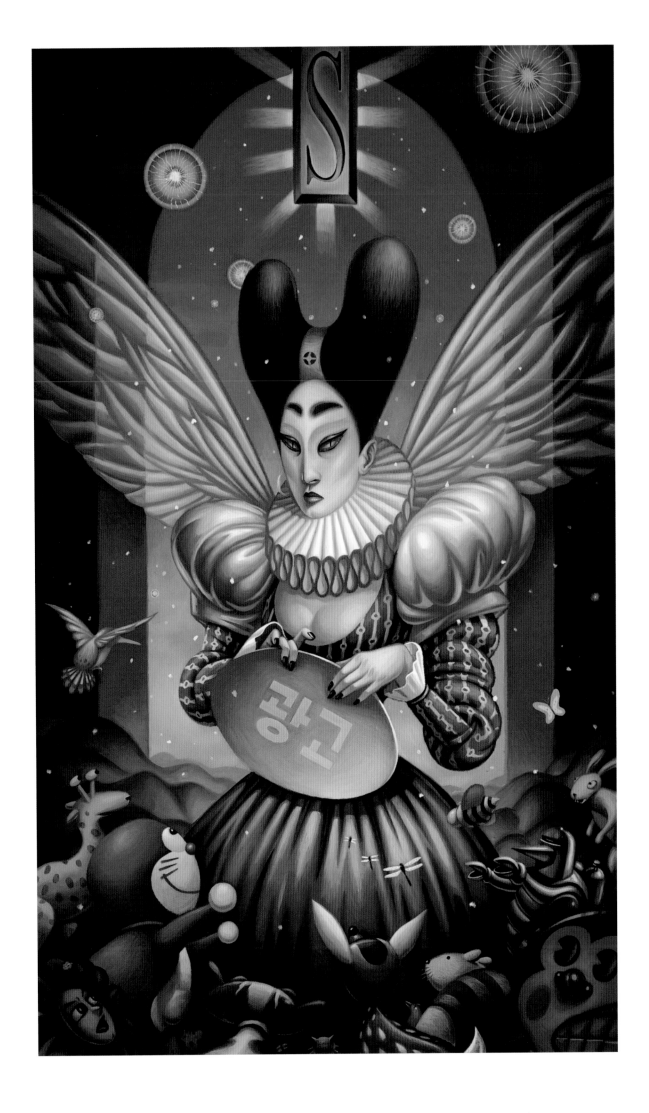

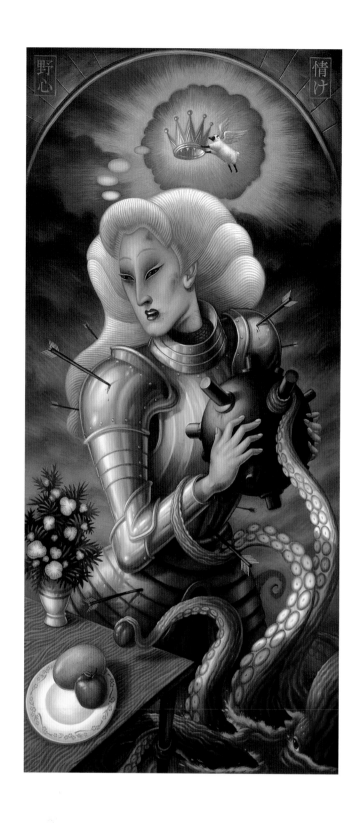

AMBITION AND MERCY

2000

OIL ON CANVAS, 54" X 25"

(right) **THE BURNING OF TOKYO**

2001

OIL ON CANVAS, 43" X 30"

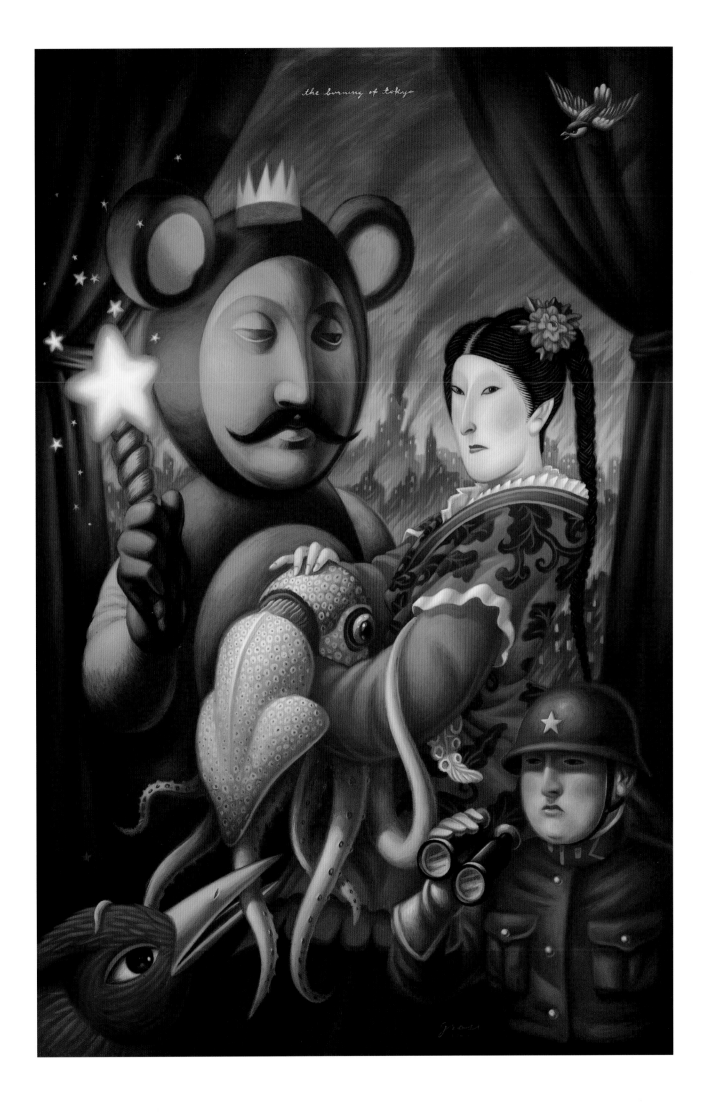

the burning of tokyo

LOVE
2003
OIL ON PANEL, 32 1/2" X 16 1/2"

(following spread) UNTITLED
2002
OIL ON CANVAS, 33" X 52"

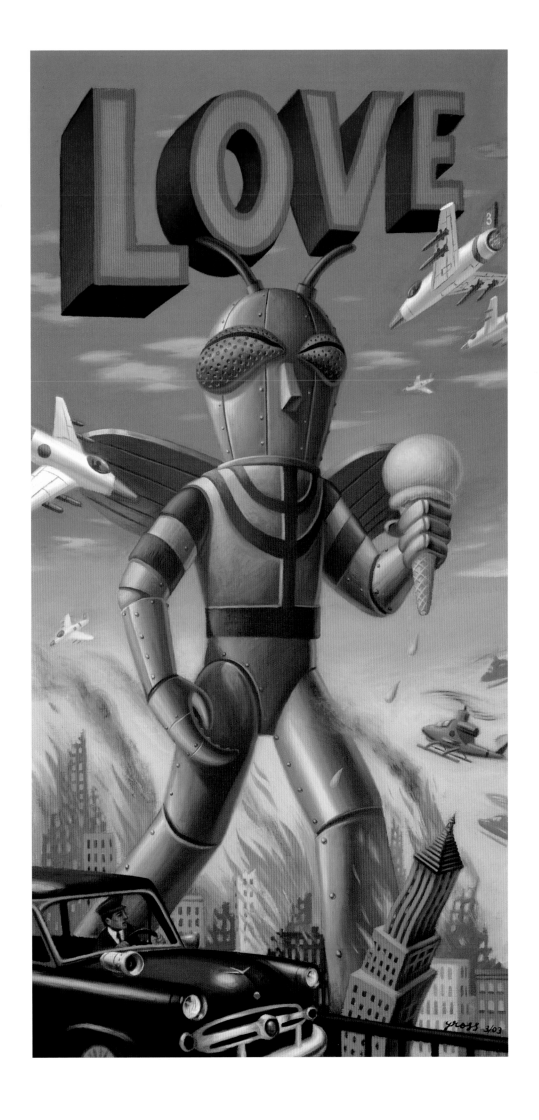

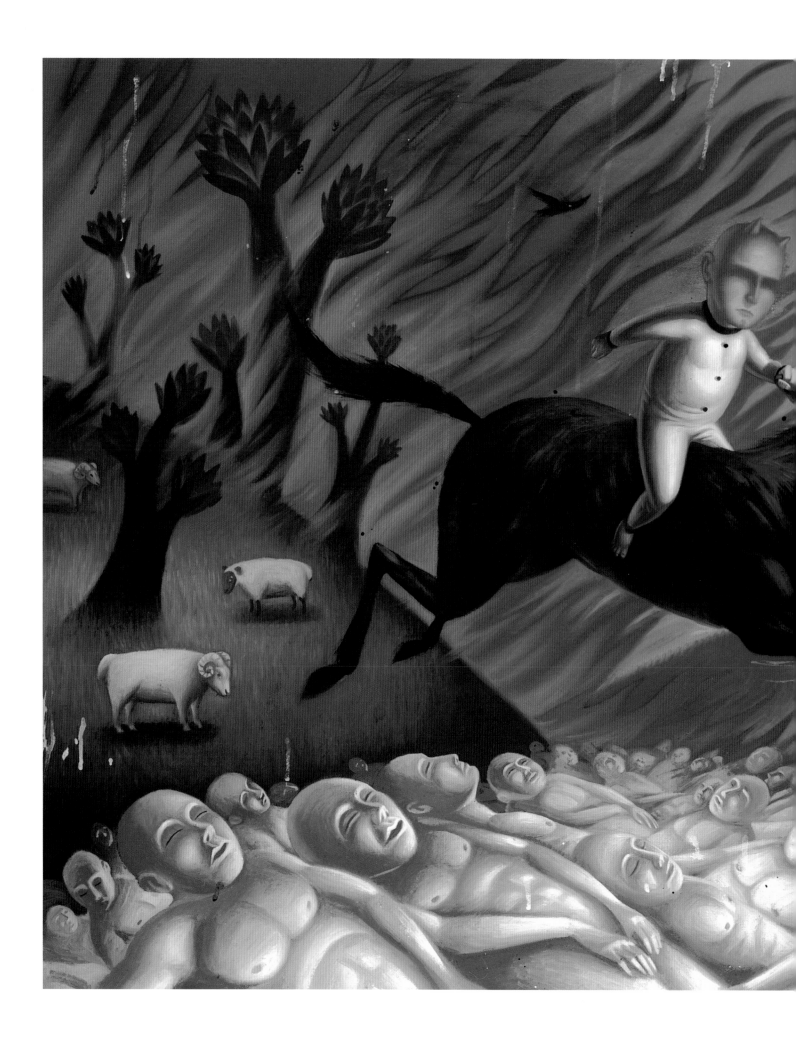

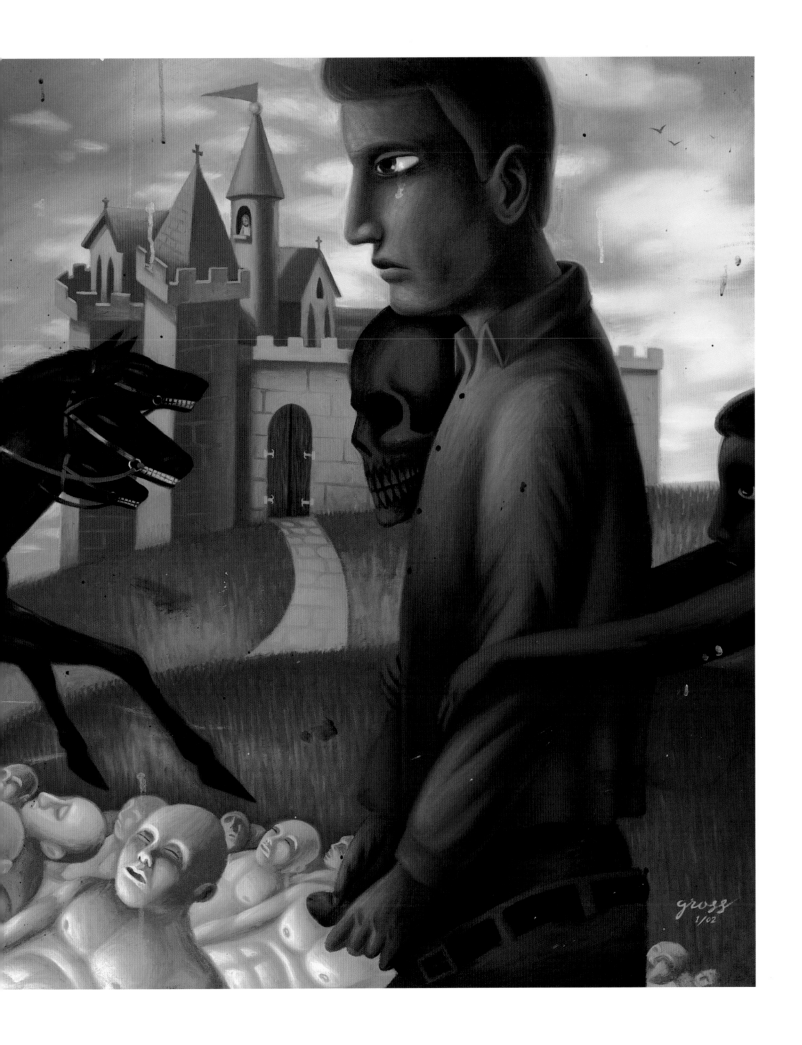

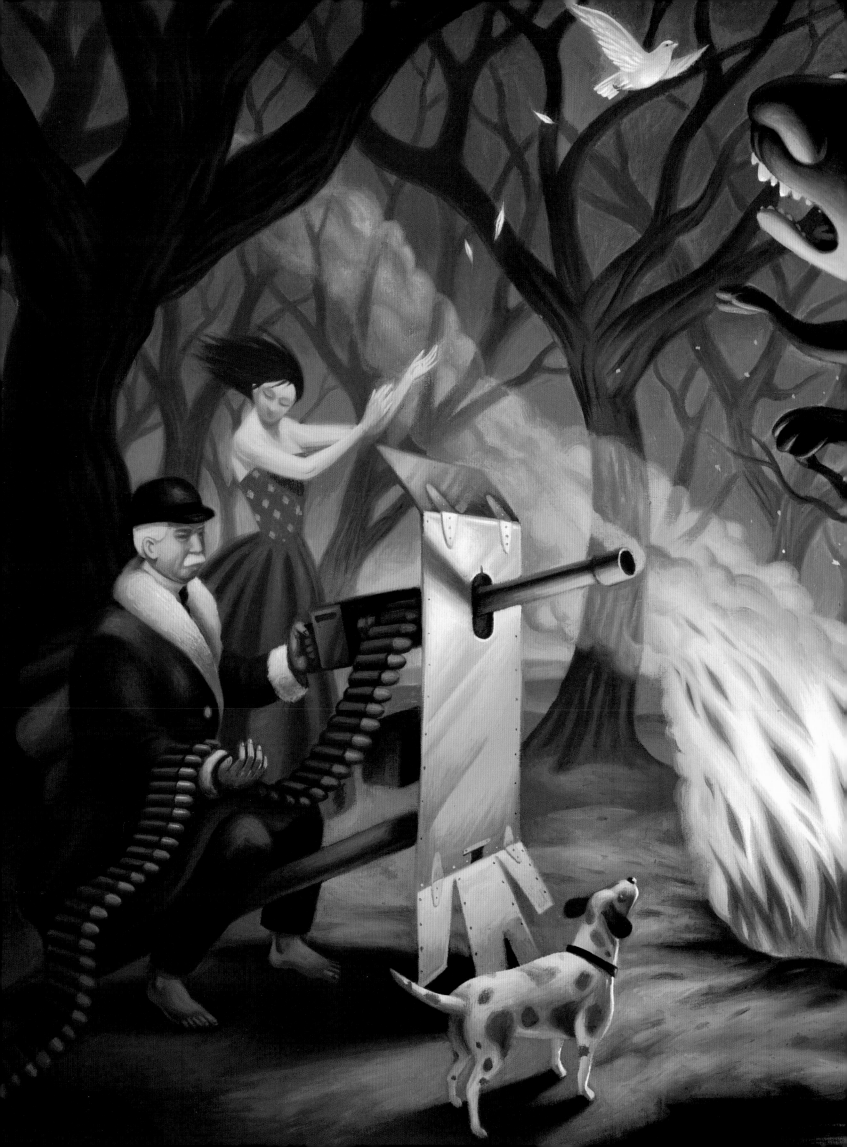

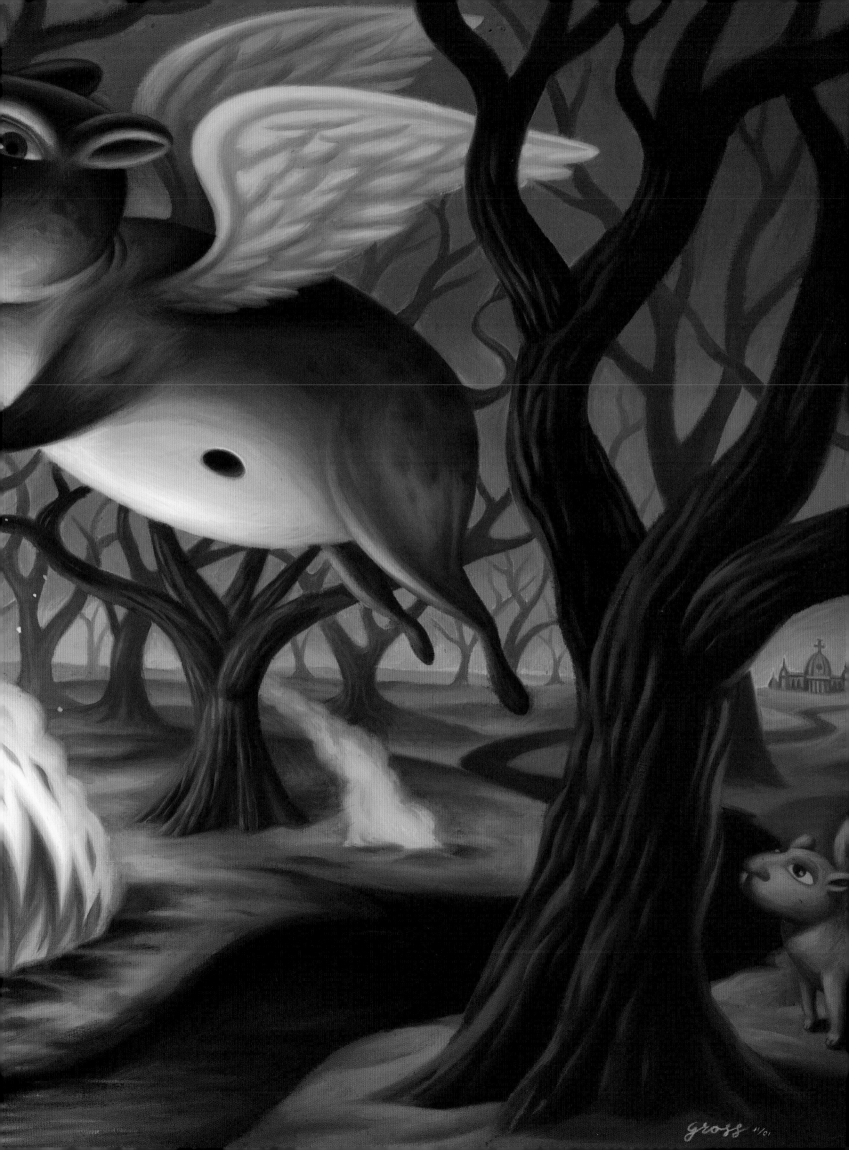

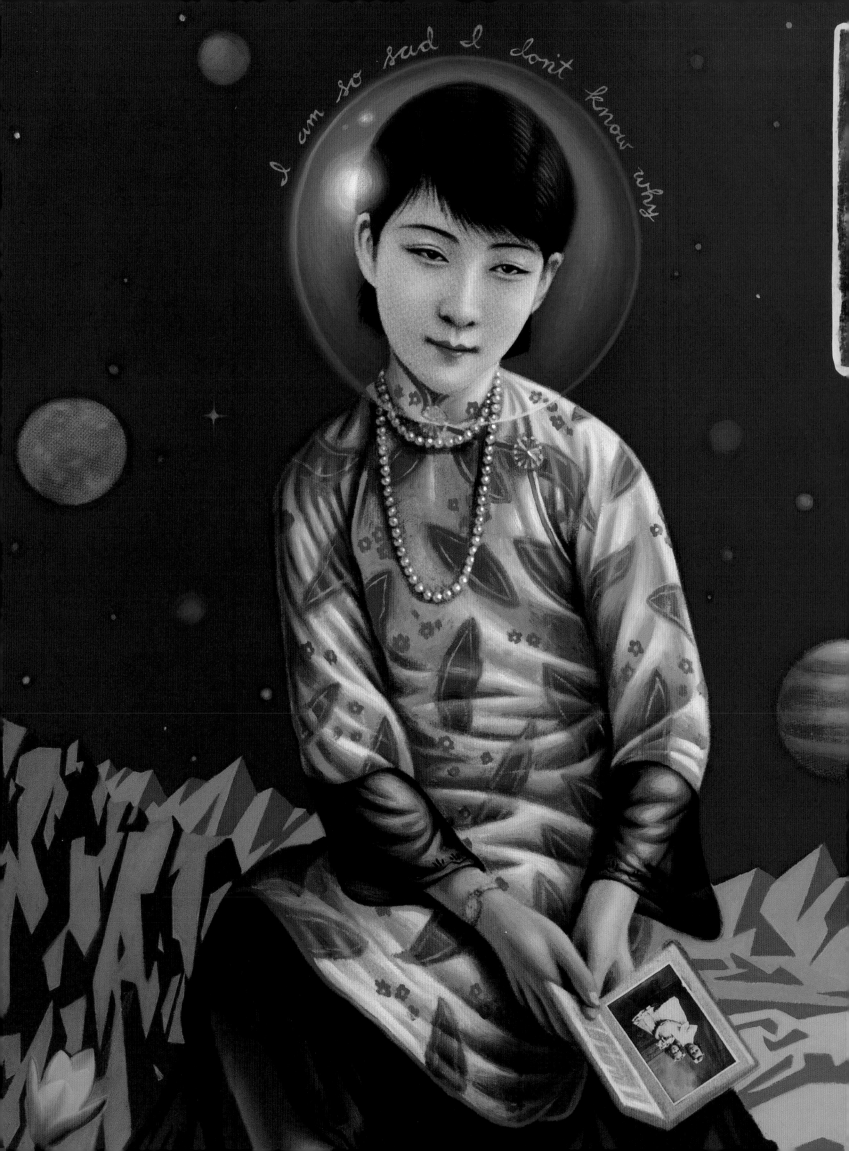

(previous spread) THE PERJURERS
2001
OIL ON CANVAS, 27" X 44"

OUTER SPACE IS A LONELY PLACE
2001
MIXED MEDIA ON PAPER, 18" X 18"

SYCOPHANT

2001

OIL ON PANEL, 41" X 29" OVAL

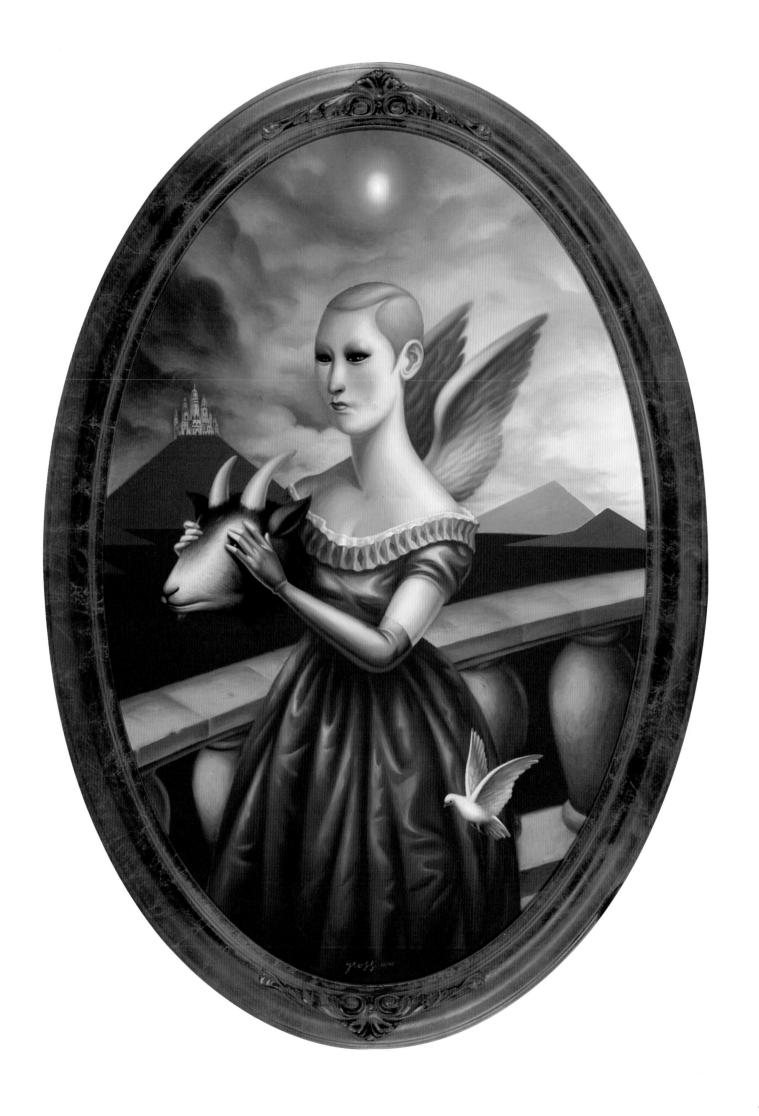

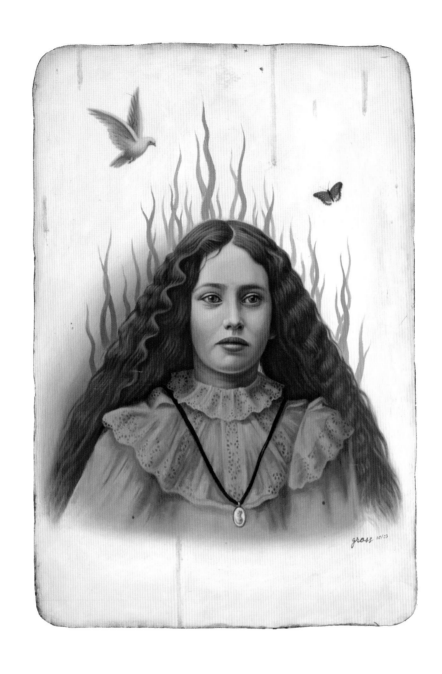

MÄDCHEN
2004
MIXED MEDIA ON PAPER, 19" X 13"

(right) MY OWN DEATH
2001
MIXED MEDIA ON PANEL, 42" X 29"

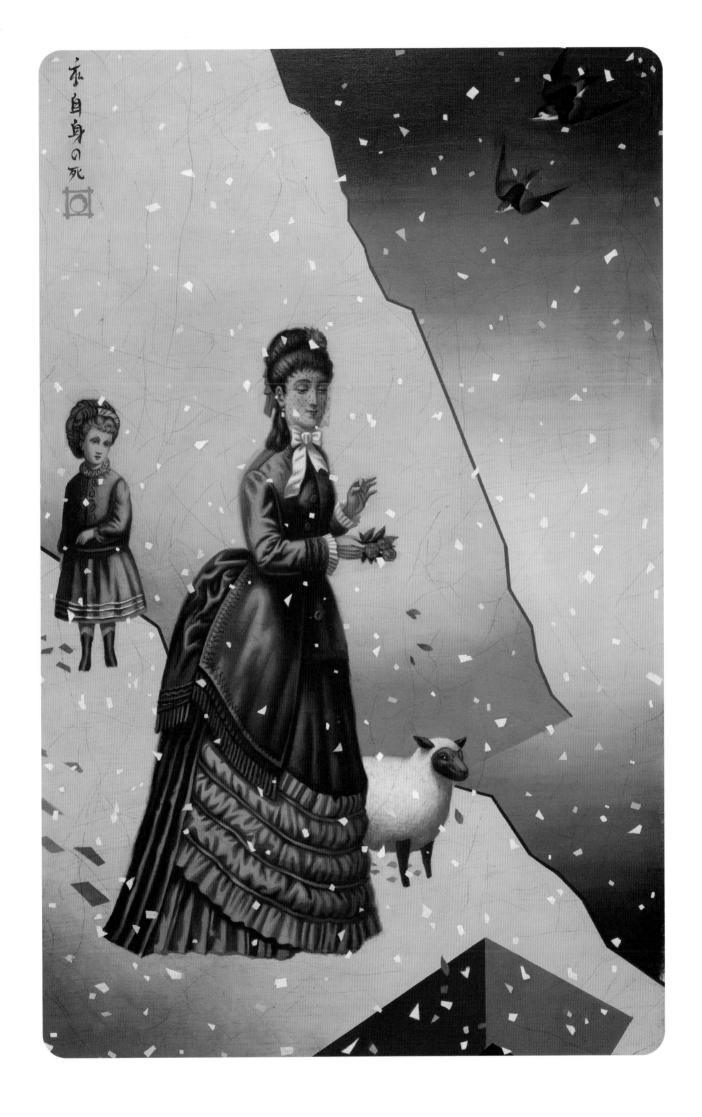

永自身の死

73

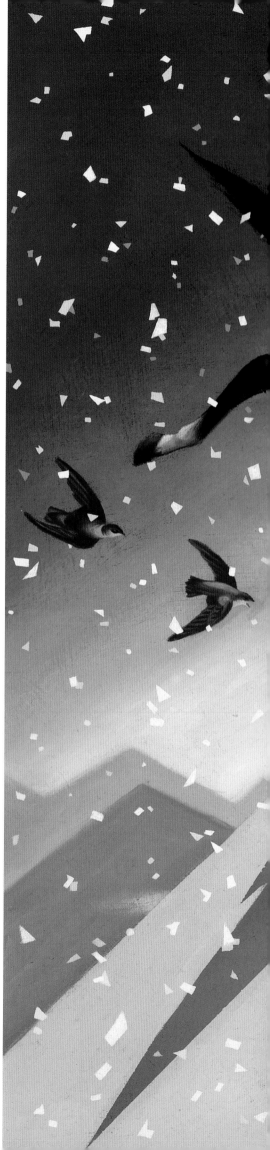

ARRIVAL
2002
MIXED MEDIA ON PANEL, 28" X 28"

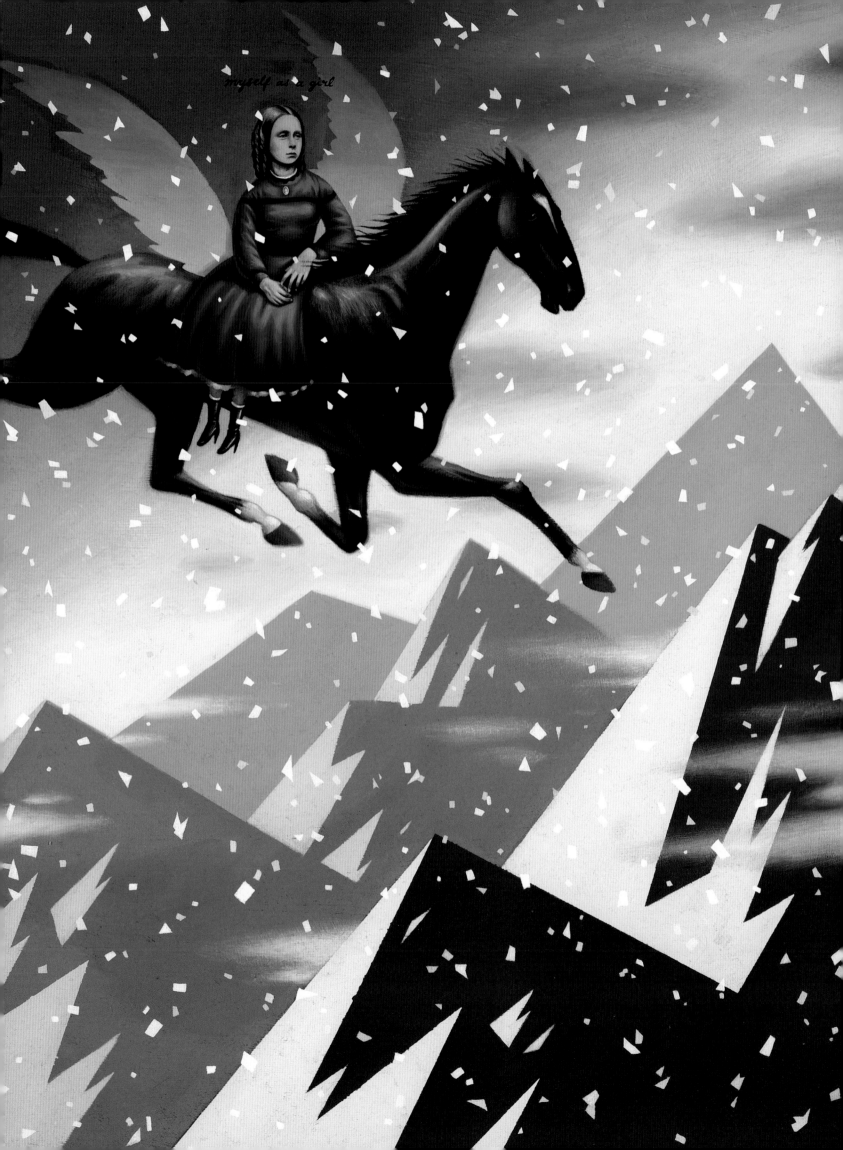

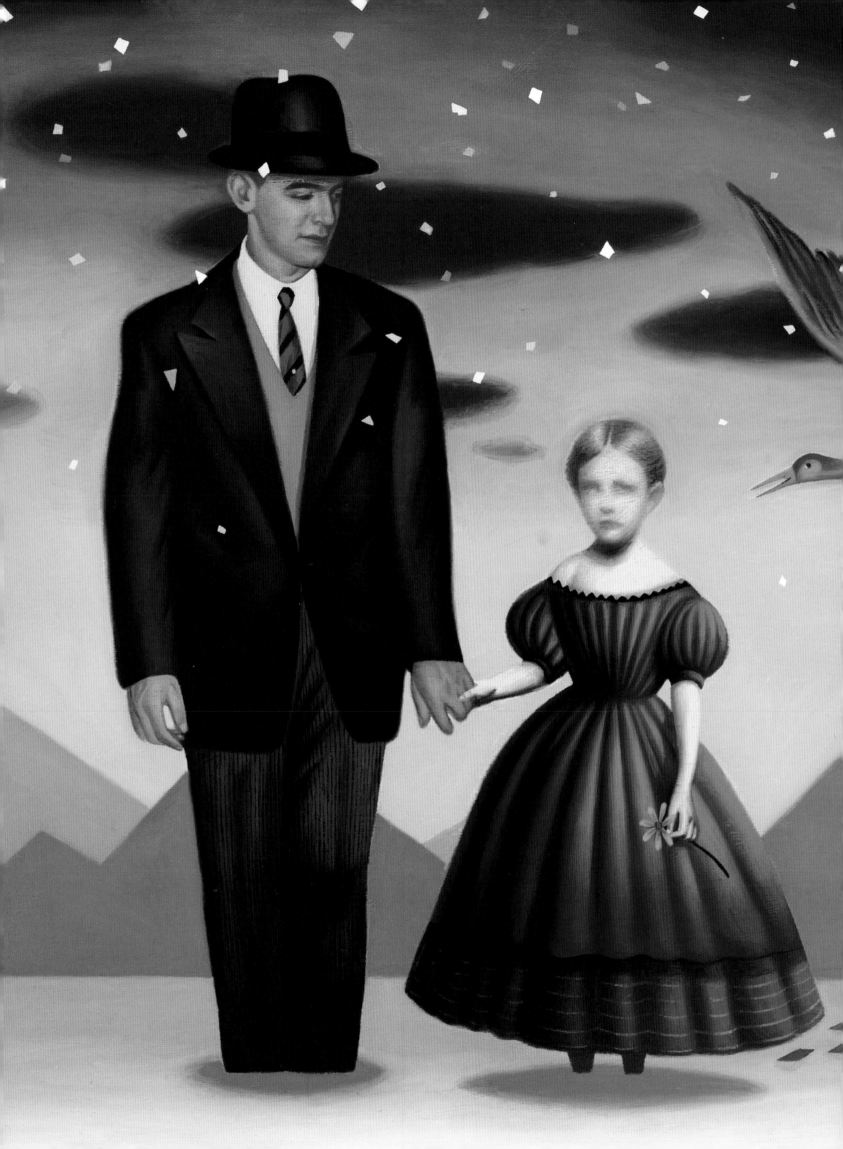

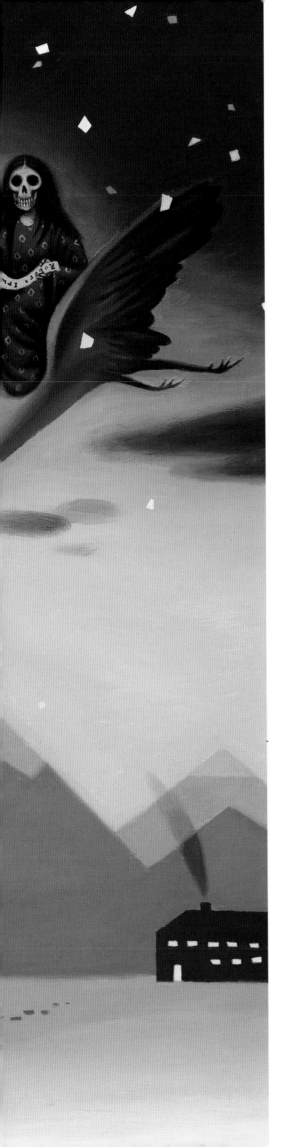

DEPARTURE

2002

MIXED MEDIA ON PANEL, 28" X 28"

PAMELA

2002

OIL ON PANEL, 42" X 21"

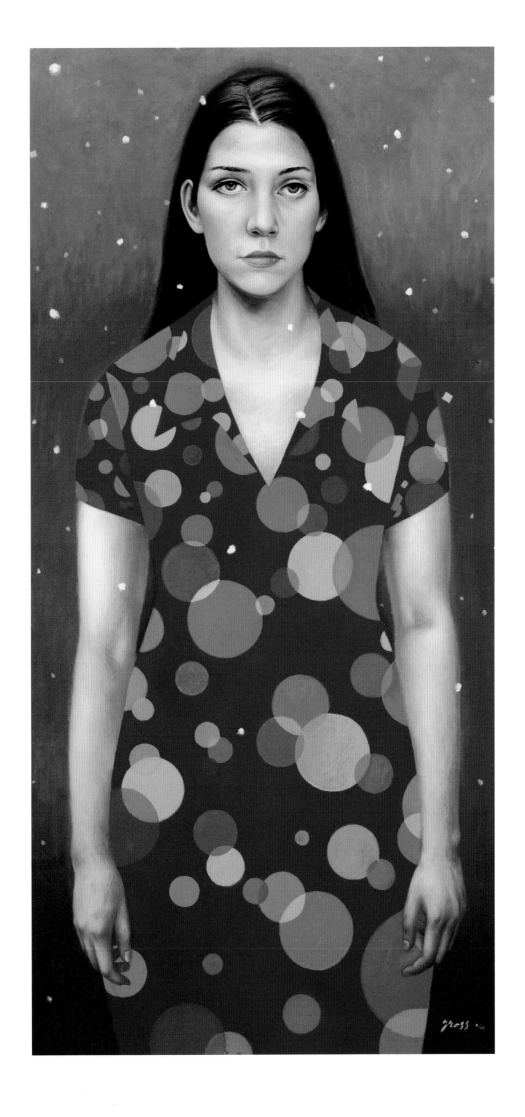

Vintage photograph

The True Origin Of Green Lantern

2002

OIL ON PAPER, 19" X 13"

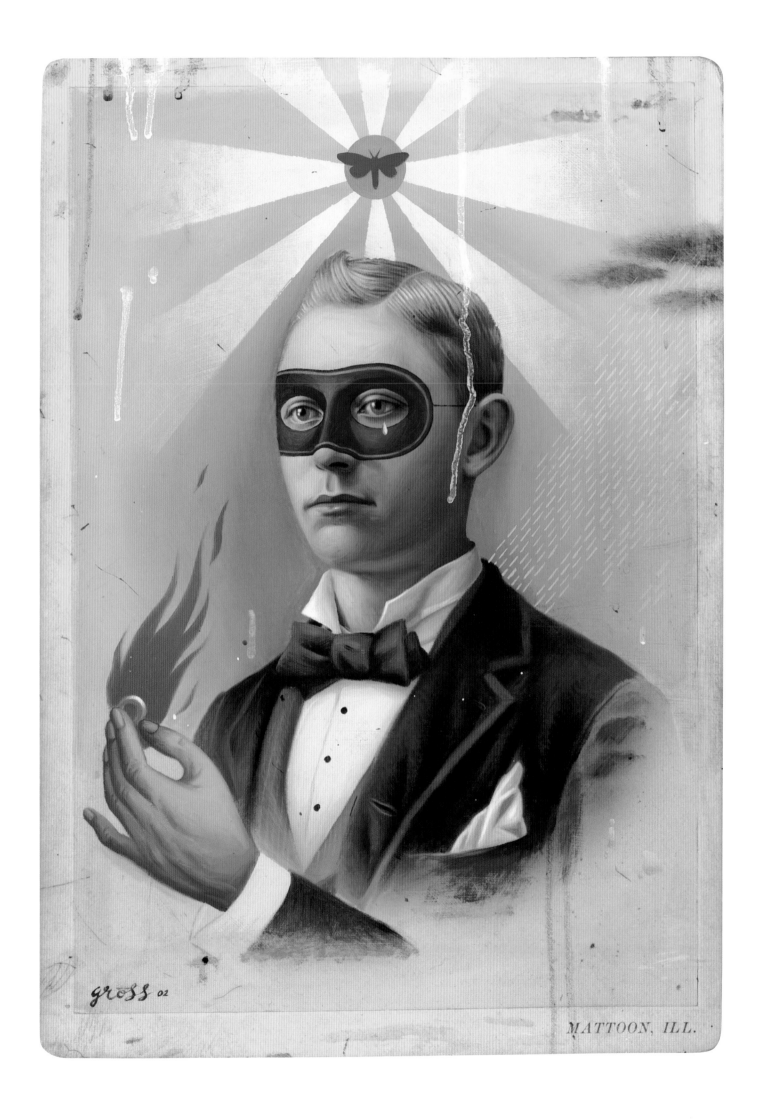

gross 02

MATTOON, ILL.

THE SUGAR SICKNESS

2002

OIL ON PANEL, 47" X 47"

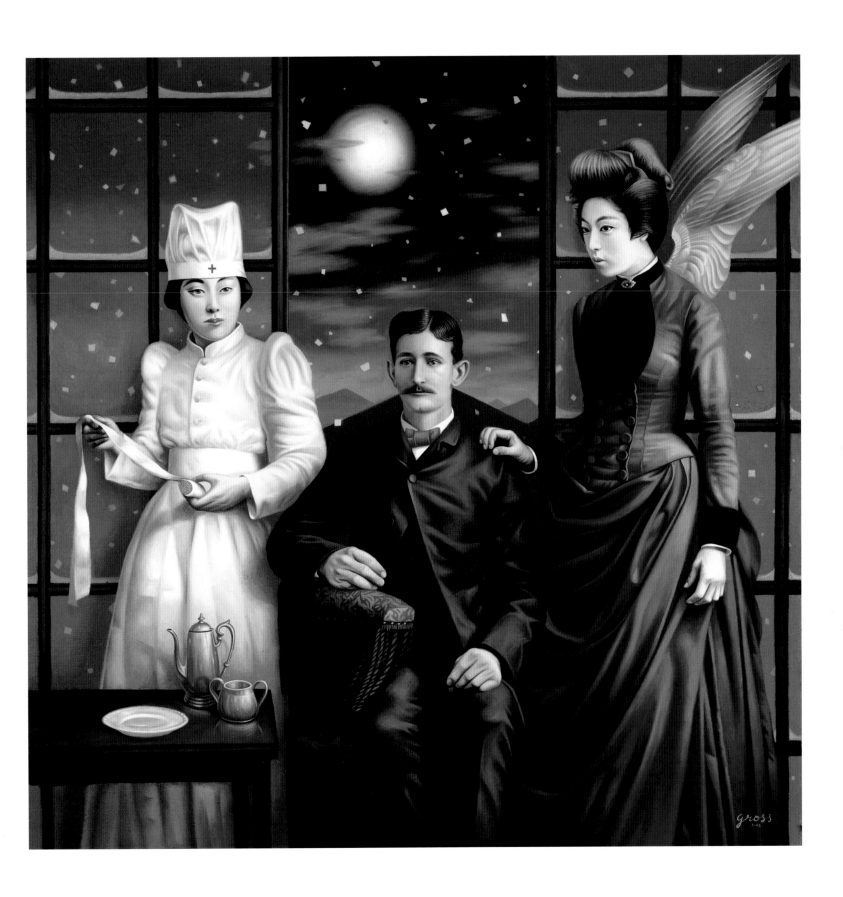

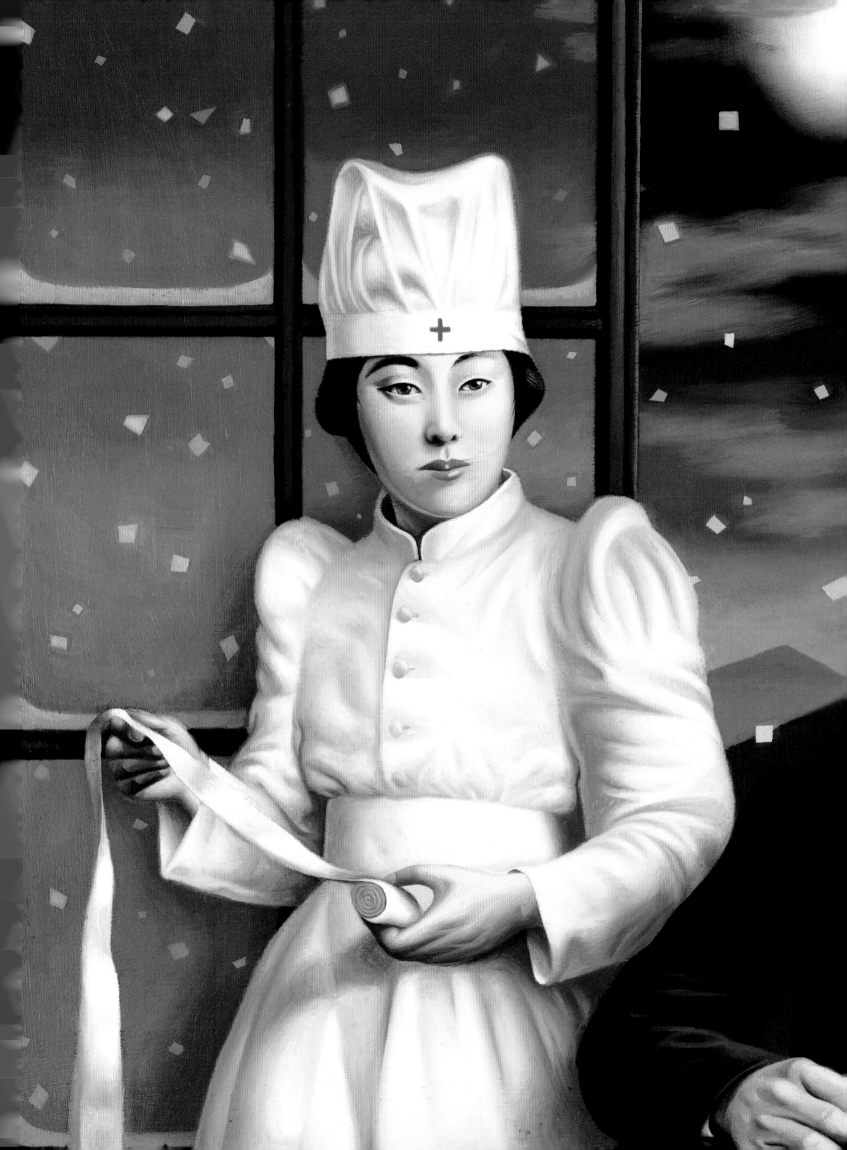

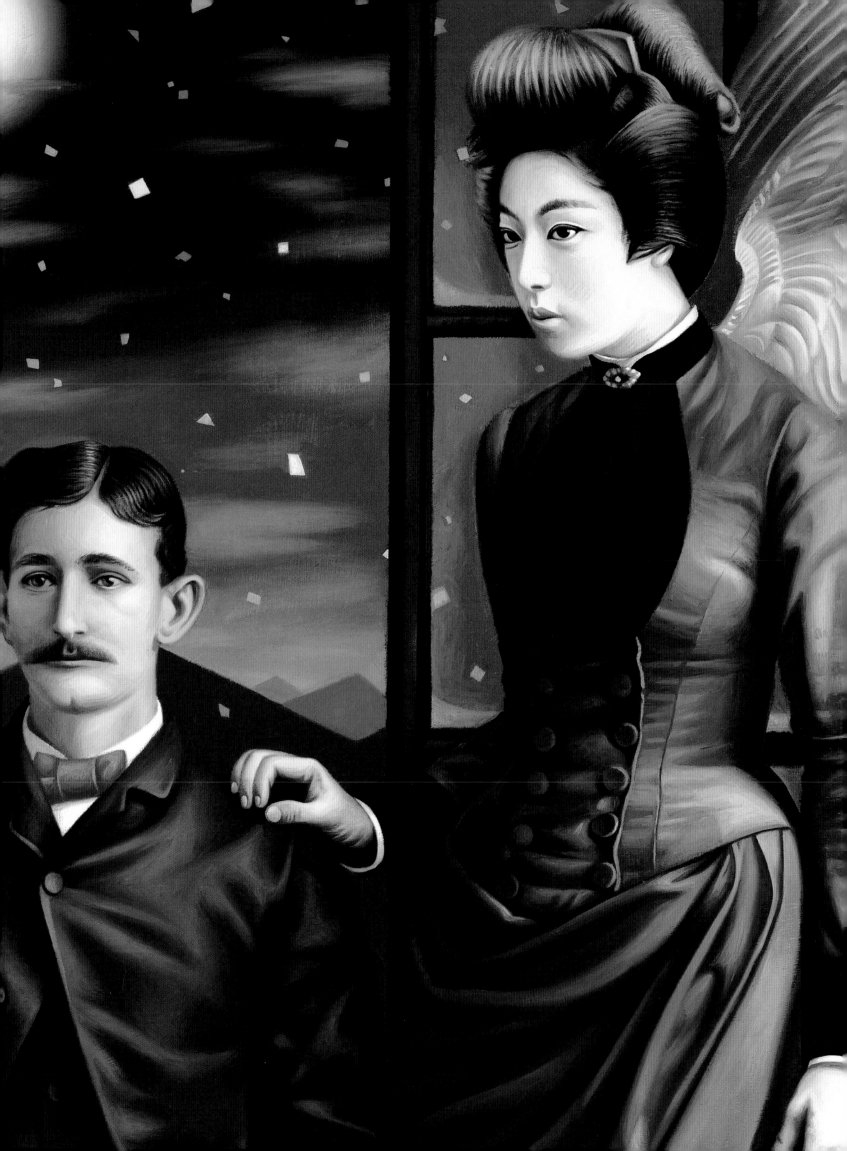

MATASABURO OF THE WIND
2001
OIL ON CANVAS, 40" X 30"

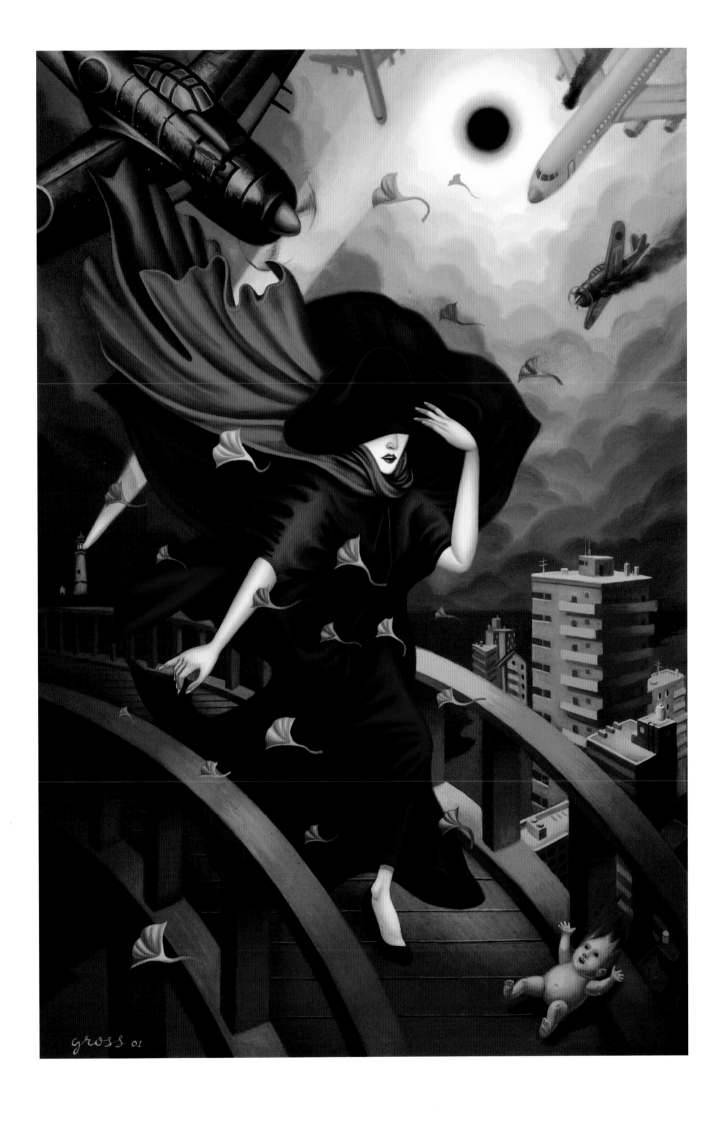

Study for The Forgotten Thing, *etching*

THE FORGOTTEN THING

2002

OIL ON CANVAS, 45" X 30"

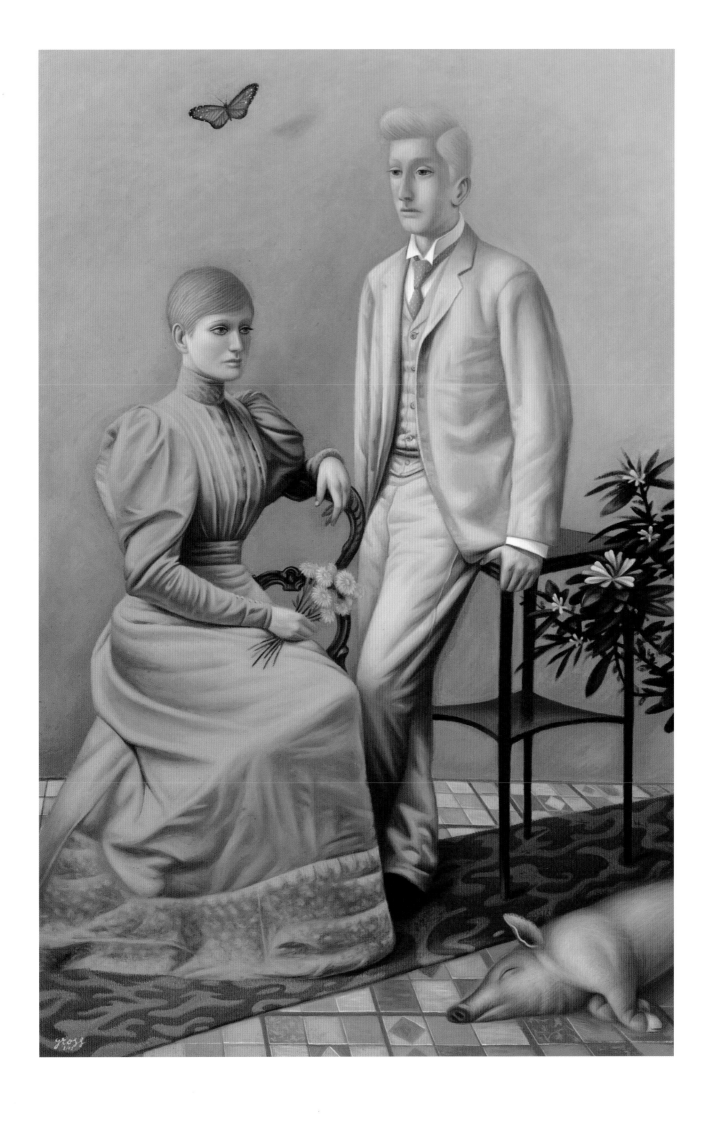

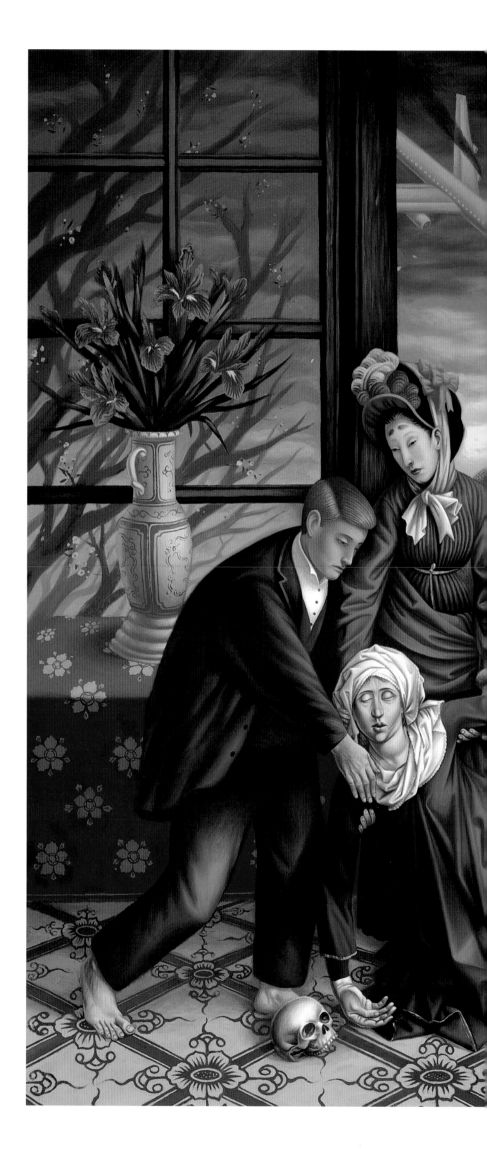

ASCENT/DESCENT
2002
OIL ON CANVAS, 50" X 65"

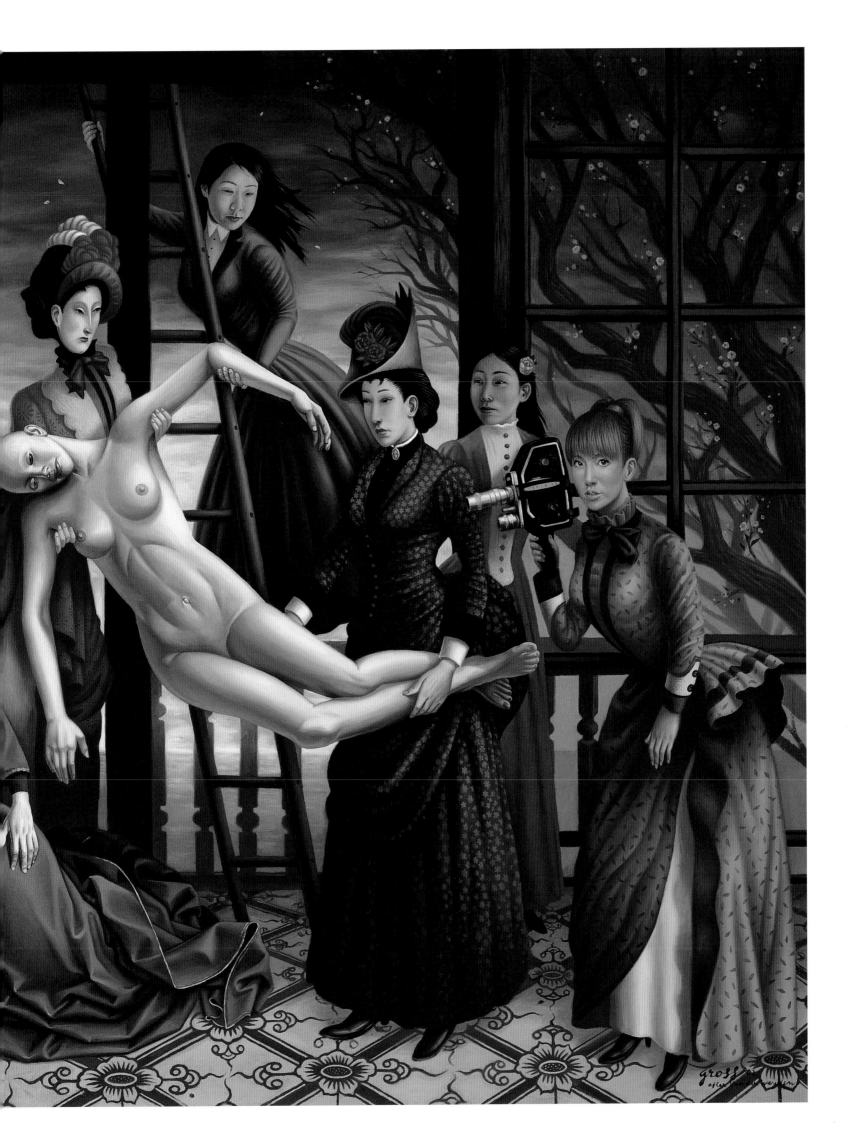

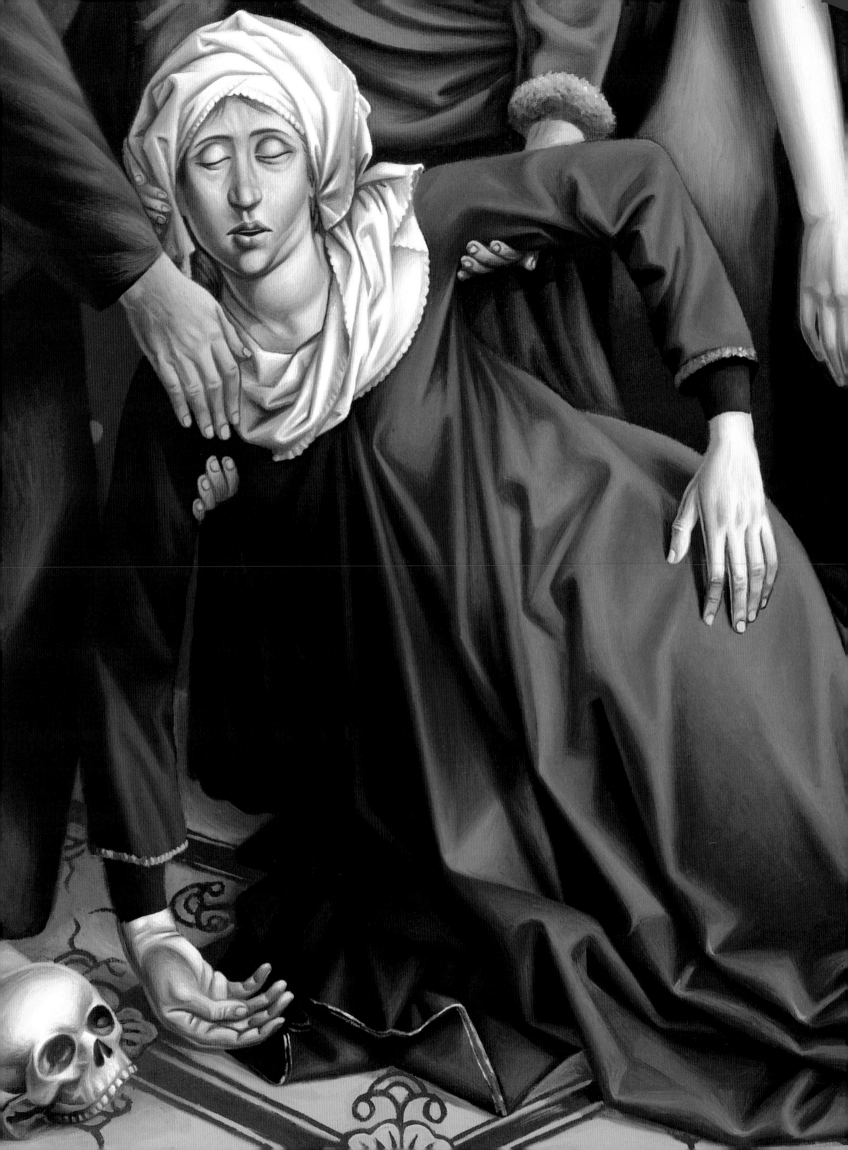

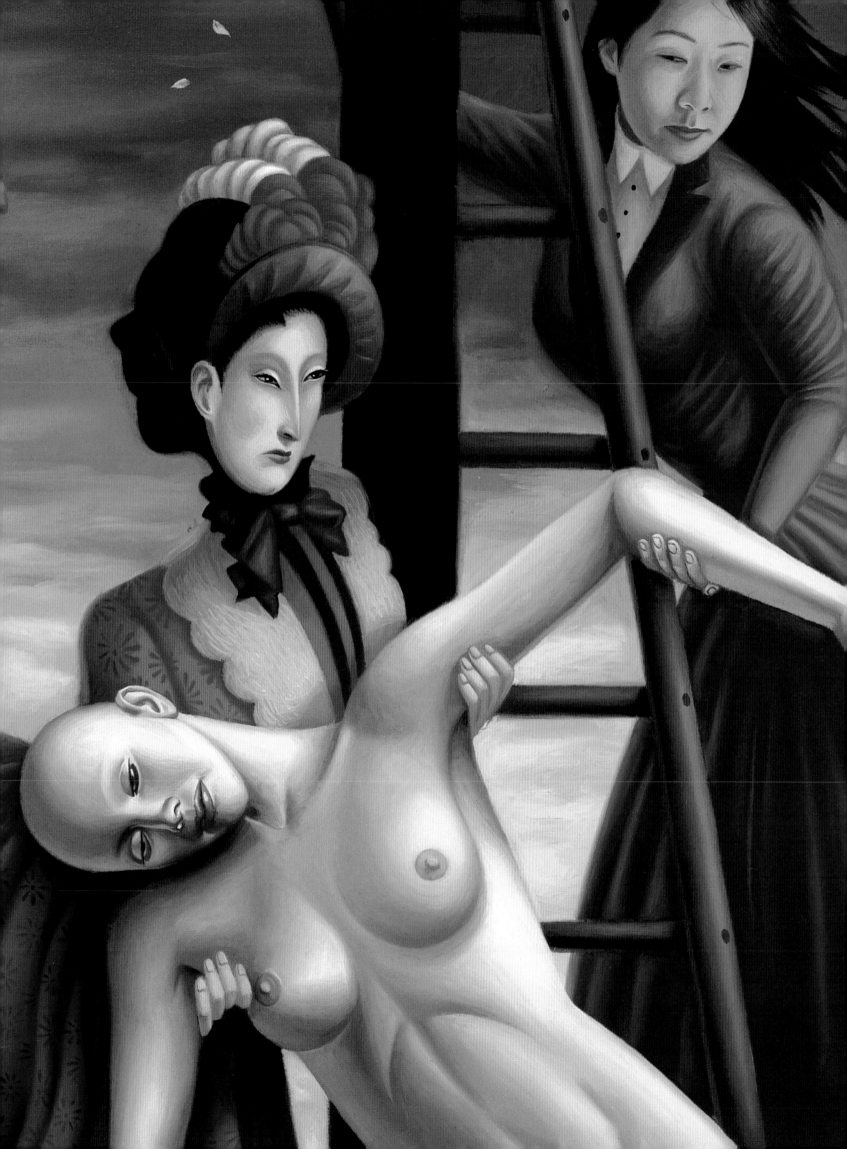

El Rayo-X

2004
OIL ON PAPER, 23 1/2" X 16 1/2"

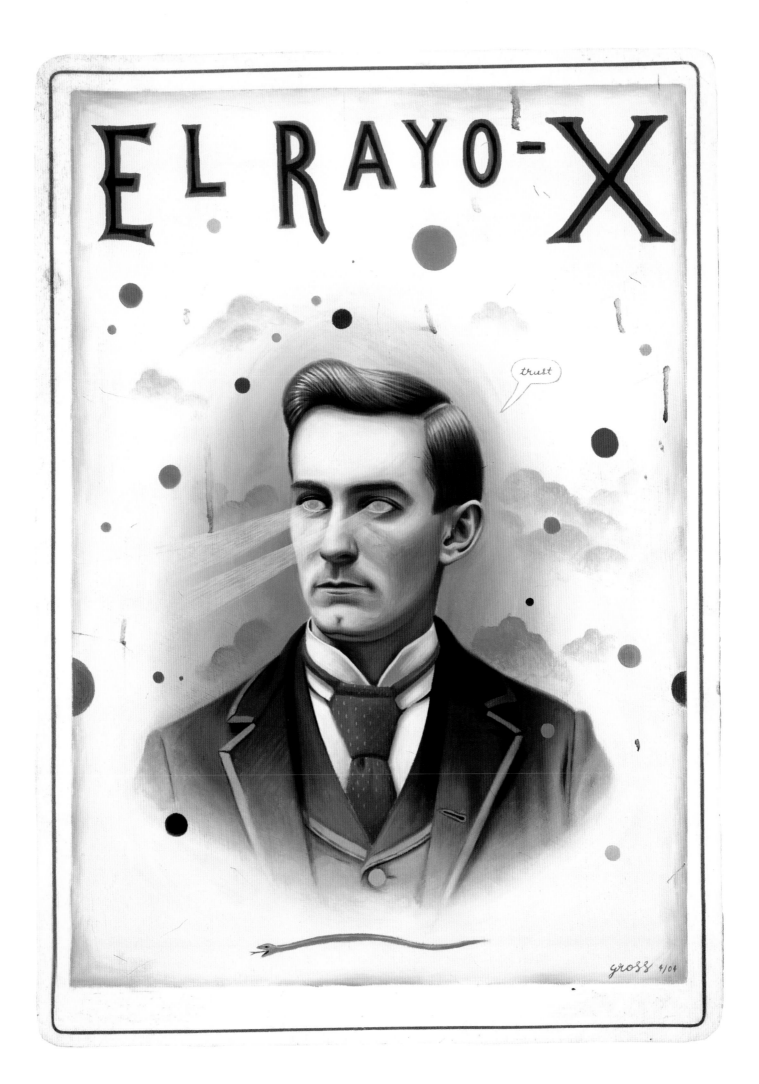

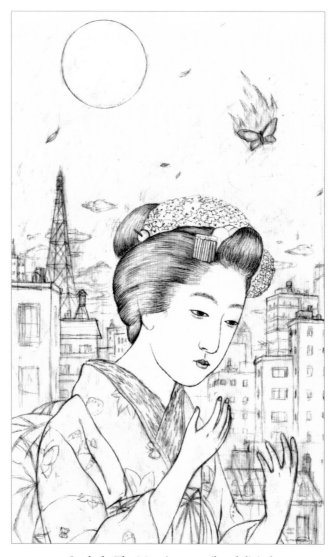

Study for The Meaning, *pencil and digital*

THE MEANING

2003

OIL ON CANVAS, 72" X 45"

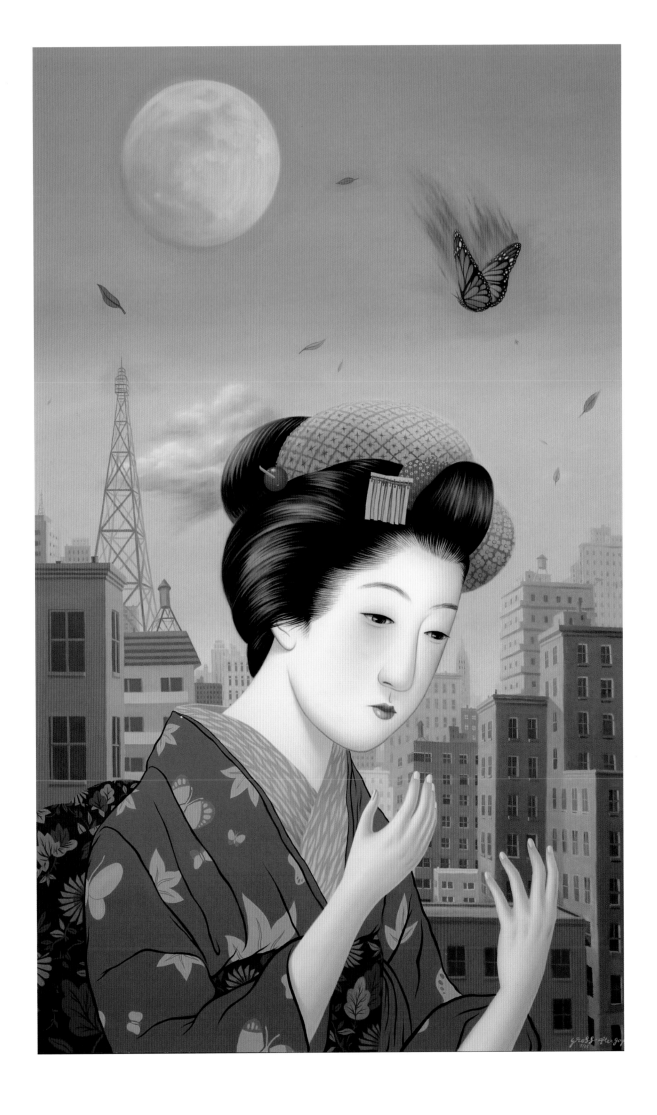

See him there, that angel of the pestilence . . .
He is hovering above your roofs with his great
spear in his right hand, poised to strike,
while his left hand is stretched toward . . . your houses.
Maybe at this very moment his finger is pointing
to your door, the red spear crashing on its panels,
and even now the plague is entering your home
and settling down in your bedroom
to await your return.

from The Plague,
by Albert Camus
(Alfred A. Knopf, 1947)

HAKIKE (LA NAUSEÉ)
2003
OIL ON PANEL, 44" X 28"

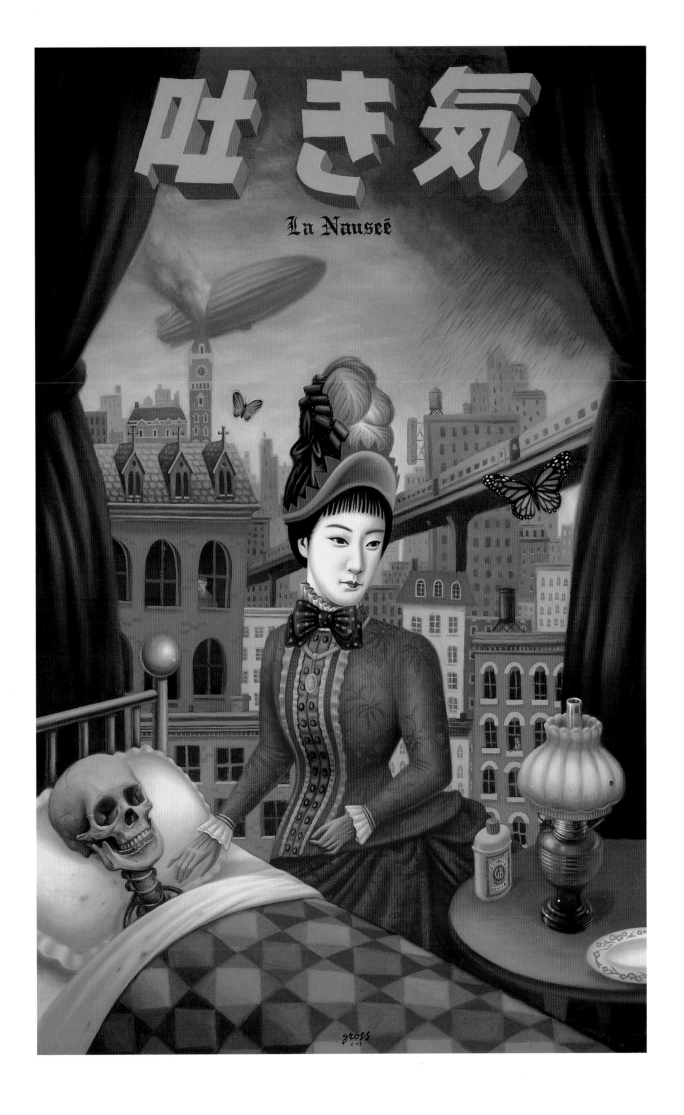

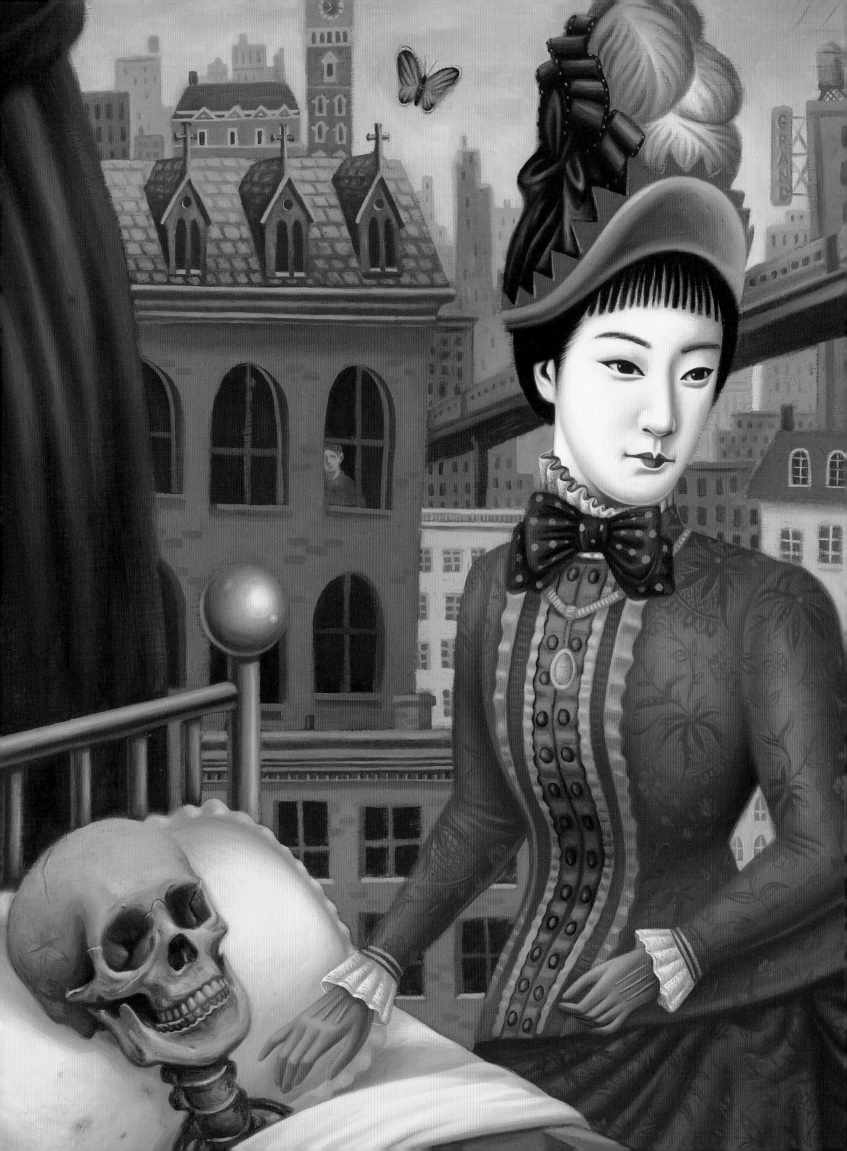

HAKIKE (DETAIL)

(following spread) SHOKEI (PUNISHMENT)
2004
OIL ON CANVAS, 67" X 40"

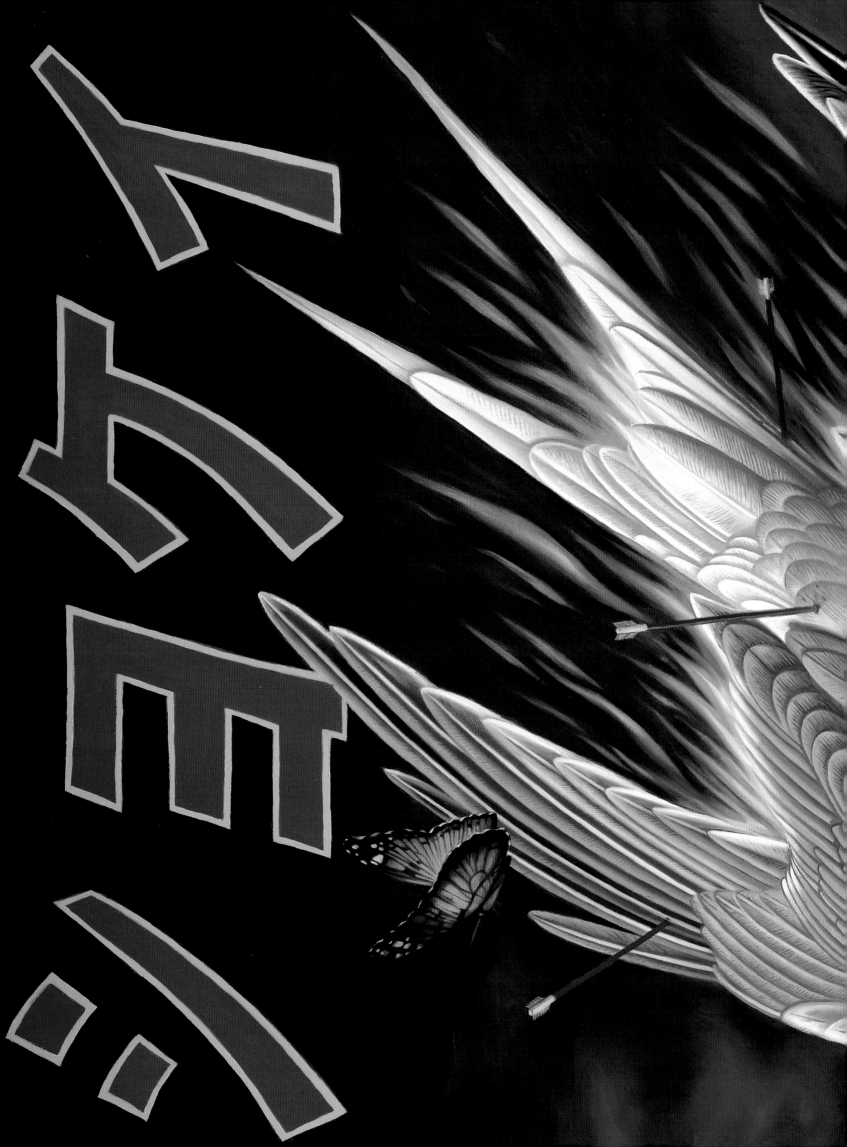

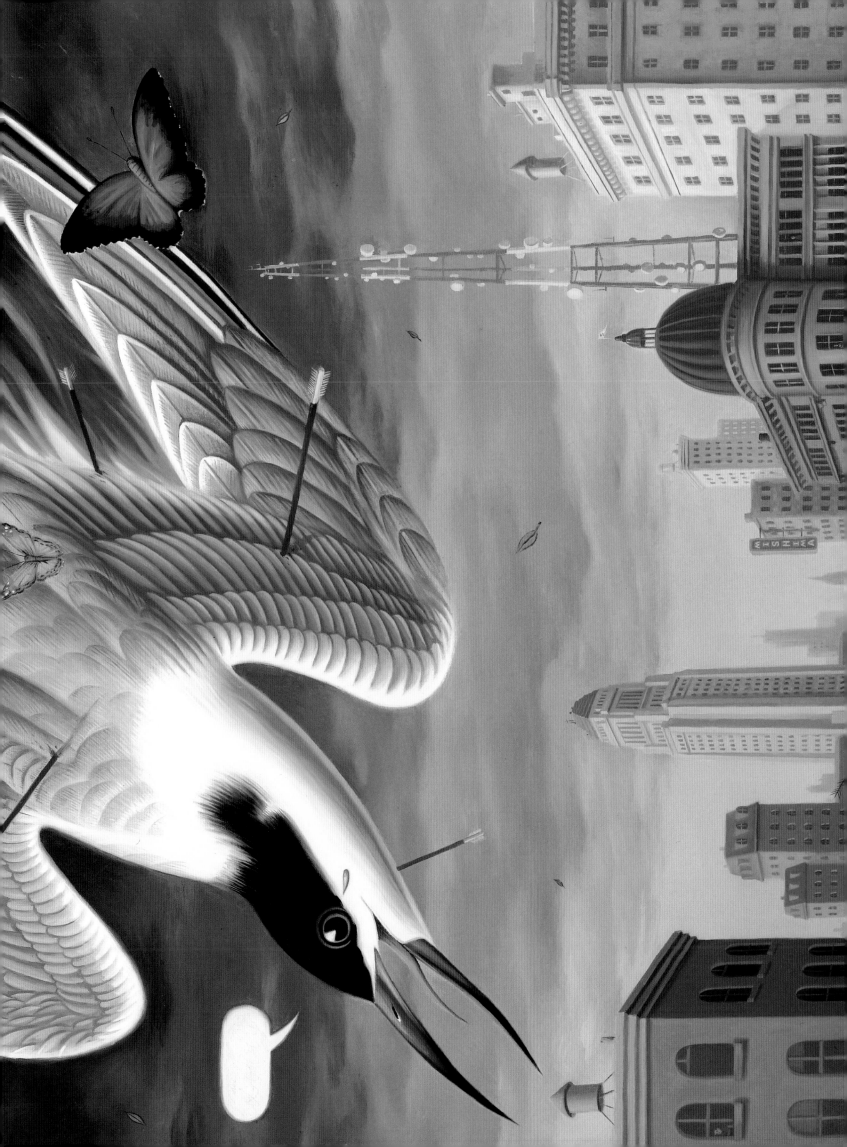

TWENTY

2003

OIL ON CANVAS, 58 1/2" X 36"

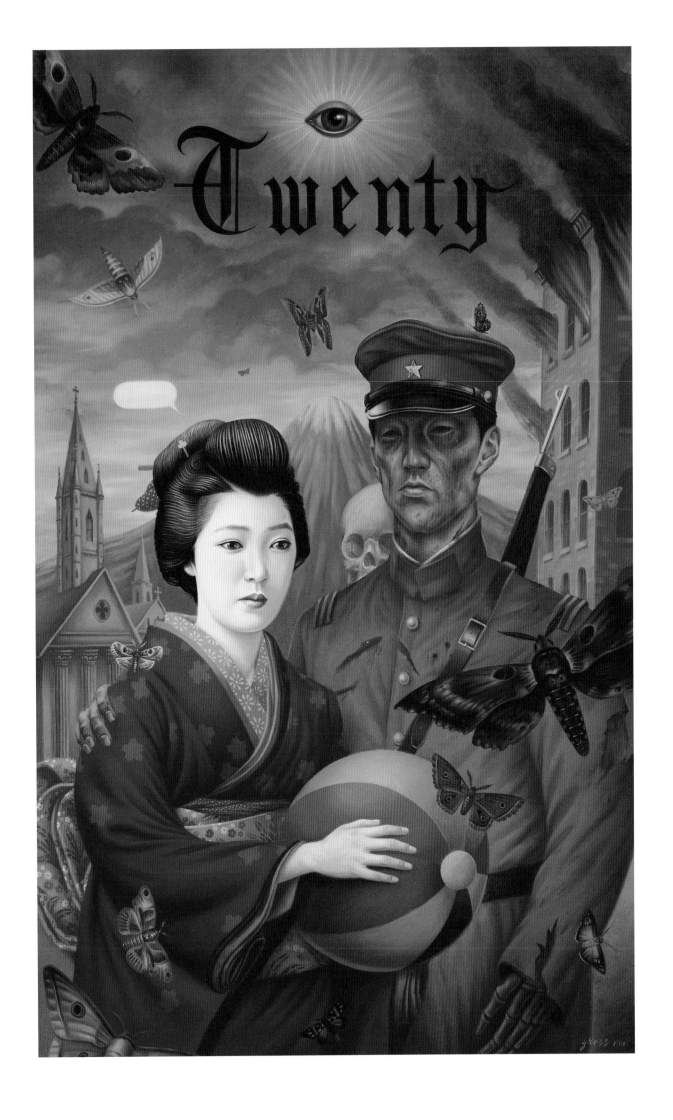

The Meaning, Part II

2004

OIL ON CANVAS, 73" X 42"

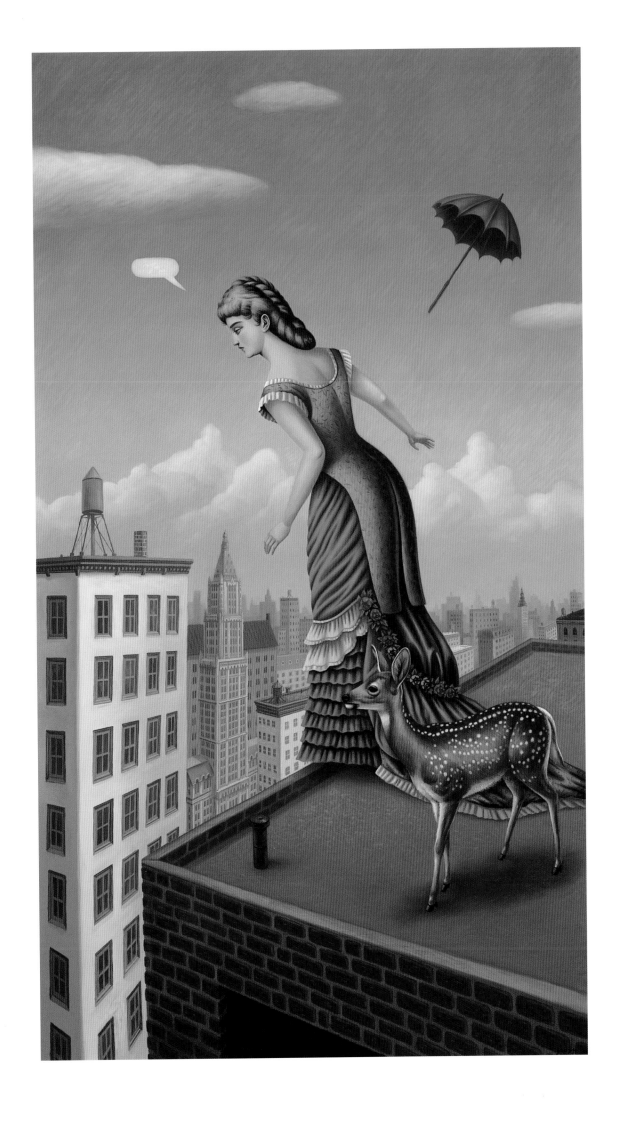

THE MEANING, PART II (DETAIL)

(following spread) SIREN
2004
OIL ON PANEL, 28 1/2" X 45 1/4"

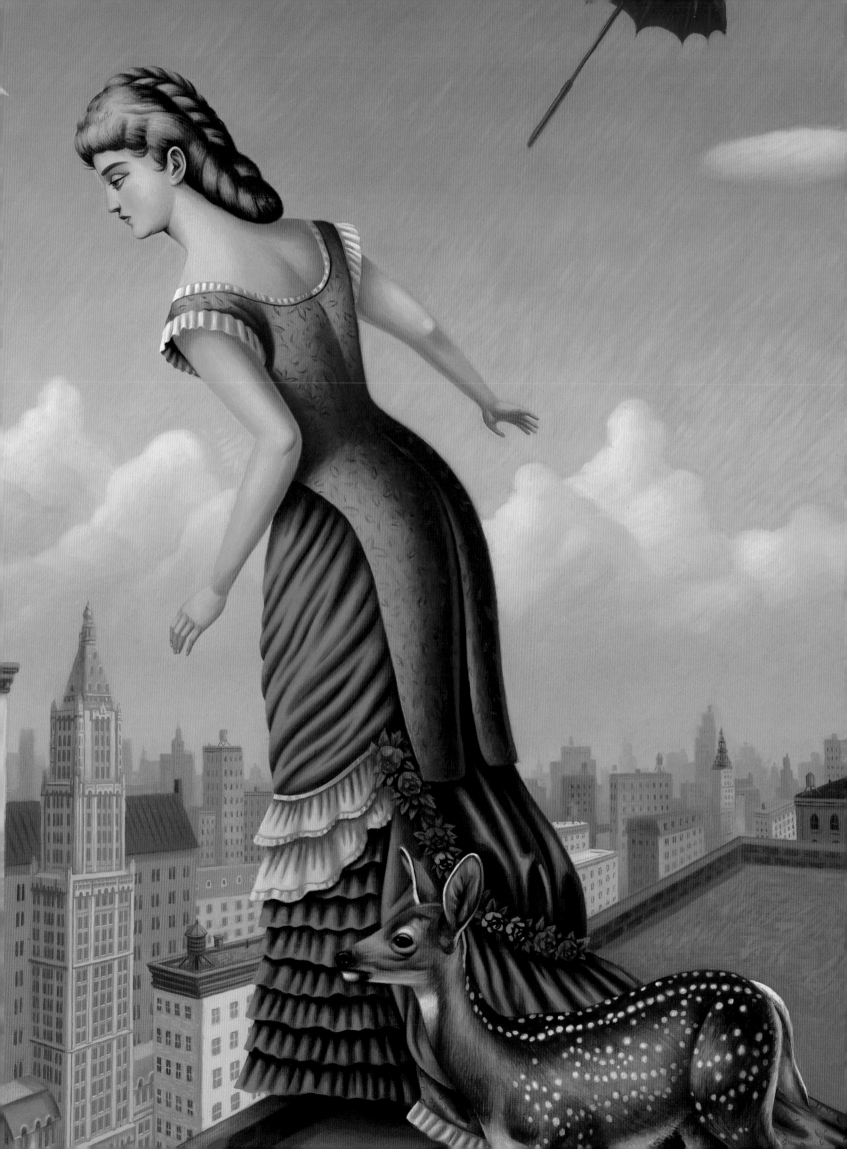

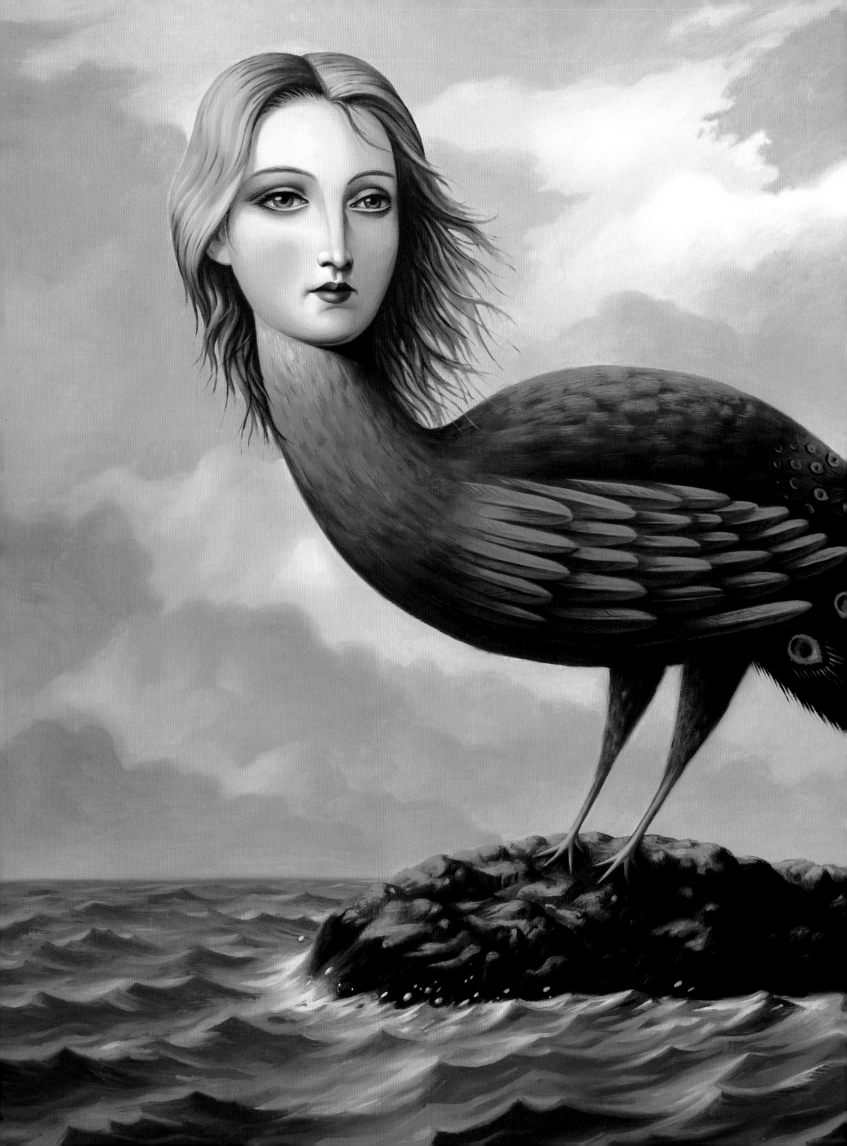

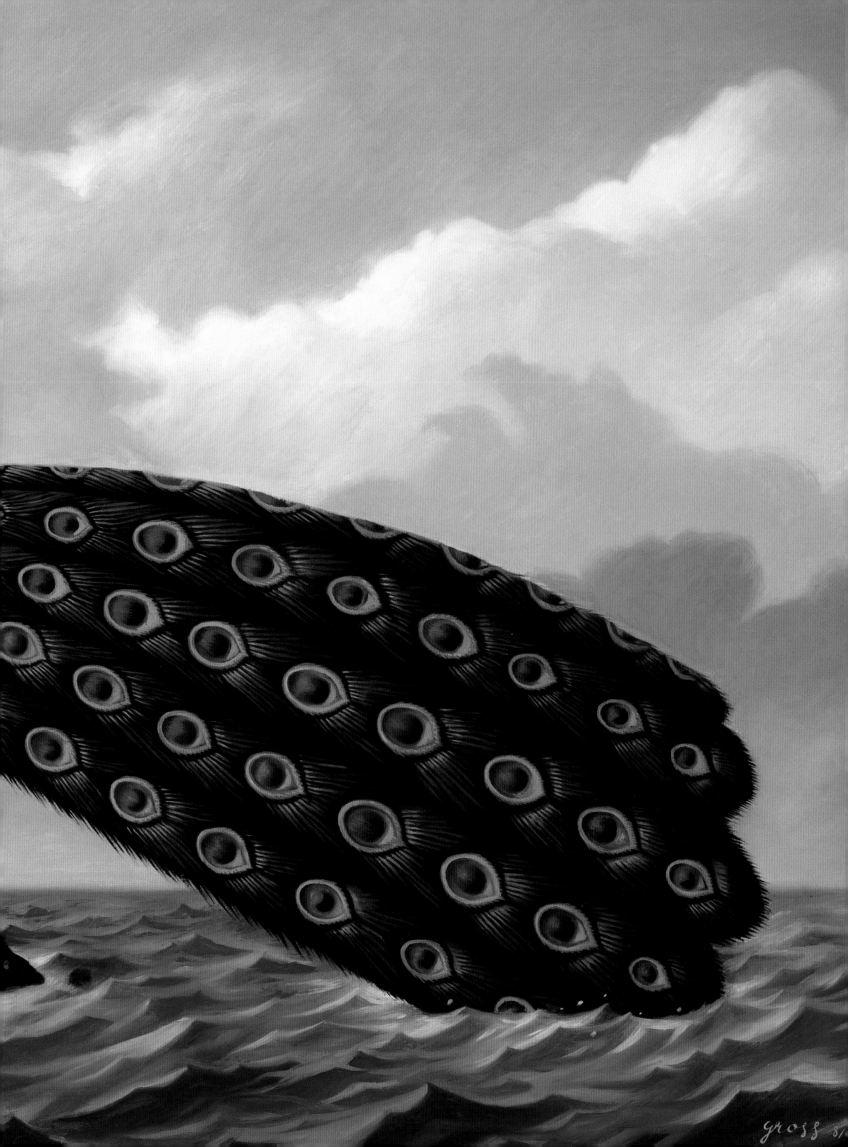

Crowds of angels are plucking on zithers,
beating on drums.
But there is no suggestion of vitality,
the music has fallen to the dull buzz
of a fly on a summer afternoon . . .
The five signs have come.

from The Decay of the Angel,
by Yukio Mishima
(Alfred A. Knopf, 1970)

THE DECAY OF THE ANGEL

2004

OIL ON CANVAS, 65" X 48"

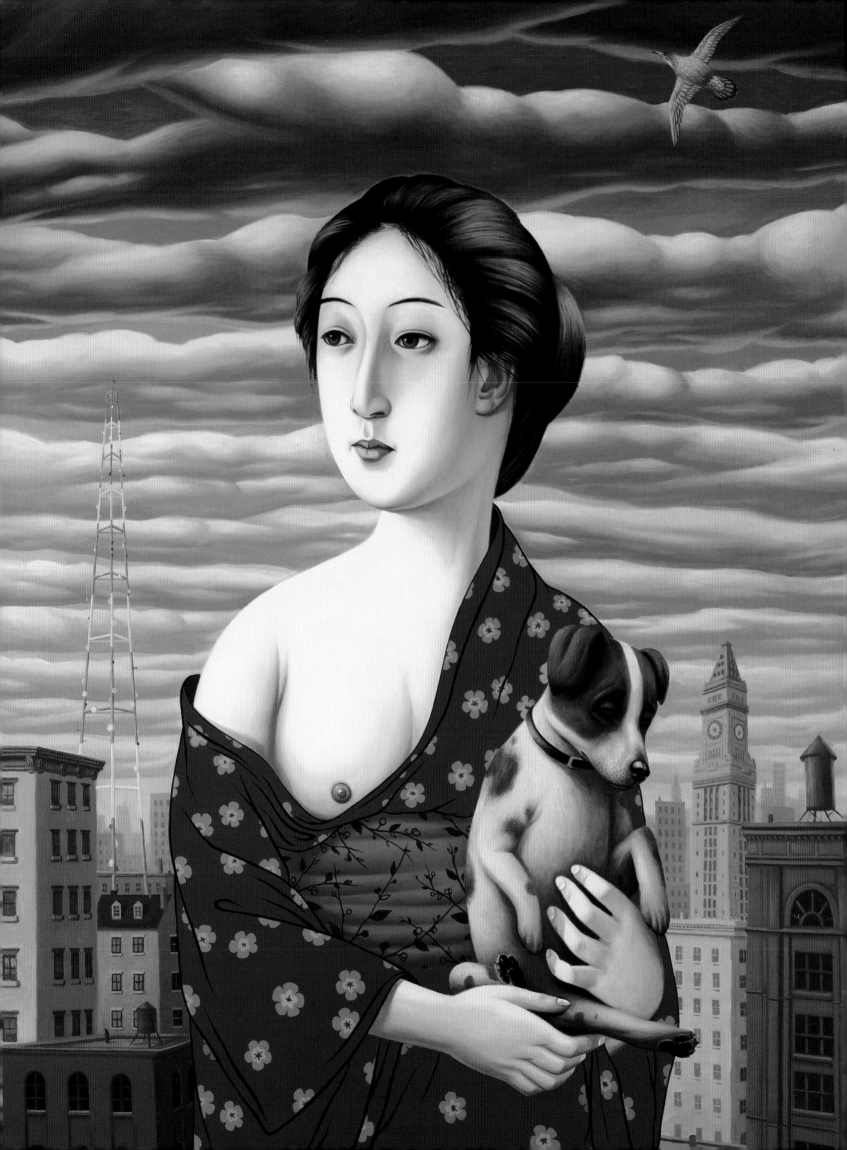

JAUNDICE
2003
OIL ON CANVAS, 56" X 40"

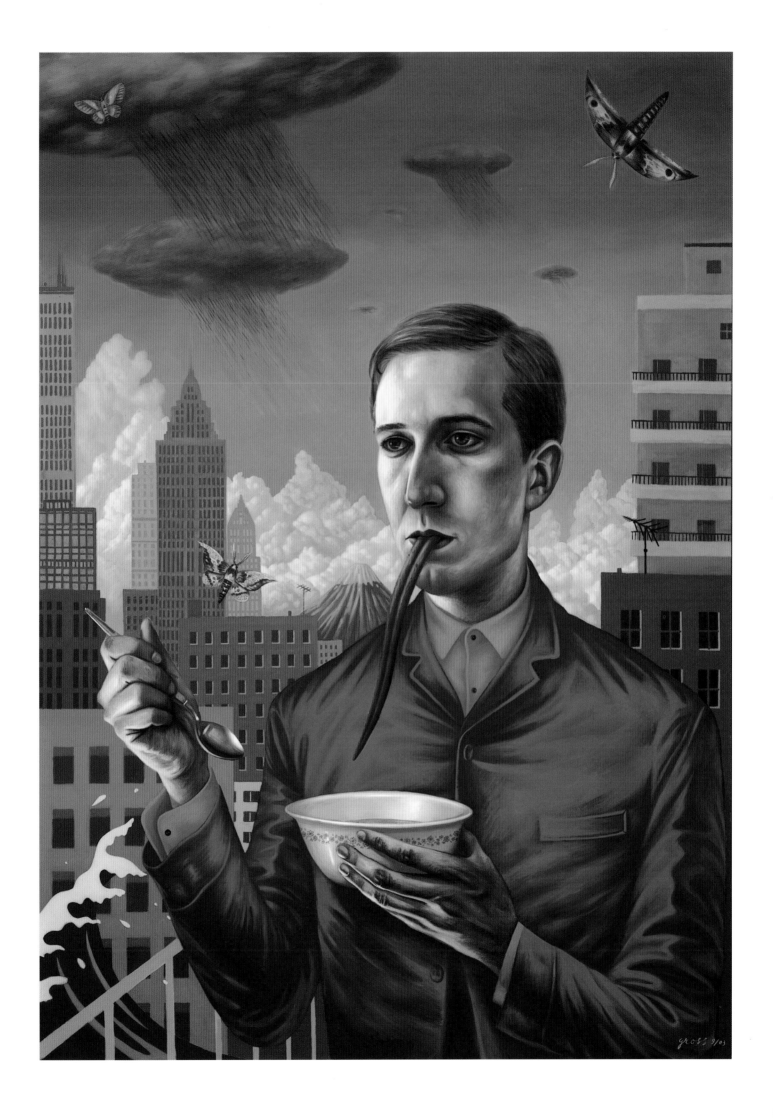

KOSHIMAKI-OSEN
2003
OIL ON CANVAS, 42" X 69"

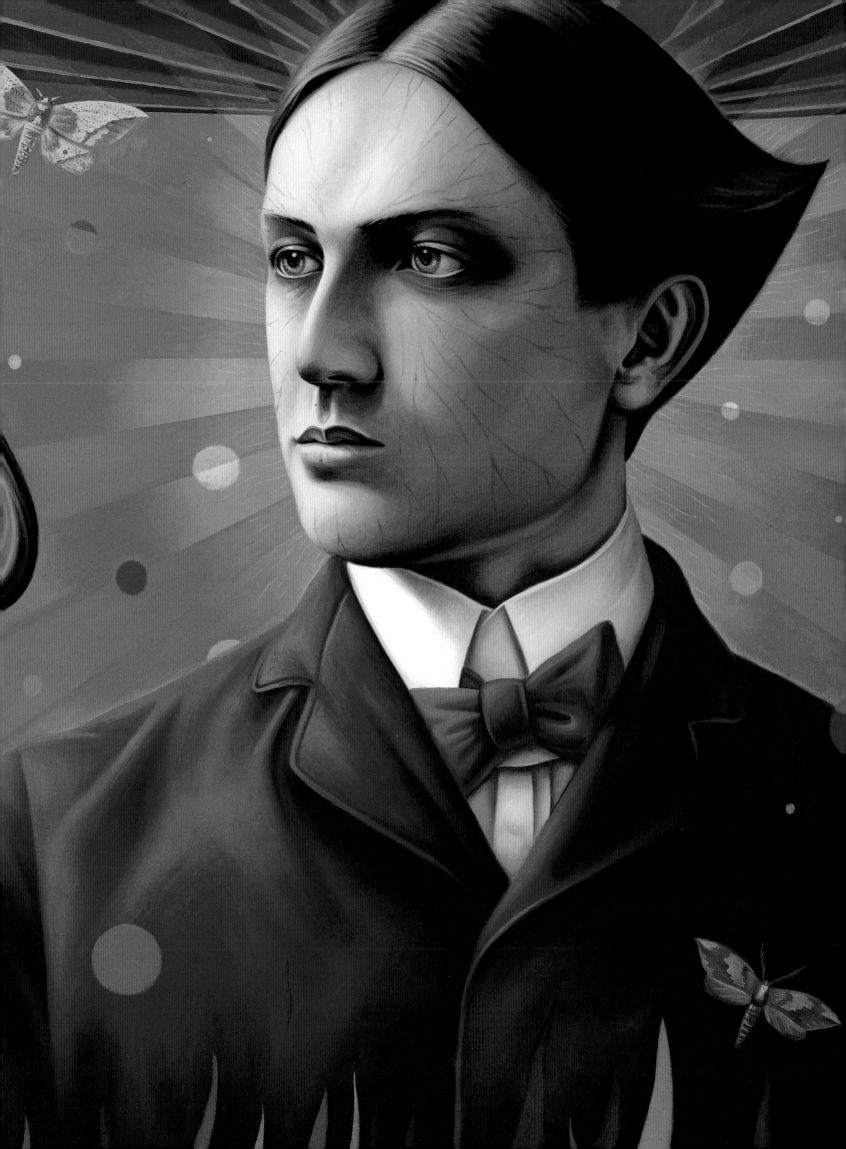

The Poppyfield

2004
MIXED MEDIA ON PANEL, 48" X 34"

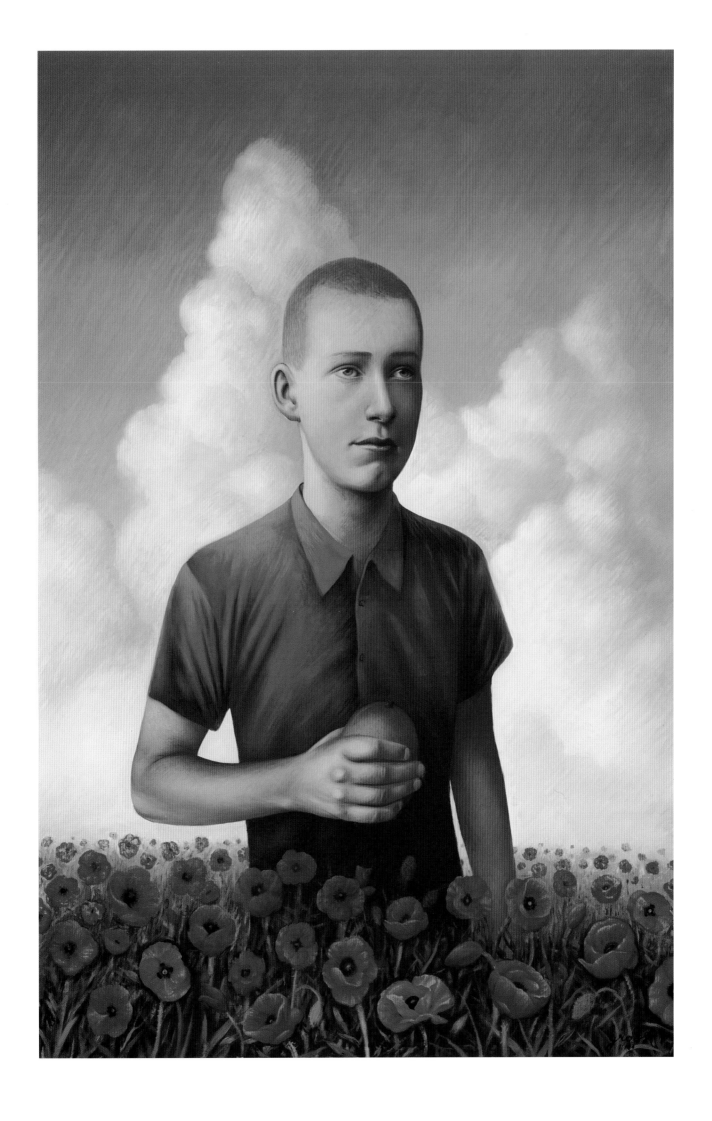

MIRROR
2005
OIL ON CANVAS, 56" X 76"

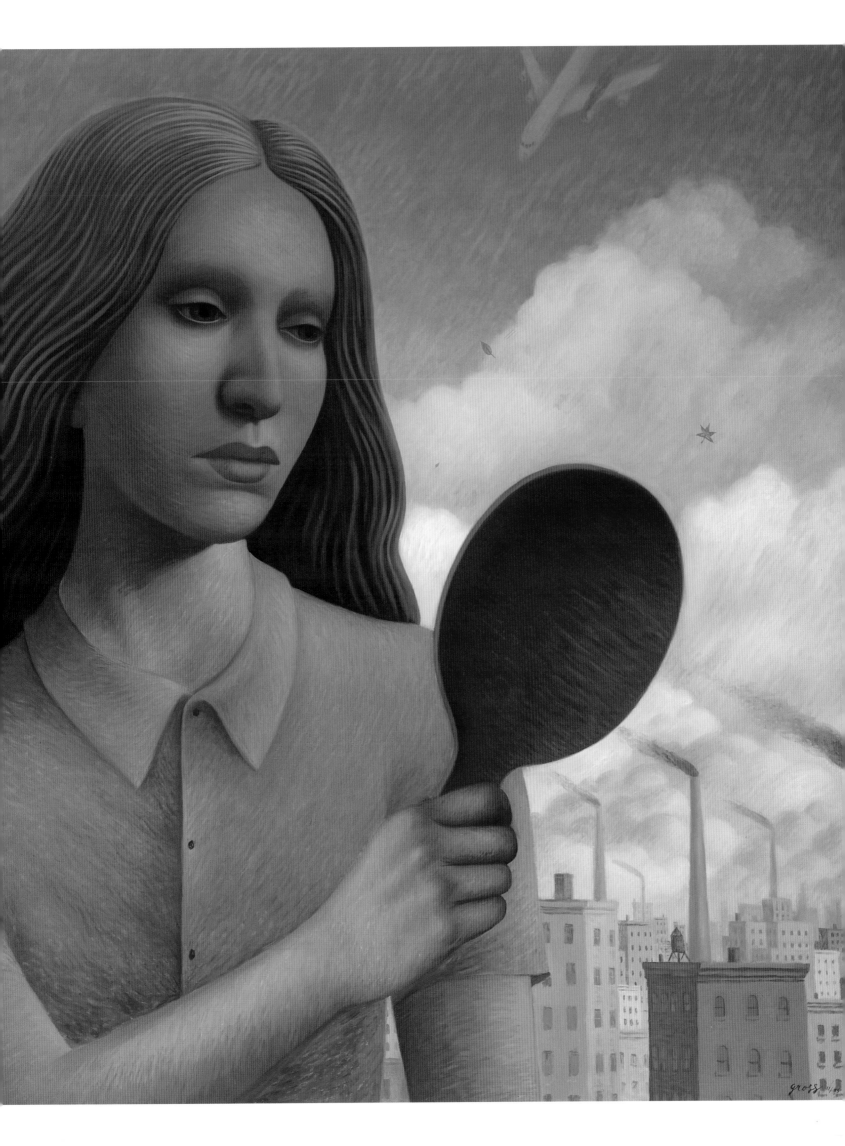

THE DAY OF THE LOCUST
2004
OIL ON CANVAS, 60" X 40"

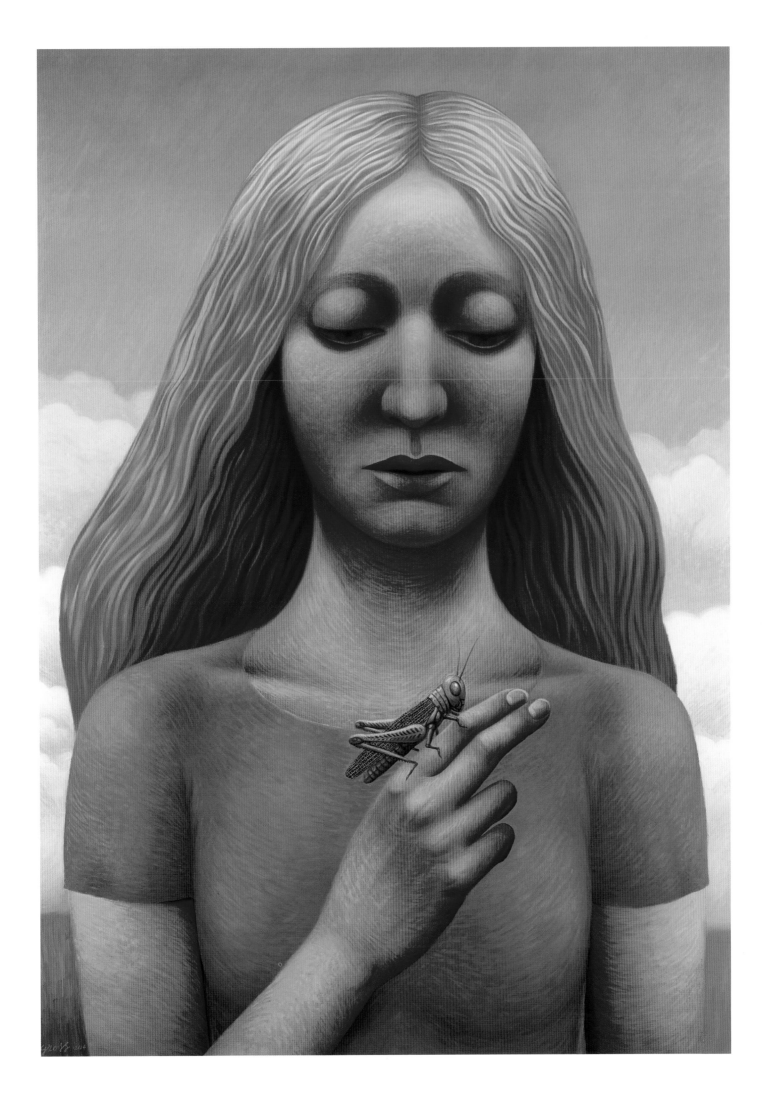

With this water that has salt in it,
and has lain on thy corpse,
I drink away all the evil that is upon thee,
and may it be upon me,
and not upon thee,
if with this water
it cannot flow away.

from the Irish folktale
"The Sin-Eater,"
by Fiona Macleod
(Duffield & Company, 1895)

THE SIN-EATER
2005
OIL ON CANVAS, 60" X 47"

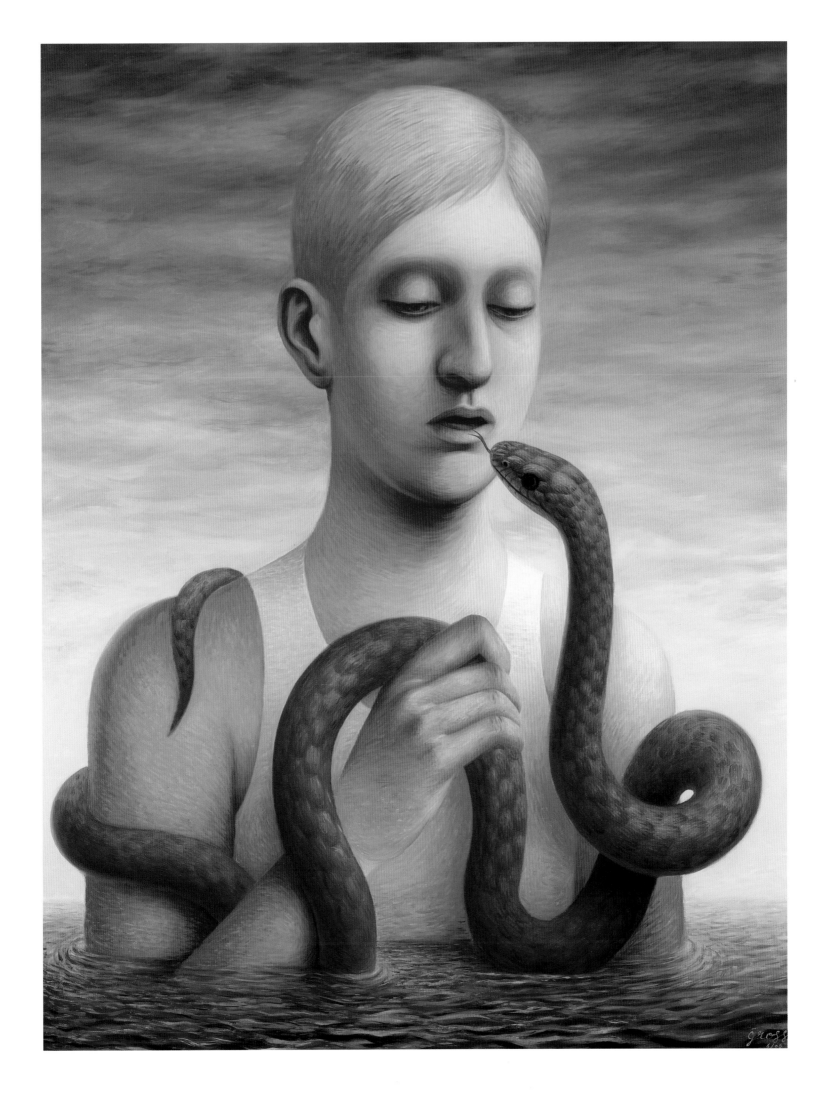

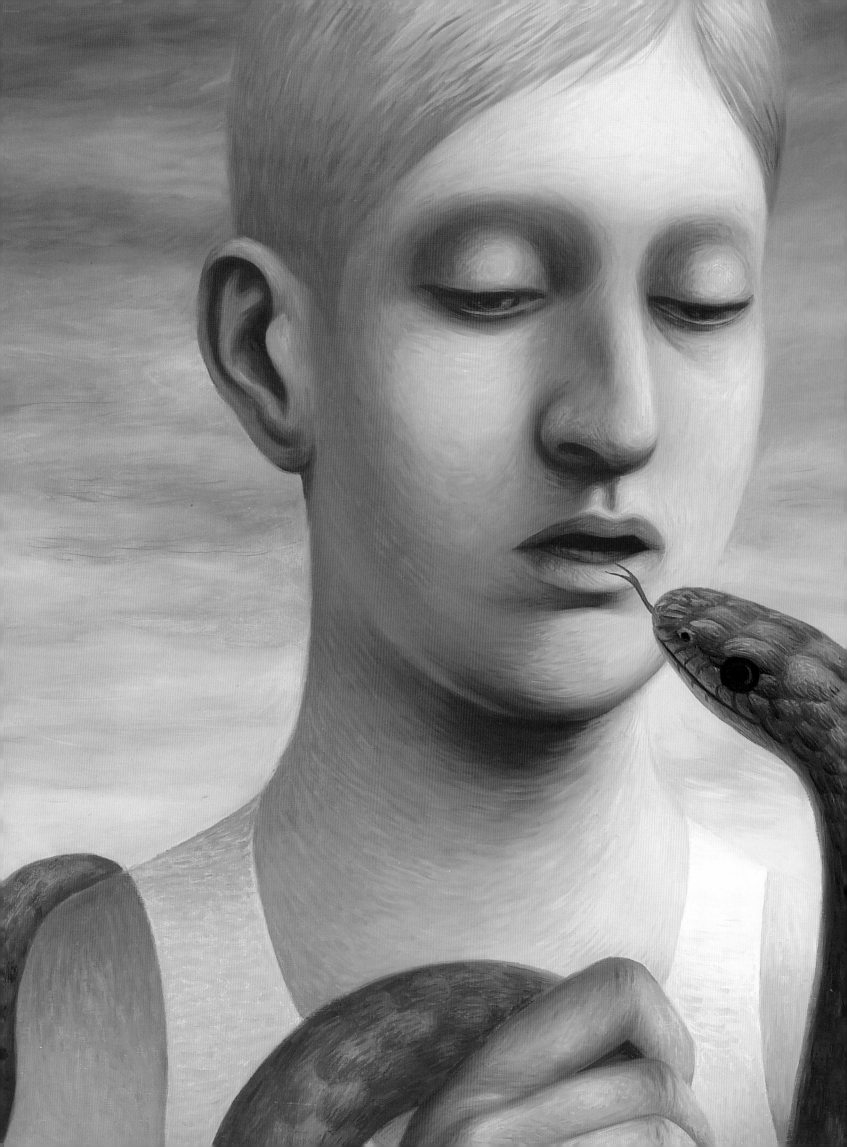

THE SIN-EATER (DETAIL)

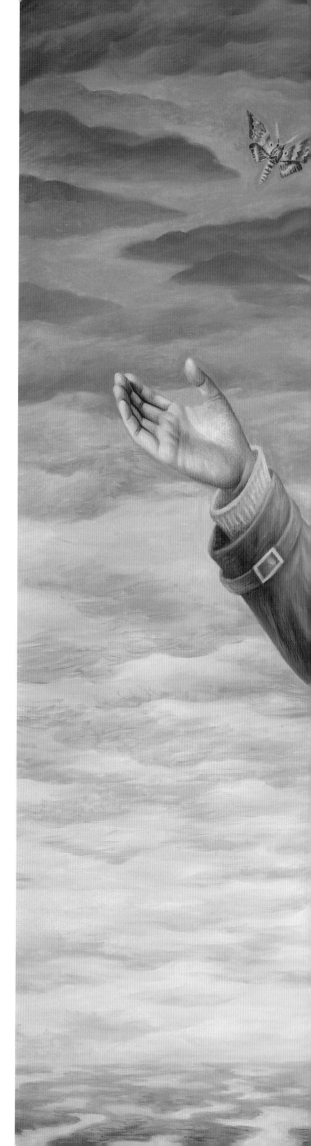

THE APOLOGIST
2006
OIL ON CANVAS, 60" X 67"

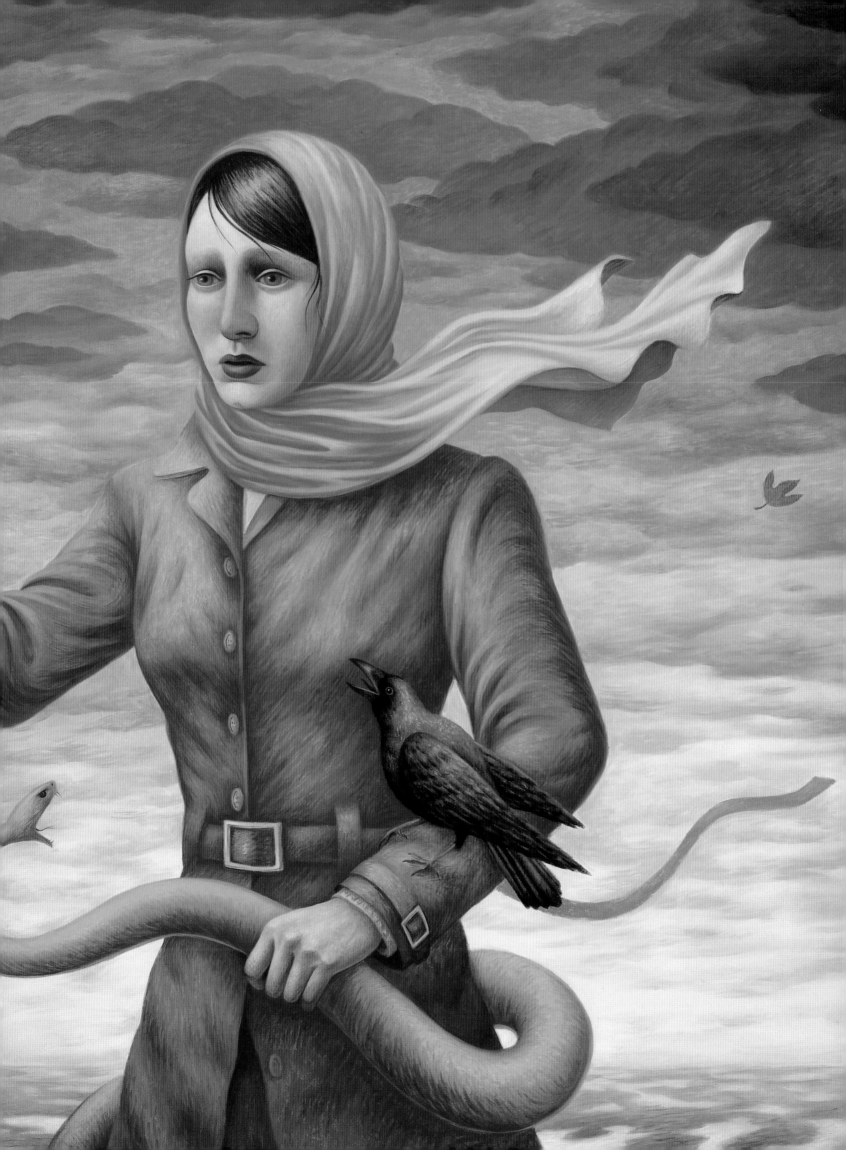

DRAWINGS, ETCHINGS, AND OTHER PRINTS

SHOKEI

2004

SKETCH, 19" X 11 1/4"

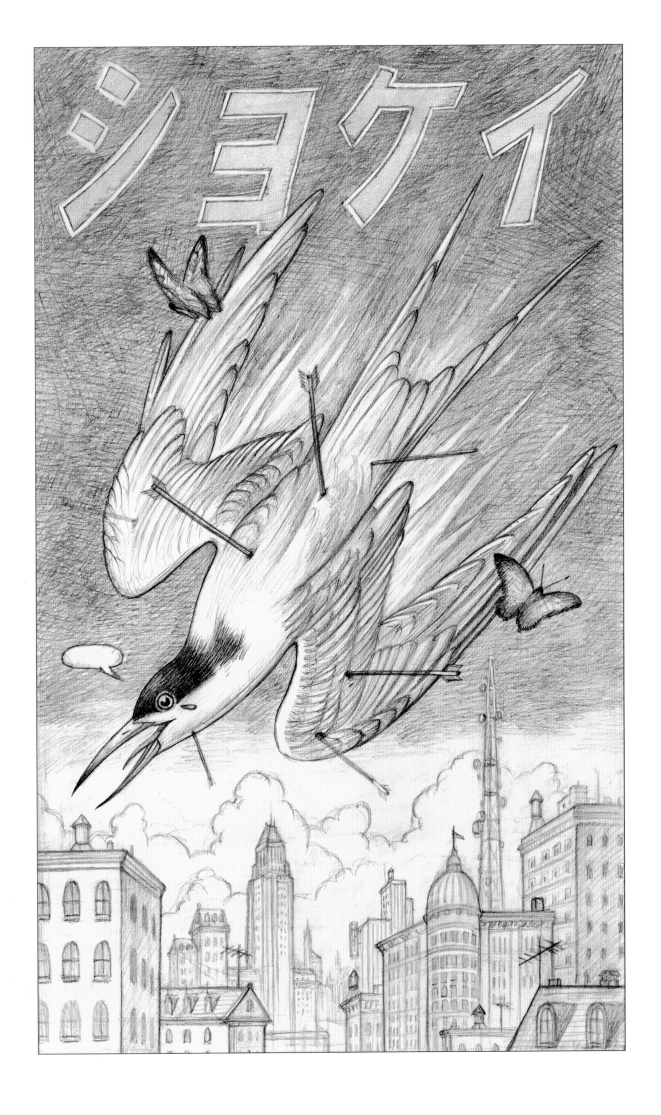

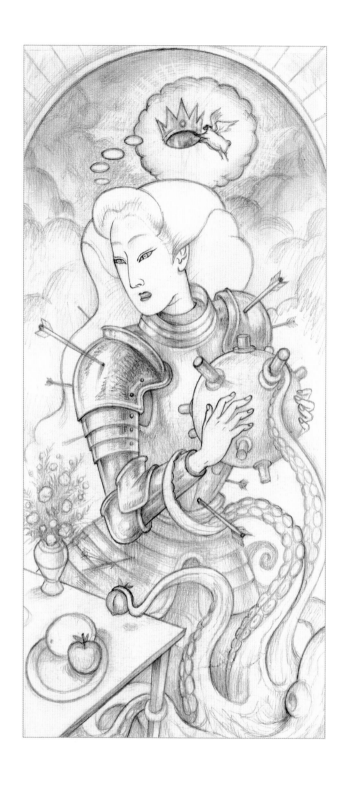

AMBITION & MERCY
2000
SKETCH, 18 1/2" X 8 1/2"

(right) **TWENTY**
2003
SKETCH, 23" X 9"

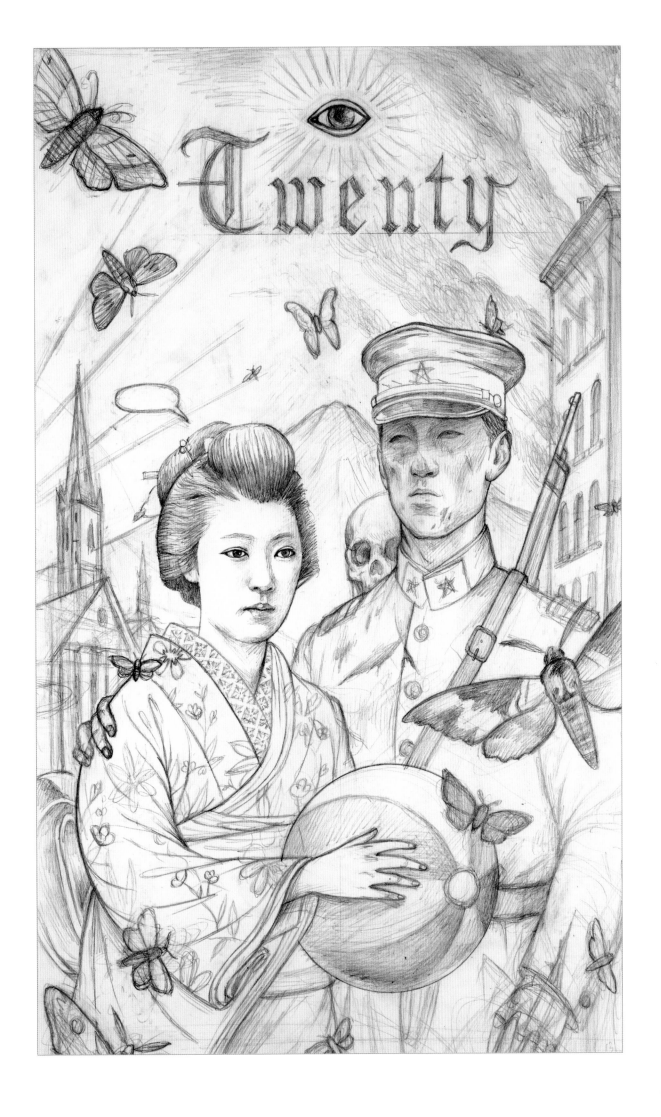

MATASABURO OF THE WIND
2001
SKETCH, 18" X 12"

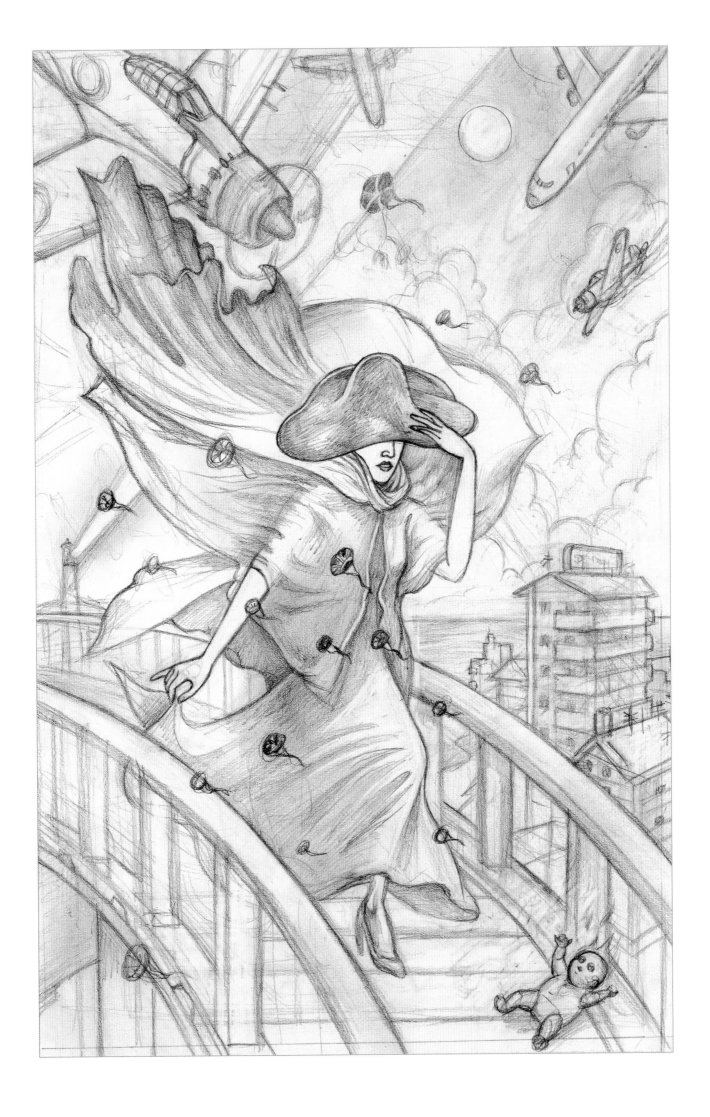

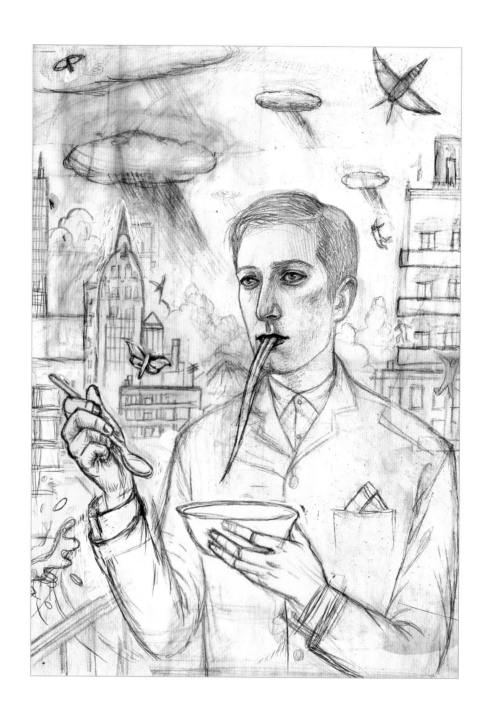

JAUNDICE
2003
SKETCH, 13 1/2" X 9 1/2"

(*right*) HAKIKE (LA NAUSEÉ)
2003
SKETCH, 18" X 11 1/2"

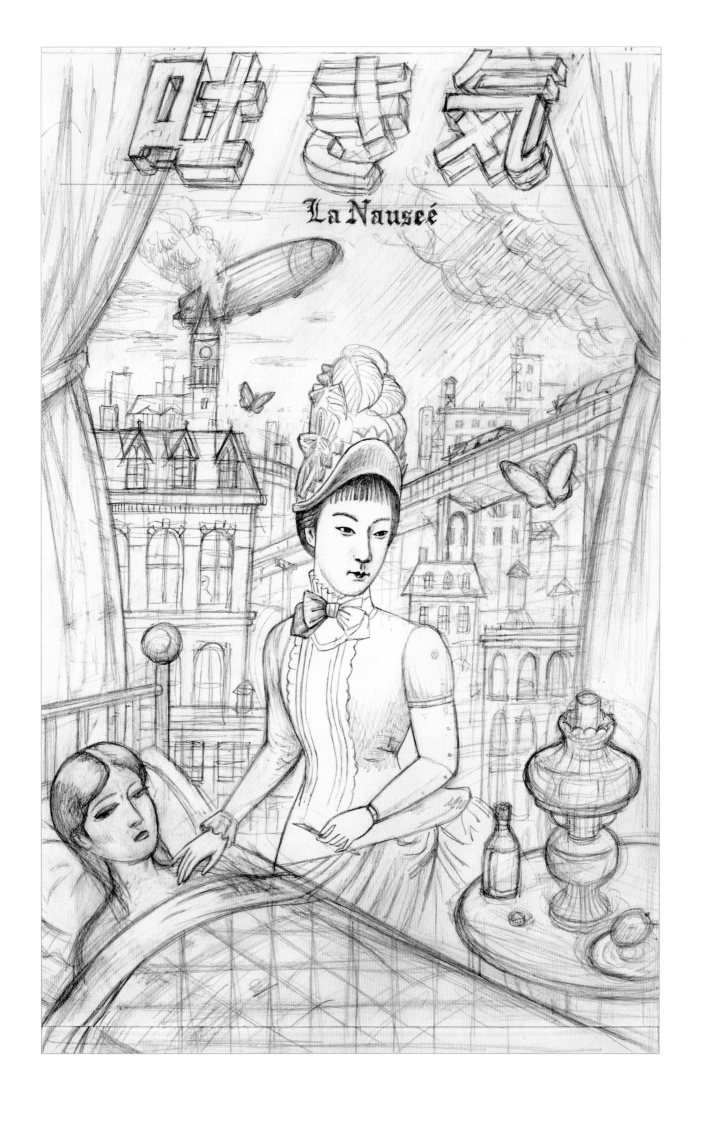

La Nauseé

THE BURNING OF TOKYO
2003
ETCHING WITH CHINE COLLÉ, 18" X 11 1/2"

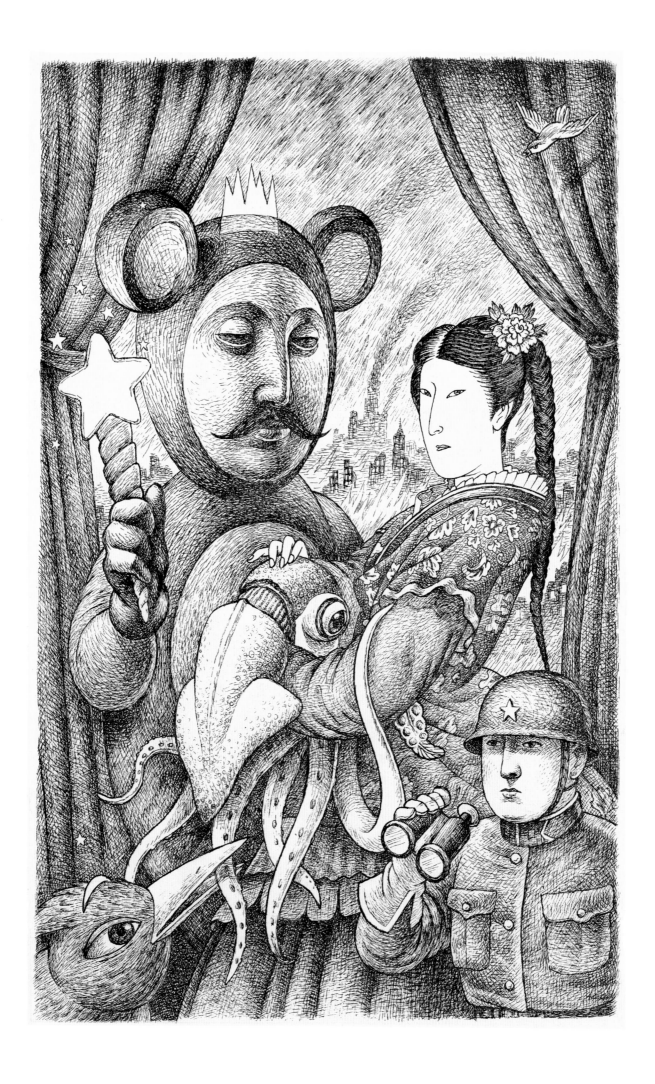

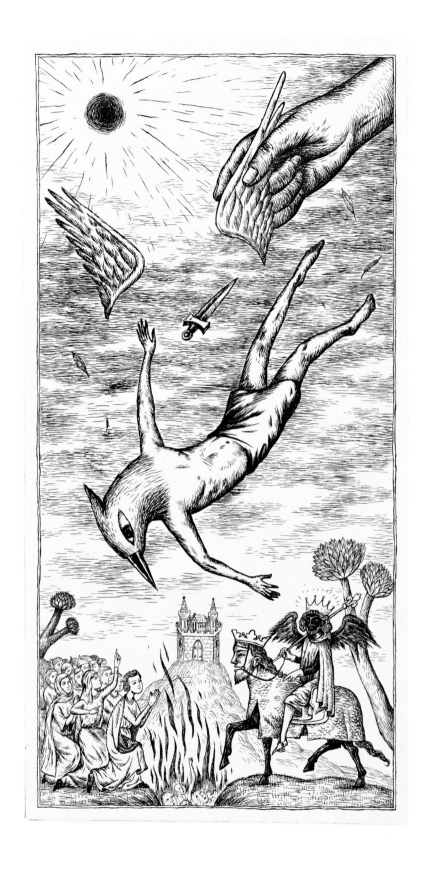

THE FALL
2003
ETCHING WITH CHINE COLLÉ, 18 1/2" X 9 1/2"

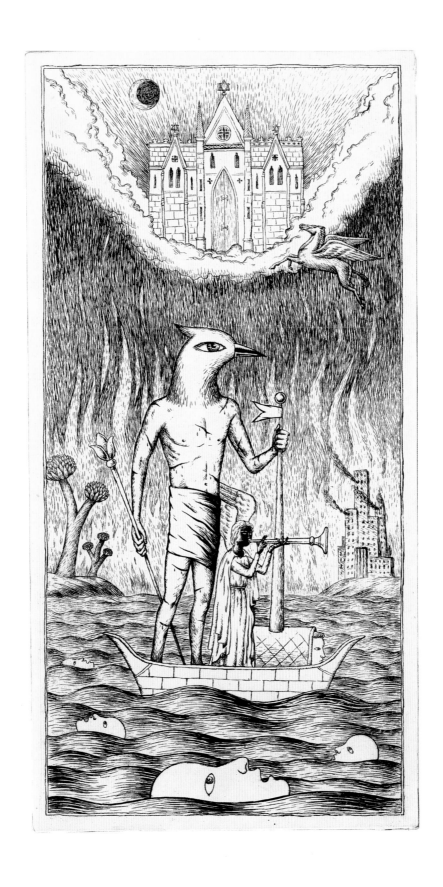

PURGATORY
2003
ETCHING WITH CHINE COLLÉ, 18 1/2" X 9 1/2"

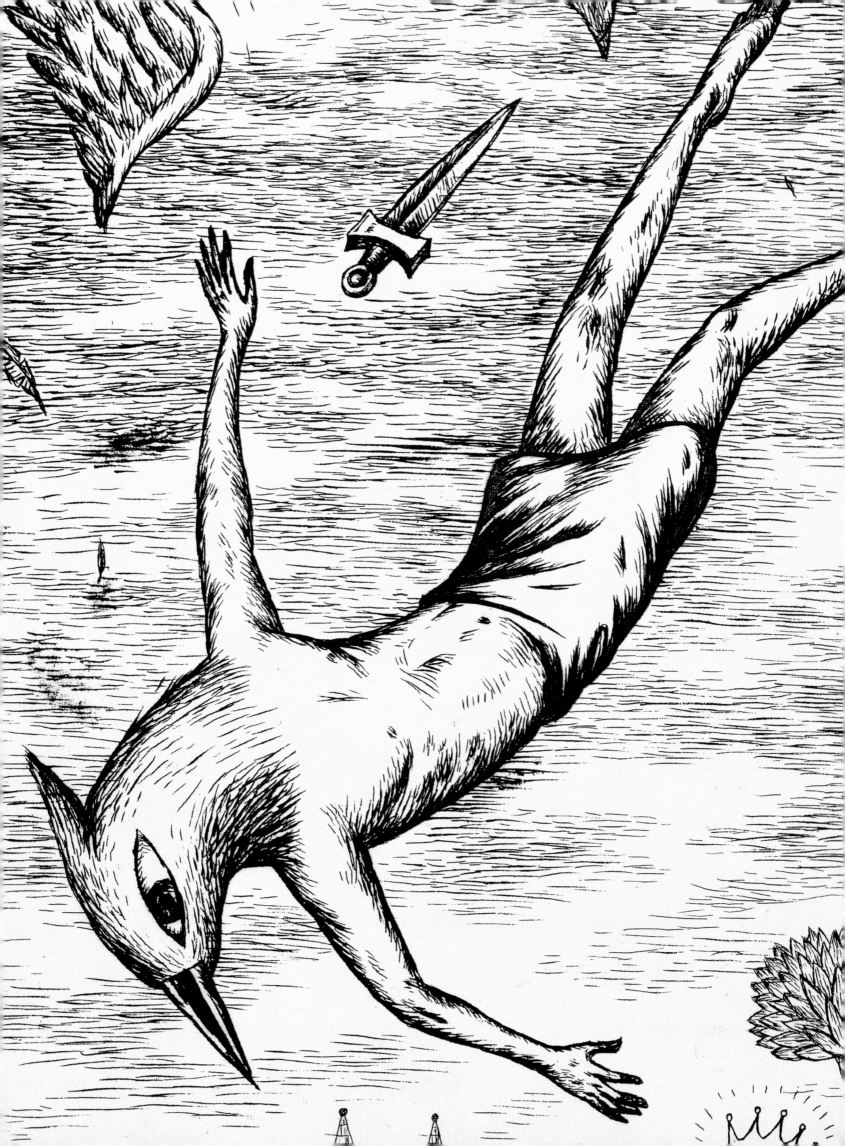

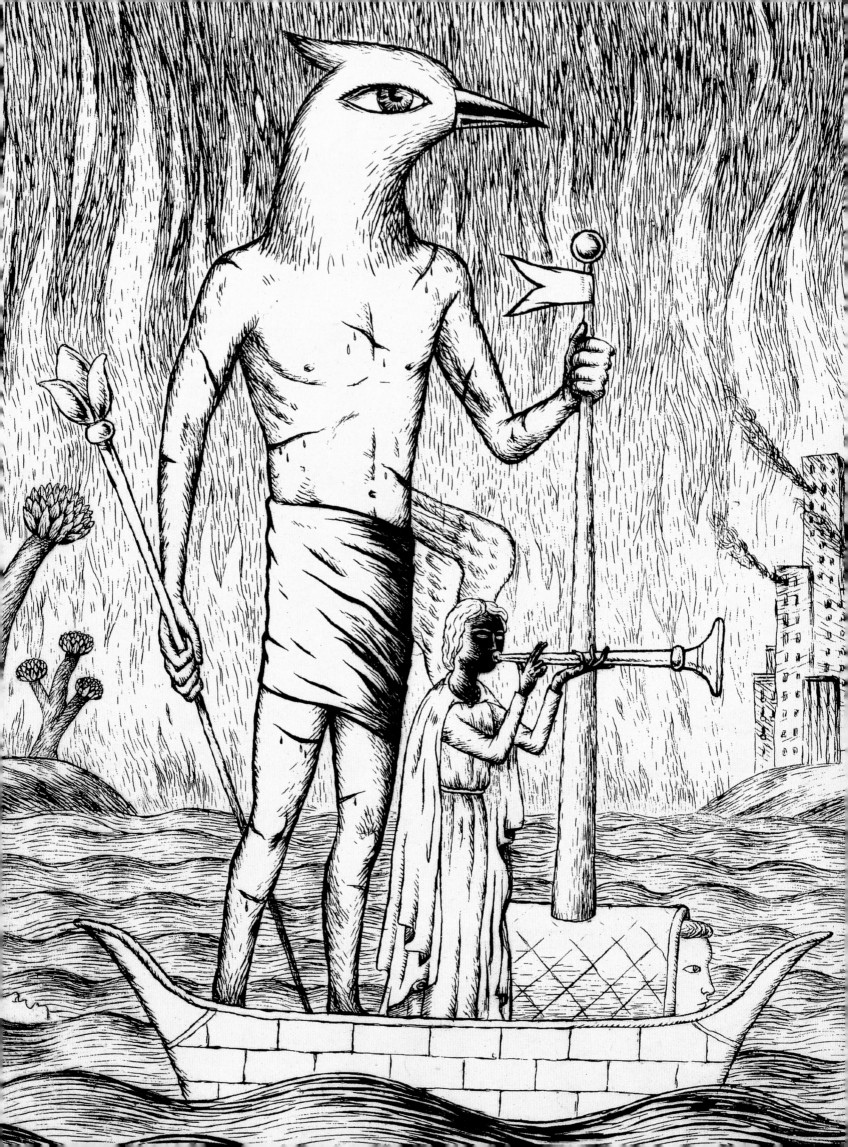

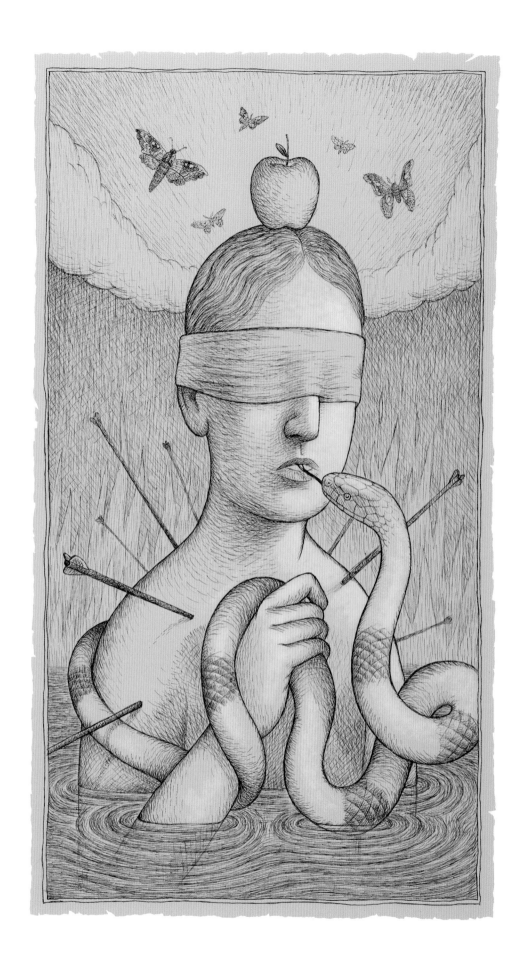

THE SIN-EATER SERIES
THE SCAPEGOAT
2005
PEN AND DIGITAL, 18 1/4" X 10"

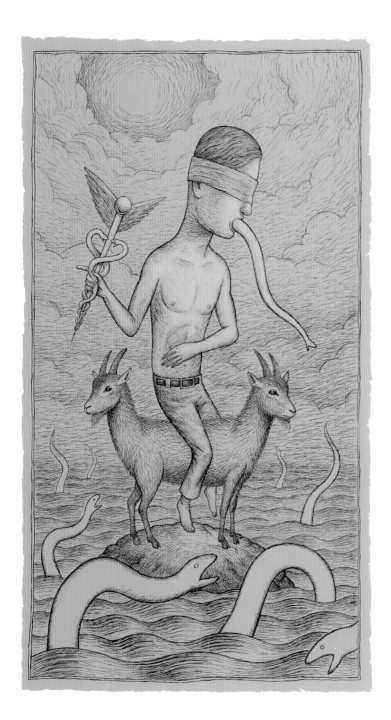 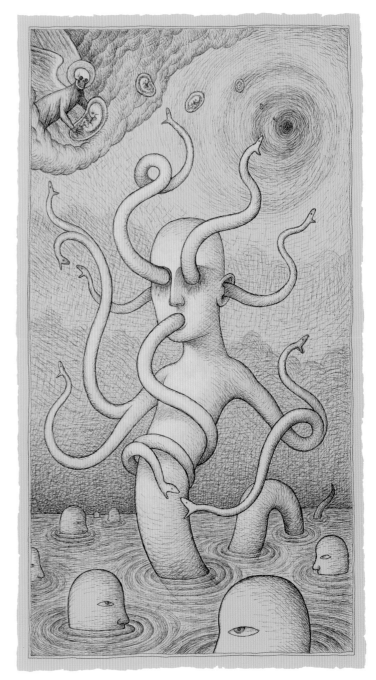

(left) THE SIN-EATER SERIES
THERE IS NO SHAKING OFF ANY SINS THEN, FOR THAT MAN
2005
PEN AND DIGITAL, 18 1/4" X 10"

(right) THE SIN-EATER SERIES
I AM JUDAS
2005
PEN AND DIGITAL, 18 1/4" X 10"

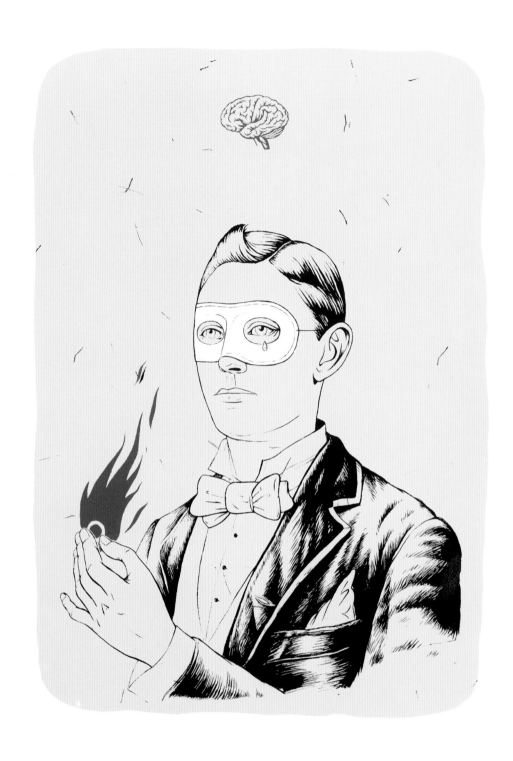

GREEN LANTERN
2003
SILK-SCREEN PRINT, 24 1/2" X 19"

(right) **FUCKER**
2003
SILK-SCREEN PRINT, 26" X 16 1/2"

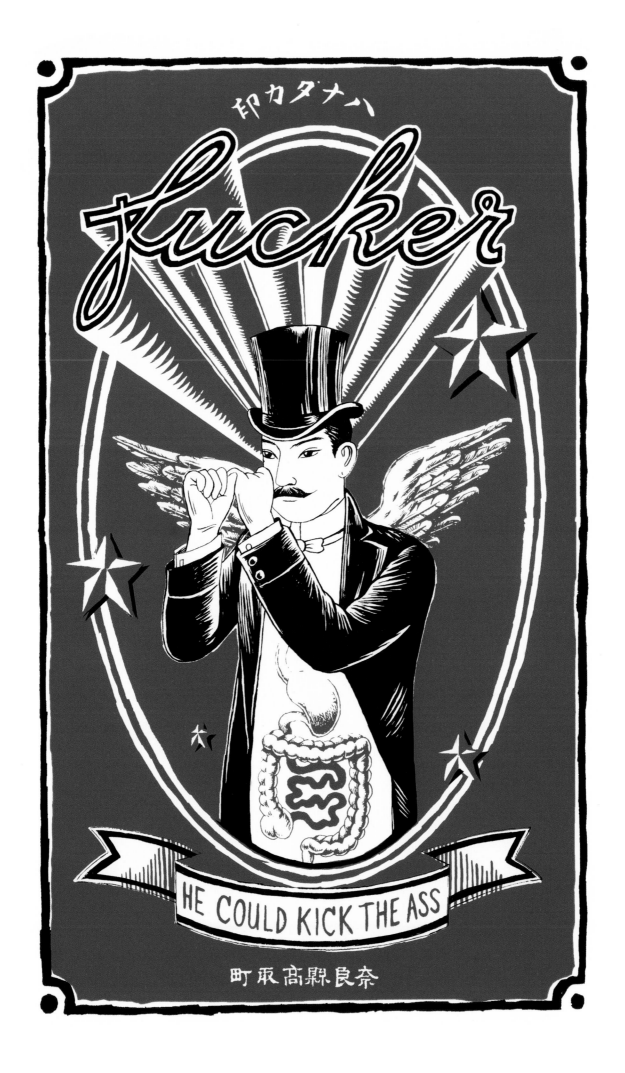

Selected Exhibitions

Solo Exhibitions

November 2006 at Copro Nason Gallery

April 2004, "The Decay of the Angel" at Earl McGrath Gallery

September 2002, "Wind and Snow" at Merry Karnowsky Gallery

September 2000, "Sleepwalkers" at Merry Karnowsky Gallery

Group Exhibitions

August 2004, "Tall Stories" at Wignall Museum at Chaffey College, Rancho Cucamonga, California

July 2004, "Age of Aquarius" at Copro Nason Gallery, Culver City, California

December 2003, "Raising the Brow" at Early McGrath Galleries, Los Angeles and New York

December 2002, "Gods and Monsters" at Roq la Rue Gallery, Seattle, Washington

"*Juxtapoz* 8th Anniversary Show" at Track 16 Gallery, Santa Monica, California

April 2003, "Robots Have Feelings Too" at Culture Cache Gallery, San Francisco, California

2000, 2001, and 2005, La Luz de Jesús Gallery, Los Angeles, California

December 1999 and 2001, Merry Karnowsky Gallery

Ongoing exhibition of print work at Outré Gallery, Melbourne, Australia

Biography

ALEX GROSS HAS BEEN A SUCCESSFUL PAINTER SINCE 1990, WHEN HE GRADUATED
FROM ART CENTER COLLEGE OF DESIGN IN PASADENA, CALIFORNIA.
HE HAS BEEN TEACHING AT ART CENTER SINCE 1994, AND HAS BEEN AWARDED
TWO FACULTY ENRICHMENT GRANTS TO DO RESEARCH FOR HIS FINE ARTWORK.
ADDITIONALLY, ALEX WAS THE RECIPIENT OF A PRESTIGIOUS ARTIST'S FELLOWSHIP FROM THE
JAPAN FOUNDATION IN THE YEAR 2000. HE SPENT TWO MONTHS TRAVELING IN TOKYO, OSAKA,
KYOTO, AND KOBE, COLLECTING A WIDE VARIETY OF JAPANESE FINE AND COMMERCIAL ART.
ADDITIONALLY, AT THE INVITATION OF THE ART CENTER KOREAN ALUMNI ORGANIZATION,
ALEX TRAVELED TO SEOUL, KOREA, IN OCTOBER OF 2004 TO LECTURE AT SEVERAL
UNIVERSITIES AND ART SCHOOLS THERE.

ALEX'S ONE-MAN EXHIBITIONS HAVE BEEN IN LOS ANGELES AT COPRO NASON GALLERY,
EARL MCGRATH GALLERY, AND MERRY KARNOWSKY GALLERY.
HIS WORK IS OWNED BY COLLECTORS IN
PARIS, LONDON, NEW YORK, TOKYO, SPAIN, AUSTRALIA, AND MANY OTHER PLACES,
AND PROMINENTLY FEATURED IN SEVERAL PUBLICATIONS.
THIS IS THE FIRST MONOGRAPH OF HIS PAINTINGS.

ALEX LIVES IN SOUTH PASADENA, CALIFORNIA, WITH HIS SEVENTEEN-YEAR-OLD CAT, CARLOS.
HE COLLECTS JAPANESE WOOD-BLOCK PRINTS, OLD MOVIE POSTERS, VICTORIAN-ERA CABINET PHOTOS,
BOOKS ON HIS FAVORITE ARTISTS, AND SHOGUN WARRIORS.
HE ALSO LIKES MOTORCYCLES.

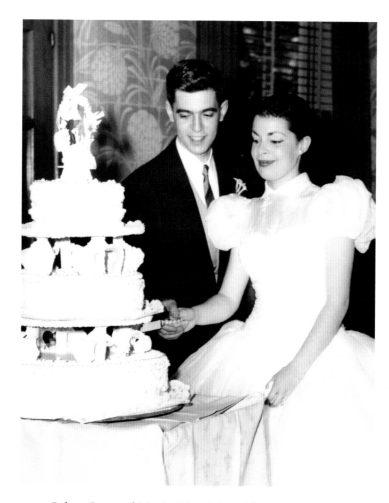

Robert Gross and Marcia Feinstein's wedding, June 9th, 1957

Acknowledgments

I would like to express my gratitude to the following people for their encouragement over the years: My mother, Marcia, my brother, Stephen, Doug Aitken, David and Courteney Cox Arquette, Gary Baseman, Rob Clayton, Dave Cooper, David Castro and Shana Taylor, Rosette DeLug, Stephane Duval, Greg Escalante, Norman Fisher-Jones, Mark Frauenfelder, Bruce Frisch, Jim Heimann, Debi Jacobson, James Jean, Gemma Jones, David Keeps, Merry Karnowsky, Tatsuro Kiuchi, Ja-Hee Lee, Long Gone John, Susan McDonnell and Brian Wakil, Earl McGrath, Martin McIntosh, Urara Nakada, Erik Olson, David Pescovitz, Gary Pressman, Keith Pressman, Liz Quesada, Alan Rapp, Jeremy Revell, Dave Robertson, Paul Rogers and Jill Von Hartmann, Erik Sandberg, Rick Short and Lisa Marie Lyou, Alix Sloan, Aaron Smith, Jeff Soto, Kevin Sparks, Charles Stern, Laurel Sterns, Makiko Sugawa, Yoshimaru Takahashi, Anthony Terrana, Rebecca Trawick, Richard "Blue" Trimarchi, Cindy Vance, Kelly Watson, Aron Weisenfeld, Markus Werner, Andreas Zachrau, and Anthony Zepeda.

I'd especially like to thank five people: the late Philip Hays, who was my friend as well as my mentor as both a painter and as a teacher; Bruce Sterling, for his wonderful introduction; Kirsten Anderson, for helping to make this book a reality; Morgan Slade, for being a fan, a great friend, and a creative partner in many amusing endeavors; and Akiko Iwasaki, who has taught me so many wonderful things.

(following spread) **PANDORA'S BOX**
2001
OIL ON CANVAS, 22" X 38"

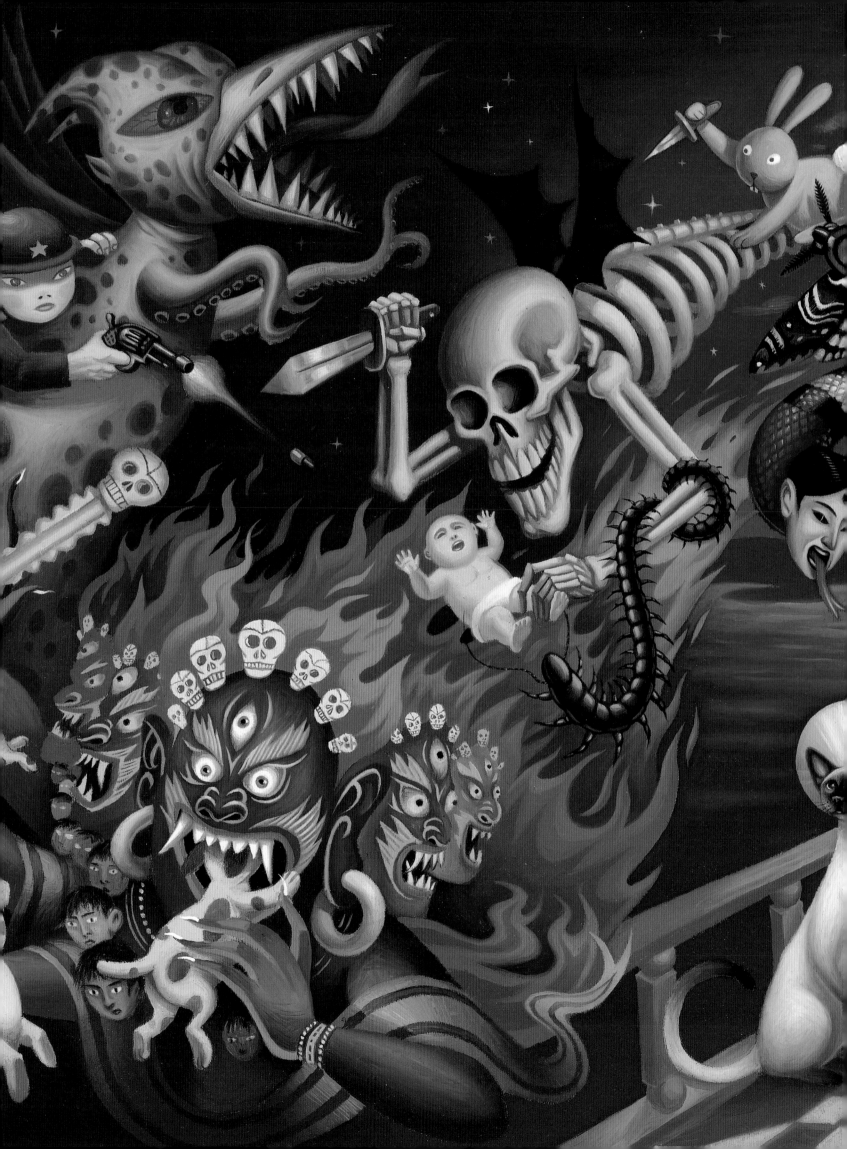

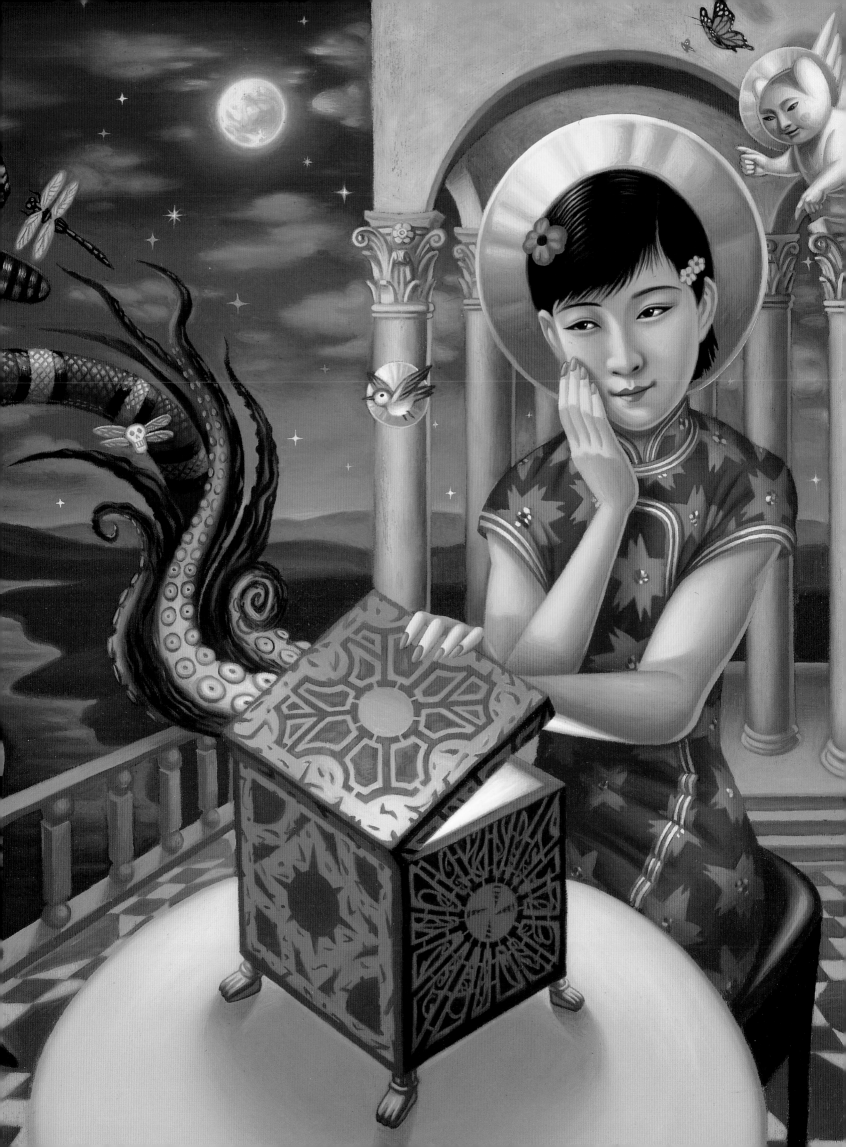

Credits

Library of Congress Cataloging-in-Publication Data available.

ISBN-10: 0-8118-5534-1
ISBN-13: 978-0-8118-5534-1

Manufactured in China.

Designed by Alex Gross and Cindy Vance

Distributed in Canada by Raincoast Books
9050 Shaughnessy Street
Vancouver, British Columbia V6P 6E5

10 9 8 7 6 5 4 3 2 1

Chronicle Books LLC
680 Second Street
San Francisco, California 94107

www.chroniclebooks.com

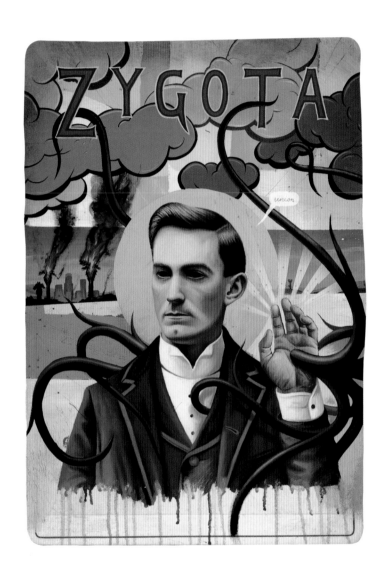

ZYGOTA (WITH JEFF SOTO)
2004
MIXED MEDIA ON PAPER, 21" X 15"